CY TWOMBLY

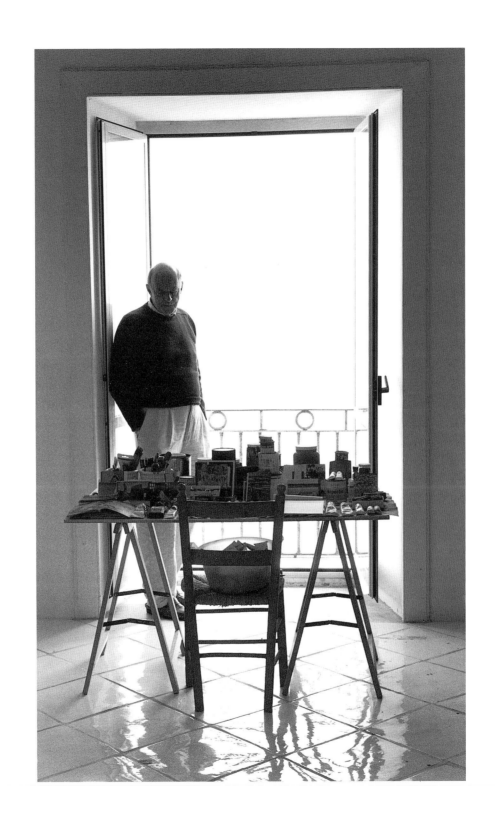

CY TWOMBLY

A RETROSPECTIVE

KIRK VARNEDOE

THE MUSEUM OF MODERN ART, NEW YORK

DISTRIBUTED BY HARRY N. ABRAMS, INC., NEW YORK

Published in conjunction with the exhibition "Cy Twombly: A Retrospective"
at The Museum of Modern Art, New York,
September 25, 1994–January 10, 1995, directed by Kirk Varnedoe,
Chief Curator, Department of Painting and Sculpture

The exhibition is generously supported by Lily Auchincloss.

Additional support has been provided by Lufthansa German Airlines.
An indemnity for the exhibition has been granted by the Federal Council
on the Arts and the Humanities.

Produced by the Department of Publications
The Museum of Modern Art, New York
Osa Brown, Director of Publications
Edited by James Leggio
Designed by Emily Waters
Production by Amanda Freymann and Vicki Drake
Composition by U.S. Lithograph, New York
Printed by Tiemann GmbH & Co KG, Bielefeld, Germany

Second printing, revised

Published by The Museum of Modern Art,
11 West 53 Street, New York, New York 10019

Clothbound edition distributed in the United States and Canada by
Harry N. Abrams, Inc., New York, A Times Mirror Company

Clothbound edition distributed outside the United States and Canada by
Thames and Hudson Ltd., London

Printed in Germany

COVER: Detail of *Leda and the Swan*, 1962 (pl. 64)
FRONTISPIECE: Cy Twombly in his studio at Gaeta, spring 1994

CONTENTS

This publication is made possible by a generous gift from Emily Fisher Landau.

FOREWORD

The Museum of Modern Art is privileged to have the opportunity to honor Cy Twombly. Though his work is held in the highest regard by connoisseurs worldwide, he has perhaps been lauded more extensively in Europe than in his native land. It was the firm conviction of Kirk Varnedoe, Chief Curator of Painting and Sculpture, that our public, and especially a generation of younger artists, needed an opportunity to study afresh the full extent of Twombly's achievement. Since the retrospective exhibition mounted at the Whitney Museum of American Art in 1979, significant early works have reemerged, and the artist has produced a substantial body of important new work. Many of the works in the present exhibition have never before been incorporated into a retrospective, and many others have not previously been shown in America.

We hope that a new view of Twombly will be stimulating to contemporary artists and their public, and will also provide the opportunity for us to reconsider our familiar ideas of the progress of avant-garde art since 1945. Twombly's art—which seems to belong both to America and to Europe and embraces abstraction, figuration, and writing—unifies in a challenging way many of the styles and domains of recent art that are frequently considered to be rigidly separate.

We deeply appreciate the generosity of the many collectors and institutions whose loans made the exhibition possible. We are also especially grateful for the committed patronage of two exceptional benefactors, Lily Auchincloss and Emily Fisher Landau, whose donations supported respectively this exhibition and its publication. A project of this nature, with art as challenging as Twombly's, is unfortunately not likely to attract corporate support. We therefore depend on the vision and generosity of such private donors, who believe both in the mission of the Museum and in the value of contemporary creativity.

Finally, we owe very warm thanks to the director of the exhibition and author of this publication, Kirk Varnedoe. His admiration for the art of Cy Twombly, and his personal commitment to presenting it as fully and thoughtfully as possible, are evident in all aspects of this project. Preparing this exhibition and book with such care and intelligence, while meeting with equal sensitivity and professionalism the heavy demands of his role as Chief Curator of Painting and Sculpture, required extraordinary dedication, energy, and long hours. He too deserves our admiration as well as our gratitude.

Richard E. Oldenburg
Director
The Museum of Modern Art

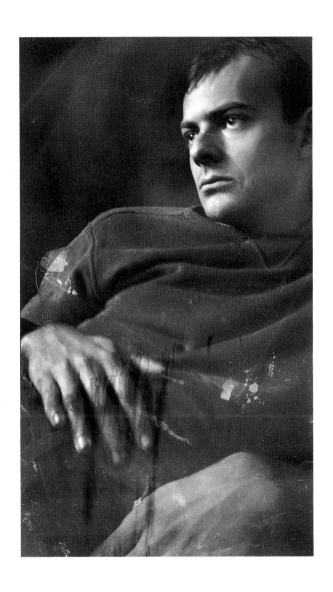

Cy Twombly at Black Mountain College. 1951. Photograph by Robert Rauschenberg

INSCRIPTIONS IN ARCADIA

ILLUSTRIOUS AND UNKNOWN: this was what Degas aspired to be, and what Cy Twombly has become.[1] His imposing reputation has an aura of myth and ambiguity, for reasons that have partly to do with the elusiveness of the artist himself (residing abroad and protective of his privacy), but more to do with the singularity of his art. Twombly first came to prominence in the later 1950s, when his graffiti-like pencilwork appeared to subvert Abstract Expressionism. Yet he then sustained painterly abstraction through a time in the 1960s when the imagery of mass culture and the certainties of geometry seemed destined to kill it off. While linked by generational ties and friendship to Robert Rauschenberg and Jasper Johns, he has suffered from the fact that unlike theirs, his work—with no bold graphic or photographic imagery—tells little in reproduction, and provides no convenient entrance into Pop art. The elements of ironic realism in their art have been considered progressive and in tune with postmodern sensibilities, but Twombly's unique combination of bare astringency and sensual indulgence has proved harder to confine within such tidy generalizations. He has further distanced himself from his contemporaries by embracing the classical past and reaching for epic narrative in an era when such models appeared wholly derelict. In addition, his work has often sought its own poetics by invoking the heritage of literature, during a long period in which "literary" was a term of condemnation. These commitments, and their author, have never found a ready niche in accounts of the progress of art since 1950. The countless paperbacks and catalogues that have canonized the line of artists from Pollock to Warhol as the mainstream of American art's postwar ascendancy have typically neglected

Twombly rather than contend with the ways his inclusion might disrupt that story's flow. A fellow artist already saw the problem in 1955: "[Twombly's] originality," he said, "is being himself. He seems to be born out of our time, rather than into it."[2]

That assessment cannot satisfy: no person has such autonomy, and clearly Twombly's art is specifically contemporary. Efforts to link him to the art of his time have left us, though, with an oddly piecemeal fabric of interpretations—one which only now, in the mid-1990s, appears to be assuming enough breadth and density to wrap the complex achievements of the work itself. Over almost three decades, Twombly has been repeatedly "rediscovered" by American critics, in various ways. The white-on-grey paintings he made in the late 1960s were welcomed as having an anti-sensual, cerebral spareness that related them to Minimalism and Conceptual art; and the fascination with linguistic models of criticism focused special attention on the play of marking, writing, and schematic figuration in his work. Then, more important, American awareness of European contemporary art expanded: in the 1970s a sharpened focus on the art of Joseph Beuys—concerned with grand myth and history, but also esoterically personal and tied to a bodily animism—began a reorientation that favored Twombly in other ways; and the advent of a new painterly expressionism in the 1980s, in artists as diverse as Anselm Kiefer and Francesco Clemente, further catalyzed a fresh assessment of his importance.

More recently a fraught concern with sexuality has appeared among contemporary artists whose anti-formal expressivity and candor about the body has

opened still another avenue into Twombly's complex achievement. As did the earlier frames of reference (Abstract Expressionism, Neo-Dada, Minimal and Conceptual art, Neo-Expressionism, and so on), this one can help us see valid aspects of the work. Taken in sequence, however, each of these terms has tended to exclude or ignore the others, and none accounts for the presence within Twombly's art of all these, and more, contradictory climates of feeling. Offhand impulsiveness and obsessive systems; the defiling urge toward what is base and the complementary love for lyric poetry and the grand legacy of high Western culture; written words, counting systems, geometry, ideographic signs, and abstract fingerwork with paint—all ask to be understood in concert.

In that complexity, this art has proved influential among artists, discomfiting to many critics, and truculently difficult not just for a broad public, but for sophisticated initiates of postwar art as well. It will almost certainly continue to defy ready acceptance by a wide audience, as its particular impact depends so strongly on the kind of direct response to physical presence that is resistant to verbalization and uncongenial to analysis. In the extensive literature on Twombly, many sensitive writers and acute theoreticians have already grappled with that difficulty, in efforts to capture poetically the seductive force of his work, and to analyze its singular aesthetic structure. With respect for and indebtedness to many of their texts, this retrospective essay approaches its subject in a different and perhaps more prosaic fashion, by attempting to examine the art within the context of a fuller account of the basic circumstances of time, place, and biography in which it has been made.

It is, after all, not just the internal complexity of any given work that is so challenging; the several shifts and turns this long career has seen, and the varieties of feeling that shape its different periods, also confound generalizations. Yet—amazingly, given Twombly's stature—there still exists no standard, documented history of exactly what has happened in the evolution of his art, when, and in what order. The dates and the durations of his formative experiences have been only vaguely sketched out in writing on him, and the shifting locales in which he has worked (clearly understood by his intimates as central to the variety of his production) are known to outsiders only as a string of often unfamiliar names— Sperlonga, Bassano, Bolsena, Gaeta, and so on (see map, fig. 47, in the notes). If we are ever to come to firmer grips with the art in its broader implications and historical role, we would do well to start by better understanding these basic matters, and trying to integrate them into a reliable chronicle of Twombly's experience. This will not of course "explain" anything: a creator's work is never reducible to his or her life, and lives are themselves constructs that need interpretation. Yet

few artists' work seems so closely—one wants to say so nakedly—tied to the vicissitudes of an individual temperament unfolding in time. Historians must eventually reckon with the specifics of that connection, not because such facts will provide answers, but because they will help us frame more telling questions.

The crucial first step has already been taken by Heiner Bastian in his superb catalogue raisonné of Twombly's paintings, which is mapping the extent of the oeuvre, allowing us to see countless little-known canvases, and establishing an order.[3] With that reference in hand, we can now trace the development of the work, and, with the artist's generous cooperation and the help of new documentation, begin to chronicle more fully his life and art in tandem. The thumbnail biography that has been ritually repeated throughout the literature cites, for example, three formative episodes: his childhood in Virginia; his education in Boston and New York and at Black Mountain; and his move to Italy in 1957. We can start simply by reexamining these givens, and reassessing what they have meant for Twombly as an artist—with the intent that through such efforts he should become a little less unknown, and thereby the more illustrious.

EARLY LIFE AND EDUCATION, 1928–52

Edwin Parker Twombly, Jr., was born on April 25, 1928, at Stonewall Jackson Hospital in Lexington, Virginia. Second child and only son, he inherited the nickname his father had earned—recalling the legendary pitcher Cy Young— as a professional baseball player.[4] Both parents were Northeasterners by birth, but the South was vital to the family's experience and Twombly has remained unmistakably Southern in important aspects of his presence and character.[5] The rhythm of his childhood, inflected by regular sojourns with his extended family in Massachusetts and Maine, involved what he sees as a happy alternation of two basic American cultures. The family's roots in New England supplied cooler, analytic elements of Yankee temperament, but it is the South, he feels, that is more closely allied with the Mediterranean world he embraced as an adult. Virginia and Italy, Twombly maintains only half jokingly, are both Mediterranean cultures.

That connection is long-standing: the antebellum South had a special vein of neoclassicism, from Thomas Jefferson's Palladian buildings at Charlottesville and Monticello through the pedimented porticoes of plantation architecture, to the Latin names frequently imposed on slaves. More generally, the traditional elements that thickened the "atmosphere" of Southern life—a honeyed ease with spoken language and a rich literary tradition, a certain sensual languor, and

the lingering romance of fallen grandeur—could all be taken to have predisposed Twombly toward the Roman life he later chose. There are also other, less evident strains of Southern culture that Twombly understands explicitly, including a dark current of fantasy and irrationality, just as there are more specific aspects of his birthplace that helped form him.

Lexington, set in the Blue Ridge Mountains west of the Shenandoah, is dominated by two institutions: Washington and Lee University, where Twombly's father worked as coach and later athletic director,[6] and the Virginia Military Institute. The community's bookstores and faculties opened horizons and encouraged ambitions in ways that belied the usual limitations of a small town. The military college also added a special dimension. Within the Old South, the uniformed cavalier had always constituted a special ideal of aristocracy, fostering the cult of honor and the formalities of chivalry; nowhere would this have been more evident than in the place where Robert E. Lee and Stonewall Jackson taught and are buried.[7] In Twombly's youth, when local sons and daughters of Confederate soldiers still retained memories of Manassas they had learned at the knee, this association among historical myth, cultural grace, and arms would have been especially pervasive. It might seem to have little direct bearing on art, but on an imagination later fired by Troy and Thermopylae, it left its imprint. (In 1975, Twombly made a collage whose title, *Mars and the Artist* [pl. 83], specifically associated creativity with the god of war.) Moreover, the military households in Lexington—more spartan than other homes, but often informed by wider travel and experience of the world—displayed their porcelain and other fine objects in an austere and focused isolation that Twombly recalls as one of his earliest experiences of aesthetic sophistication.[8]

As for true artistic instruction, though, Lexington was barren. Twombly was artistically gifted and precociously facile at working with his hands, and his parents and teachers encouraged him.[9] Yet his training might have depended only on the Sears, Roebuck art kits he ordered by mail, if Pierre Daura (a Spanish artist connected to Virginia by marriage and driven from Europe by the outbreak of war) had not settled nearby and started giving private lessons just when Twombly, at the age of twelve, began to devote significant energy to painting. As a veteran of the avant-garde and an adept of the Cercle et Carré group in France, Daura opened an avenue out of the provincial South toward the tradition that extended from Paul Cézanne into modern European art.[10]

Twombly embraced that tradition swiftly. The first painting he remembers making was a copy of Marie-Thérèse Walter slumbering on the cover of Jean Cassou's 1937 book on Picasso; and on his sixteenth birthday, his mother gave

1. Cy Twombly with untitled assemblage (no longer extant), Groveland, Massachusetts. 1946

him Sheldon Cheney's *A Primer of Modern Art*, which he says he "devoured." Cheney's book was less a history than an evangelical tract: it trumpeted the visionary courage of the modern movement, sneered at bourgeois tastes, and—with a grudging nod to Cubism, but no regard for geometric abstraction—preached that the tradition of expressionism manifest in artists such as Oskar Kokoschka was the true legacy of Cézanne and the royal road of contemporary creativity.[11]

Twombly's first formal art school training, in Boston after high school, reinforced this emphasis.[12] Though the School of the Museum of Fine Arts emphasized practical matters of technique and materials with an eye to training teachers, it had a bias toward German aesthetics and was a seedbed of the expressionist painting that flourished in Boston in the late 1940s.[13] The local Institute of Contemporary Art shared that orientation. In contrast to the perceived prejudices of The Museum of Modern Art in New York, it favored Northern Europe over Paris as the central terrain of the modern tradition, and figurative over nonobjective painting.[14] Twombly visited the Institute often; to the extent that it valued regionalism and mistrusted abstract art, its programs would have helped delay his awareness of the avant-garde in New York and focus him instead on a European expressionist heritage. In this vein, aside from such figures at the school as the German Karl Zerbe and locals such as Hyman Bloom, more exalted

2. Robert Rauschenberg. *22 The Lily White*. c. 1950. House paint and pencil on canvas, 39½ × 23¾" (100.3 × 60.3 cm). Collection Mrs. Victor W. Ganz

models were also available: both Max Beckmann and Kokoschka showed in Boston and visited the school during Twombly's years there (1947–49).[15] He admired the work of Lovis Corinth, and in his most expressionist moments was strongly attracted to the convulsive, visceral art of Chaim Soutine, which he emulated briefly but intensely.[16]

At the same time, however, Twombly developed an interest in aspects of Dada and Surrealism, and especially in Kurt Schwitters and Alberto Giacometti. Schwitters's death in 1948 brought a new flurry of interest in his work, and Twombly remembers making collages under his inspiration, from ticker tape and other detritus collected in Boston's Scollay Square. (A taste for assemblage might already be discerned in the early object with which he was photographed in 1946; see fig. 1.) A new edition of Alfred H. Barr, Jr.'s *Fantastic Art, Dada, Surrealism* was published in 1947, and apparently its reproduction of Giacometti's *The Palace at 4 A.M.* inspired an early assemblage sculpture (pl. 2) that elevates two doorknobs and a faucet handle into a symmetrical, hieratic order. Tellingly, Twombly recast his admiration for the ethereal, spindly architecture of *The Palace* in terms of found objects that recall Schwitters's assemblages of wood and detritus; and he used white paint and tiered pedestals in a way that anticipates many of his own later three-dimensional pieces (see pls. 7, 84, 87, 94).[17]

Before he ever confronted New York, Twombly had thus absorbed from European modern art both an ideal of uncompromising self-expression—he was to write years later that the main challenge of progressive art "lies in the complete expression of one's own personality through every faculty available"[18]—and a feel for the irrational poetry latent in society's most humble material facts. He was also prepared to explore the possibilities, generally scanted by his training, of abstract art as an arena for these impulses, and was in any event outgrowing the bounds of provincial instruction, as his next teacher clearly saw.

In the autumn of 1949, after the two-year course in Boston, Twombly enrolled, at his parents' insistence, in the newly created art program at Washington and Lee. The sole instructor, Marion Junkin, immediately recognized a talent that needed a more competitive environment, and prodded him upward. Junkin had attended the Art Students League of New York from 1927 to 1932,[19] and he encouraged Twombly to apply for a fellowship from the League, as well as an additional grant from the Virginia Museum of Fine Arts to help him live in New York—both of which he won. In the supporting material for the Virginia application, his childhood instructor, Daura, called him "the most promising young art student I ever came across," while Junkin's letter was fuller in its retrospect, and prophetic in its sense of Twombly's future: "I feel," Junkin wrote, "that he will develop into a poet in paint and that it will be a strong poetry as he is not easily changed from his purpose."[20]

•

Twombly arrived in New York in September 1950, ostensibly to study under Will Barnet and Morris Kantor at the Art Students League; but their teaching became only a small aspect of his accelerating education. As he said in a letter written that autumn: "The League is full of diverse talent—and I learn as much from watching the students work as I do from the instruction."[21] He gorged himself on art of all eras and kinds, making a regular round of museum shows (including an Arshile Gorky retrospective at the Whitney Museum of American Art) and gallery openings, where he saw or met "such diverse men as Dali, Stamos, Gottlieb, Tchelitchew and others."[22] Galleries such as those of Sam Kootz, Betty Parsons, and Charles Egan afforded him his initial broad, firsthand experience of advanced abstract painting by New York artists such as Jackson Pollock, Mark Rothko, Robert Motherwell, and Franz Kline. These experiences helped purge residual figurative aspects from his art and encouraged him to pursue a simplified form of abstraction.[23] To the extent his resources permitted, he also began acquiring a few works of art, including prints by Chagall and Rouault and a collage by Schwitters.[24]

Working productively through the early months of 1951, Twombly appeared in League exhibitions and even received an offer for a one-person show.[25] Most important, though, during the spring he established a close relationship with his fellow League student Robert Rauschenberg. Married at the time to Susan Weil, who was expecting their child in the summer, Rauschenberg was three years Twombly's senior, and a veteran of art school training in Kansas and Paris and at Black Mountain College in North Carolina. Through articles and exhibitions, including a one-person show at the Betty Parsons Gallery in May, he was getting a first taste of notoriety in the spring of 1951.[26] Some of Rauschenberg's work at the time—notably *22 The Lily White* (fig. 2), a white painting with ample pencil-working of incised diagrams, words, and numbers—might be taken to anticipate aspects of Twombly's later art. By the same token, Twombly's attention to Schwitters and his earlier experiments in assembled sculpture may have been instructive for Rauschenberg. At the start, however, a more general affinity of energies sparked the relationship: Twombly has said that this was the first time he encountered someone close to his own age who shared his interests and goals as an artist.[27]

With Rauschenberg's encouragement, Twombly enrolled for the summer session of 1951 at Black Mountain College, with the intention of studying under Ben Shahn and Robert Motherwell.[28] The founding artistic spirit, Josef Albers, had departed, and the school was entering another phase. Talented young writers assembled there, around the poet Charles Olson, and visiting New York School innovators such as Motherwell and Kline mixed with the progenitors of a new aesthetic, especially John Cage and Merce Cunningham.[29] As at the Art Students League, direct classroom instruction was perhaps the least of the experience. Though Shahn looked on Twombly as a favorite pupil, Motherwell was little inclined to teach formally, and told him to work on his own.[30] In any case, Twombly was by then ready to stop being a student and start becoming an artist: the earliest oil paintings he credits as his own were done at Black Mountain in 1951 and 1952. The first (see fig. 5) seem dominantly built from Kline's open-work timbers of black on white, while others from the same summer (fig. 4) have an all-over interlocking of dark and light elements that may owe more to Pollock. The surviving works of later 1951 and of 1952 are, however, sharply altered in conception and more personal. Many suggest symmetrically splayed paper cutouts (figs. 6, 7; pl. 3).[31] Others repeat a compositional type that features circular or knob-like forms clustered horizontally in the top part of the canvas, bound to an array of hanging "legs" or vertical, pole-like structures below (pls. 4, 5).

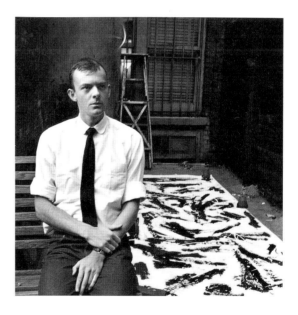

3. Cy, Black Mountain II, 1951 (Bastian 1, no. 23),
Black Mountain College. 1951. Photograph by Robert Rauschenberg

4. Twombly with unidentified painting, Black Mountain College. 1951(?).
Photograph by Robert Rauschenberg

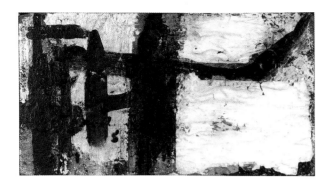

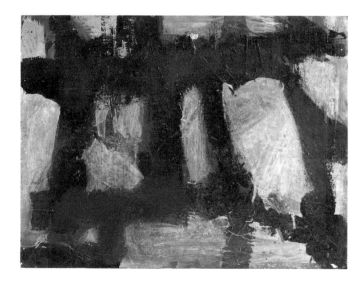

5. Cy Twombly. *Landscape*. 1951. House paint, oil, and paper collage on wood, 11 × 21" (27.9 × 53.3 cm). Collection PaineWebber Group Inc.

6. Cy Twombly. *Didim*. 1951. House paint on masonite, 18 × 24¼" (46 × 61.5 cm). Collection the artist

Some of the earlier works bear such titles as *The Slaughter* and *Attacking Image*, and as late as April 1951 the artist could write that the emphasis of his art was on "movement and power."[32] In contrast, the motifs of the late summer and beyond seem increasingly static in their monumentality, and more evidently marked by a form of primitivism that was becoming central to Twombly's art. Such interests may have had early roots—Cheney's book already invited an attention to archaic styles, and Daura's wife, Louise Blair, was known for her interest in prehistoric cave art[33]—but it was not until after he arrived in New York that he acknowledged the fascination. "I've been very interested in the primitive art of the American Indian—of Mexico and Africa," he wrote in late November 1950. "So much art looks affected and tired after seeing the expressive simple directness of their work."[34]

While that sentence could easily have been penned by hundreds of artists, the sentiment in fact informed a specific and personal, threefold attraction: to the fresh simplicity of "primitive" art's forms; to the evocative richness of its aged surfaces; and to the aura of animistic superstition or obsession that surrounded certain of its objects. In a statement on his work written in early 1952, Twombly affirmed: "For myself the past is the source (for all art is vitally contemporary). I'm drawn to the primitive, the ritual and fetish elements, to the symmetrical plastic order (peculiarly basic to both primitive and classic concepts, so relating the two)."[35] The affinity for symmetry is clear in works like *MIN-OE* (pl. 3), with its heraldic confrontation between near-identical "personages," and in the series of openwork web structures that were, despite their apparent monumentality (fig. 6), based on the small, ancient Iranian metalwork pieces (bits, bridle ornaments, and so on) generically known as Luristan bronzes.[36] These latter canvases also reflect Twombly's companion interest in the corroded surfaces of archeological artifacts: the rusted crusts of the excavated iron drew him to this ancient metal. Charles Olson saw that a feel for such aged and soiled textures underlay the particular poetics of Twombly's painting; after a visit to the studio at Black Mountain in January 1952, Olson wrote: "… the dug up stone figures, the thrown down glyphs, the old sorrels in sheep dirt in caves, the flaking iron: these are his paintings."[37] Four years later, after the experience of Europe and North Africa, Twombly would still write (now with broader experience and deeper self-understanding) that "Generally speaking my art has evolved out of the interest in symbols abstracted, but never the less humanistic; formal as most arts are in their archaic and classic stages, and a deeply aesthetic sense of eroded or ancient surfaces of time."[38]

The missing ingredient in this description, however, is the irrational, and

specifically sexual, aspect that Twombly sensed in the "ritual and fetish elements" of primitive art. The fence-like arrays of vertical forms that recur in canvases, drawings, and one sculpture (pls. 4–7) were apparently inspired by African fetish works—incorporating sticks tipped with charges of pitch—which Twombly knew from books on tribal art.[39] Their phallic implications hardly need empha- sizing, and in a more general sense, Twombly tends to class all the basic shapes in such works as either male or female.[40]

The art had, on the other hand, nothing of the superficially sensual or ingratiating; its erotic energies negated the suave in favor of a rough urgency. That toughness—especially with the inclusion of earth in the surfaces of some of the works—may owe to the influence of Jean Dubuffet, whose work had first attracted Twombly in the late 1940s.[41] Just as he used static symmetry to still the compositional dynamics of action painting, so he used Dubuffet's granular, coated surfaces in order, literally, to put "grit" into its liquid, gestural virtuosity. With help from such models, Twombly reversed the evolution of the New York School, using the painterly language of the early 1950s to invoke the romance of primitive, buried signs that had occupied painters such as Gottlieb, Rothko, and Pollock years earlier.[42]

Further in the spirit of rejecting familiar indices of sensual beauty, Twombly was also bent on eliminating the vibrant colors that remained from his earlier engagement with expressionism. The exclusively black-and-white look we now see in his art of the early fifties is a result of other paintings having been lost or destroyed,[43] but also of a willful choice, conditioned by his relationship with Rauschenberg (whose 1951 show was dominantly black and white), and his admiration for the power derived from monochrome work by de Kooning, Kline, and, perhaps most directly, Motherwell. In 1949, the dealer Sam Kootz had held a show called "Black or White: Paintings by European and American Artists," for which Motherwell wrote the catalogue preface, and Motherwell's own, dominantly black *Elegies for the Spanish Republic* might be counted among the closer ancestors of some of Twombly's early compositions.

Whatever Twombly's relationship to Motherwell's painting, Motherwell was impressed by his work. He introduced Twombly to Kootz, opening the way for a show at the end of 1951, and wrote a glowing endorsement of the paintings for another show earlier in the autumn in Chicago. In that text, while lauding Twombly as "the most accomplished young painter whose work I happen to have encountered," Motherwell knowingly analyzed the mix of influences— aspects of Picasso, the loaded surfaces of Dubuffet, and a strong admiration for primitive art—that he saw in his canvases. He assessed the twenty-three-year-old

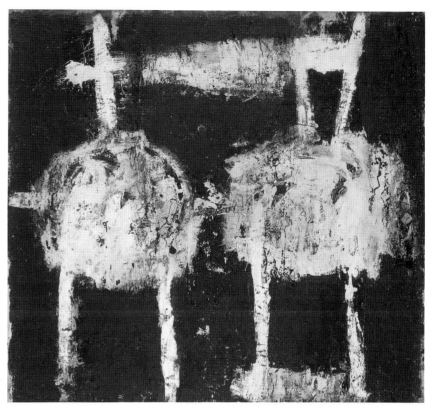

7. Cy Twombly. Untitled. 1951. Bitumen and house paint on canvas, 49½ × 54¼" (125.7 × 137.8 cm). Marx Collection, Berlin

as a "natural" in his instinctive feel for "the abandon, the brutality, the irrational in avant-garde painting of the moment," and remarked on "the sexual character of the fetishes half-buried in his violent surface."[44]

Kootz presented Twombly in December 1951, in a two-person show with Gandy Brodie. The display received only light attention from critics, who sought to identify the influences (Clyfford Still for one writer, Dubuffet for another) that formed the beginner. The responses split along lines that would become familiar: one found the work "dour," "grimy," and not sufficiently ingenious in conception, while another spotted an "insinuating elegance" in the patterns of the paintings.[45]

8. *Cy + Relics*, Rome, 1952. Photograph by
Robert Rauschenberg

EUROPE AND NORTH AFRICA, 1952–53

By the time the Kootz show closed, Twombly was looking toward Europe. In January 1952, when he and Rauschenberg were enrolled in the winter session at Black Mountain, he contacted the Virginia Museum of Fine Arts about a travel fellowship.[46] Rauschenberg, by then estranged from his wife and on the way to a divorce, joined the travel plans; with the idea that he and Twombly could eventually share the fellowship funds abroad, he prepared the photographic portfolio of paintings submitted with Twombly's application.[47] In the written part of the proposal, Twombly said he hoped to "experience European cultural climates both intellectual and aesthetic" and to "study the prehistoric cave drawings of Lascaux (the first great art of Western civilization). The French, Dutch and Italian Museums, the Gothic, Baroque architecture, and Roman ruins."[48] Another strong letter from Junkin (who explained that this young painter's

"ideas stem from a deep interest in primitive shapes") supplemented recommendations from Motherwell and Shahn—the former remarking on "the excellent reception among the painters of his recent exhibition in New York," and the latter calling him "unquestionably, the best of my students" at Black Mountain.[49]

The grant was awarded in late May, just at the close of the session at Black Mountain.[50] It seems likely that it was during a spring break, or in the latter part of June, that Twombly and Rauschenberg traveled together through the South, to Charleston, New Orleans, and Key West, and to Cuba.[51] Rauschenberg then worked at Black Mountain in July, when Kline was in residence as an instructor; Twombly, though primarily painting in Lexington and no longer registered as a student, also returned to visit.

In late August, Twombly sailed from New York, and after a brief stopover in Palermo, landed in Naples and went straight to Rome in the first days of September. He settled into a *pensione* on the piazza di Spagna, began an intensive reconnoitering of Roman sights (fig. 8), and in the latter part of the month traveled with Rauschenberg to Florence, Siena, Assisi, and Venice.[52] All of this was exciting, idyllic, and instructive, but before long Rauschenberg began to feel a sharp financial crunch (which he has blamed on Twombly's purchases of antiquities); and acting on a tip that there were jobs to be had in Casablanca, he left for North Africa.[53] At first Twombly stayed behind in Rome, where he already had plans for a January exhibition, but he followed Rauschenberg near the end of October, with the intention of touring North Africa and Egypt for two or three months.[54]

North Africa was then still divided into zones of foreign occupation. In Casablanca the ruling French were pressing local youths into conscription for military duty in Indochina, and the town was tense with hostility.[55] To make matters worse, both artists fell prey to intestinal illnesses, and as soon as Rauschenberg had earned enough money for his eventual return to the United States, they left in search of happier grounds, traveling through the Atlas Mountains to Marrakech. By mid-December they had established themselves in Tangier. Twombly pursued archeology at nearby Roman ruins, Rauschenberg photographed the symmetrical, weathered designs of local tombstones (fig. 9), and the two made contact with the expatriate writer Paul Bowles, who traveled with them, near the turn of the year, to Tetuán in Spanish Morocco. Eventually, they returned to Italy through Spain, arriving in Rome in February 1953.[56]

The gallery exhibition Twombly had been counting on having in Rome in January apparently never materialized.[57] It is unclear what he had been planning to show; he had not made any paintings during his travels.[58] The major fruit

of the trip was a group of six or eight wall hangings (which he called "tapestries"), made in Tangier from brightly colored fabrics used for local clothing. These surprising, dominantly geometric abstract designs were shown in mid-March in Florence, in a joint exhibition with Rauschenberg's tufted hanging pieces and tiny box assemblages—his *Scatole contemplative e fetici personali (Contemplative Boxes and Personal Fetishes)*—at the Galleria d'Arte Contemporanea (see figs. 48–50, in the notes). Rauschenberg disposed of most of his works from this show by dumping them into the Arno, and Twombly's fabric works have also been lost.[59]

By this point Rauschenberg was firmly fixed on returning to the States, and Twombly went back with him. The two artists were in New York in May, and Rauschenberg established a studio, which they often shared, on Fulton Street.[60] The time abroad had been a revelation for Twombly; he wrote that he had found Rome and Florence "inexhaustible," and had been strongly taken with Etruscan civilization on "many trips to the tombs of Tarquinia and Viev." "It is difficult," he said, "to begin to tell of the many, many things I saw and experienced—not only in art and history but of human poetry and dimensions in the fleeting moment and the flux. I will always be able to find energy and excitement to work with from these times. I see clearer and even more the things I left. It's been like one enormous awakening of finding many wonderful rooms in a house that you never knew existed."[61]

The same letter related that, while Twombly was eager to resume showing, Sam Kootz apparently had no immediate opening for an exhibition. Instead, Eleanor Ward issued an invitation that expanded into an offer for a joint exhibition with Rauschenberg, at her new Stable Gallery. To make possible a larger show, the two artists agreed to work during the summer to refurbish the gallery's basement space.[62] Then, for the September opening, they installed the ground floor and basement with a mix of Rauschenberg's Black paintings, White paintings, and his sculptures made from rock, wood, and string; and a group of Twombly's paintings, executed in New York since his return from Europe and titled with the names of North African villages—*Tiznit* (pls. 10, 11), *Volubilus* (pl. 14), *Quarzazat*, and others.[63]

The paintings were large (up to seven feet wide) and took a stride beyond anything the artist had done previously, but critics were in sharp disagreement as to whether or not they had anything in particular to do with North Africa.[64] The question is not a simple one to answer. Their origins lie in homemade "sketchbooks" of stapled-together conté crayon or pencil drawings (figs. 10–12; pl. 8) that were inspired principally by tribal items from Abyssinia and sub-Saharan Africa that Twombly found in the displays of the Pigorini ethnographic museum

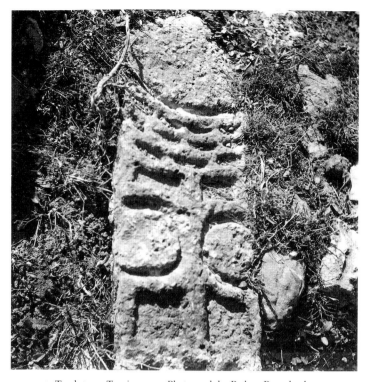

9. Tombstone, Tangier. 1952. Photograph by Robert Rauschenberg

in Rome.[65] Though the motifs do not lend themselves to precise identification, Twombly seems to have been especially fascinated not by figural works, but by costume, ornaments, sacks, and fetish pieces—and, while in North Africa, by forms of vernacular architecture, such as the beehive turrets of mud kilns.

The drawings appear to show tuberous bundles, twig fascias, and decorative accessories, made perhaps from perforated, partially depilated hides and ornamentally stitched fabric with coarsely nubbled textures. Elevated to the monumental scale of the paintings, these motifs become personages, with the kind of ponderous presence found later in the gravely comic work of Philip Guston. Building from the heraldic face-offs of works such as *MIN-OE* (pl. 3) or the fence-like array seen in *Solon I* (pl. 5), but now abandoning symmetry, they confront each other or assemble in implied narrative, animated by passages of compression and extrusion—wrapped bundles and bristling releases—that are anything but static. The drawings also suggest forms studded with nails or other embellish-

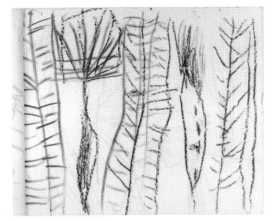

10.

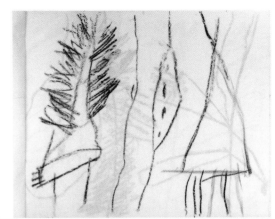

11.

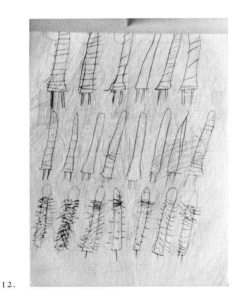

12.

THIS PAGE: 10–12. Cy Twombly. Pages from "North African" sketchbooks.
1953. Conté crayon on paper; each sheet, 8⅝ × 11" (22 × 28 cm).
Collection the artist

ments, or hung with tassels, fringes, thatches of raffia, and pendants of feathers and hair.[66] When translated onto the painted surface, the relatively casual and cursive strokes that conjure these excrescences (fig. 11; pl. 9) become the pretext for a pervasive linear scratching unattached to the description of form: overlays of repetitive markings that dig into and scarify the paint in a way that makes drawing, with crayon and pencil, a major part of the art's expressiveness (see the detail of *Tiznit*, pl. 10).

The technique of drawing into wet paint may have its roots in Twombly's earlier, student experiences of scraping into encaustic or melted crayon surfaces.[67] As used here, though, it introduces a distinct affective element: the boldness of expressionist brushwork is displaced by something dry and systematically scruffy, with overtones of slashing defacement. At a minimum, Twombly seems to have been intent on expunging any residue of virtuosity: his choice of technique for a contemporaneous printmaking experiment—scoring cardboard with a nail—bespeaks the same willfully coarse anti-aesthetic of "impoverishment" (fig. 13; pls. 12, 13).

Other painters, from Delacroix to Klee and Matisse, had drawn from their first experience of North Africa a heightened sense of vibrant color, and Twombly's brilliant wall hangings from Tangier show that he was not immune. The lasting impression evident in these 1953 paintings, however, was of white. Rauschenberg had painted all-white works two years before, but intended them to remain (by repainting when needed) forever fresh; he described them in terms of virginity and silence.[68] Twombly's white was a song less of innocence than of

experience, evoking the brightness of the Mediterranean sun through echoes of crumbling chalk, bleached bone, and eroded lime. From the white columns of Virginia and the crisp linen of torrid summers, this color had already been marked for Twombly, and other reinforcing experiences—Greek island villages, the furnishings in Egyptian tombs—were yet to come. These paintings marked the first occasion, though, on which his early, atavistic romance of dark pitch and flaking iron was transmuted into a new love of exposed rather than buried things, as the scraped tablets of time's inscription. This was certainly spurred by the North African passage: on a sketchbook page where he enumerated what he saw of materials ("rope, fur, sack, velvet, feathers, brass taks, nails, cut tin and copper") and of colors ("brown, blue, dust, black brown, orange, faded siena"), the largest, last notation, set off by a ruling line, is "CHALK WHITE" (pl. 8a).[69]

The Stable show was broadly, and unfavorably, noticed. For the first time, Twombly's art elicited the charge of infantilism and the comparison with vandals' markings that would later become, in praise and in dismissal, familiar tropes. "Large, streaked expanses of white with struggling black lines scrawled across them, they resemble graffiti, or the drawings of pre-kindergarten children," said a usually sympathetic critic who now feared, looking at Rauschenberg's and Twombly's works, that Abstract Expressionism had let too many liberties loose in the world. He used the two young artists as whipping boys for what he saw as the sins of a generation, and Twombly, later to be judged unworthy of comparison with his New York School elders, was here attacked as their all-too-legitimate heir.[70] It is impossible to gauge what proportion of such ill feelings was an effect of the dismay over Rauschenberg's all-white and all-black works; in June 1954, the critic of the *Herald Tribune* ranked this show as one of the two worst of the past season, largely because of those blank white works.[71] For both artists, it was an unhappy moment in their relationship with the New York art world. "I lost friends over that show," Eleanor Ward later recalled. "A great many people thought it was immoral. I had to remove the guest book from the gallery, because so many awful things were being written in it."[72]

ARMY SERVICE AND TEACHING IN VIRGINIA, 1953–56

After the joint exhibition with Rauschenberg, in the late autumn of 1953, Twombly (who had been avoiding military service through years of student deferments) was drafted into the U.S. Army and sent to Camp Gordon, near Augusta, Georgia, for basic training and courses in cryptography.[73] He has since affirmed that the drawings he did in Augusta, in a hotel room rented on week-

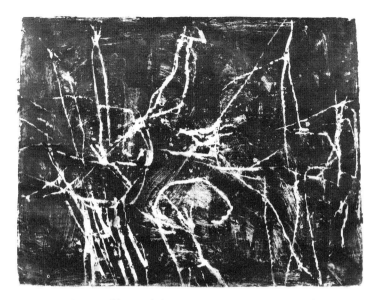

13. Cy Twombly. Untitled. 1953. Monotype in paint, 20 × 26¼" (50.8 × 66.9 cm). Collection the artist

end leaves, established "the direction everything would take from then on."[74] In soft graphite on distinctive large sheets of beige paper, these drawings are little known and only occasionally reproduced, even though they are clearly crucial for the formation of Twombly's later symbolic language (see fig. 14; pls. 15, 16). The basic motifs often recall the bundles, turrets, and strings of the so-called North African drawings, but with a greater emphasis on fluidity, they are now transposed into more insistently biomorphic entities, and the former knots, fringes, and pendants here evoke orifices, hirsute tufts, and horsetail plumes of erupting effluvia. One of the recurrent forms, for example, is a polyp with a tubular appendage that slinks and curls like an anteater's tongue, gustily spurting from both its rear sac and extended snout (fig. 14; pl. 16). This fantasy of polymorphous physical expression, coming and going at the same time, directly anticipates the metamorphic signs and libidinal exuberance of Twombly's later work.

Following on the experience of the 1953 paintings, Twombly had evidently become more concerned with the character of his draftsmanship, and with the development of a more personal linear manner. To achieve that inflection, he tried to defeat the trained habits of his hand by drawing at night with the

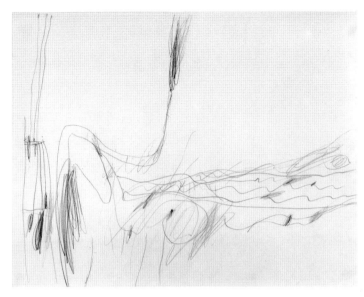

14. Cy Twombly. Untitled. 1954. Pencil on paper, 19 × 25" (48.2 × 63.5 cm).
Collection the artist

the blacks of the crayon and pencil rub that surface or lie under it, without the scarring incisions that marked the penciled passages in the 1953 canvases: those former repetitive scratchings are translated here into grassy, continuous strokes, furthering the overall effect of upheaval, turbulence, and urgency that makes the 1953 paintings look by comparison heavier and more stiffly constricted.

An equally telling change in color and surface accompanies the new forms and psychic charge. The thick white lead and ocher of the 1953 works give way to mottled alternations of matte and glossy patches, cream whites, and liquified, pink-tinged passages. In dialogue with the imagery of release and flow, the ruddy, recurrently overpainted surface speaks of staining and smeared effacement. The bleached and aged surfaces evoked by the previous year's work are now supplanted by connotations of flesh, skin, and fluids—of spillage, excess, and overflow, rather than erosion.

When these paintings were shown at the Stable Gallery in January 1955—Twombly's first show after his release from the Army the previous August, and his first one-person show in New York[78]—the critic Frank O'Hara thought the artist profited from being seen alone and on his own terms. Taken as such, he said, the work seemed less abrasively experimental than it had before:

… the quality is clear and strong. His new paintings are drawn, scratched and crayoned over and under the surface with as much attention to esthetic tremors as to artistic excitement. Though they are all white with black and grey scoring, the range is far from a whisper, and this new development makes the painting itself the form. A bird seems to have passed through the impasto with cream-colored screams and bitter claw-marks. His admirably esoteric information, every wash or line struggling for survival, particularizes the sentiment. If drawing is as vital to painting as color, Twombly has an ever ready resource for his remarkable feelings.[79]

lights out. Unlike the "automatic writing" of the Surrealists, which aimed to elicit a smooth, uninterrupted flow of unconsciously motivated line, this exercise in reduced control seems to have been intended to impede and slow down the artist's graphic skill, and force into it some of the distortions of children's drawings. The "blind" practice contributed to the scrawling cursiveness and the looping, elongated proportions that are the hallmark of the Augusta drawings, and the nocturnal, uncensored manner of rendering may also account for the more candid opening of the imagery onto a psychosexual subconscious.[75]

Both qualities feed directly into the paintings of 1954 (see pls. 17–19), which were done largely during the spring and early summer, when Twombly was posted by the Army to Washington, D.C., and frequently traveled to New York during periods of leave.[76] With their imagery of snaking tubes, meandering bladder-like biomorphs, and streaming clouds of scumble, these works are far more actively "narrative" than the arrays and face-offs of the year before. In them Twombly all but abandoned the paintbrush in order to elide—with the pencil point, a broader graphite-rubbing stroke, and wax crayon—any remaining distinction between painting and drawing.[77] Though the painted surface is still heavily striated by the marks of fingers or a blunt stylus (see detail, pl. 18),

O'Hara concluded by mentioning the sculpture in the show: "… witty and funereal, big white boxes with swinging cloth-covered pendulums and sticks and mirrors." These works are now all but unknown. The Menil Collection's example (fig. 18), with its hanging fetish-bundle, fits the description, and photographs taken by Rauschenberg in his Fulton Street studio (figs. 15, 16) confirm that others were similarly connected—by their whiteness, by their use of bundled and wrapped fabric, and by the mirrors—to the North African experience.[80] They had as well elements of deeper retrospect. The twin palm-leaf fans on block pedestals in two of the photographed works, and in one surviving from the same period (pl. 25), recall the archaic formality and symmetry in some of

20

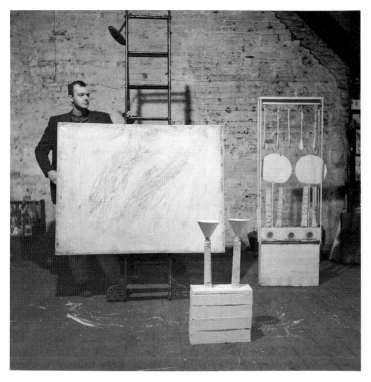

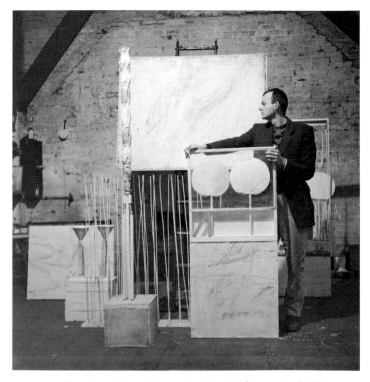

15. Twombly with sculptures and paintings (no longer extant). 1954.
Photograph by Robert Rauschenberg

16. Twombly with sculptures and paintings (no longer extant). 1954.
Photograph by Robert Rauschenberg

the artist's earliest paintings, drawings (see fig. 17), and assemblages,[81] just as the panpipe group of wrapped sticks in another 1953 sculpture (pl. 7) returns to the "fence" array of fetish-sticks in other early works (pls. 4, 5). Still, it seems clear that the works in Rauschenberg's photographs were done in 1954: two of the assemblages are experimental "combines" which include paintings or drawn elements related to the work of that year.[82]

The other important but no longer extant body of work from this period was a series of six or eight dark-ground paintings, on cheap cloth with drawing in friable white chalk. These grey-ground works are known principally from photographs (see fig. 19). The largest, *Panorama* (pl. 23), was shown in January 1957 and still exists;[83] the rest were apparently destroyed soon after they were made. They were, however, doubtless seen by Twombly's artist friends and made an impression on others as well.[84] The striking aspect of these works is not only

the reversal of light/dark relations (something Twombly had evidently tried before, and would again in the 1960s),[85] but also the radical shift in the composition, space, and emotional tenor of his art, between the residually Surrealist figuration of the 1954 paintings and the abstract quality of run-on "handwriting" in these coolly grey canvases. Some of the passages are recognizable as loopily caricatured reminiscences of forms in the paintings or sculptures of 1954,[86] but the loose mesh of overlaid lines confuses the distinction of figure from ground, making the separateness of individual forms far less important than the overall field of linear marking. The thinly painted ground also has diminished physical presence, and the black thus suggests a space of uncertain depth, behind the tangle of line.

No painter could have made pictures of this kind in New York in the mid-1950s—particularly a picture of the scale of *Panorama*—without thinking of their relation to the poured paintings of Pollock, and certainly not Twombly,

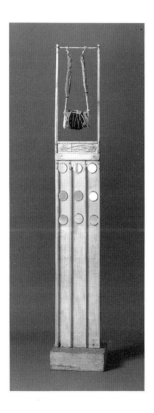

17. Cy Twombly. Untitled. c. 1951. Pencil on paper,
3 × 2⅞" (7.6 × 7.3 cm). Collection the artist

18. Cy Twombly. Untitled. c. 1954. Paint and crayon on wood, with glass,
mirrors, two wooden spools, fabric, twine, and wire, 6' 8" × 13⅞" × 11"
(203.2 × 35.2 × 28 cm). The Menil Collection, Houston

who was and is a deep admirer of Pollock's genius. The parallel elements, however, only throw the differences into sharper relief. The evidence of process here tells of insistently discontinuous, programmatically repeated passages with the chalk stick, yielding none of the liquid, variegated, organic webbing of the poured paintings. There is also, more than in Pollock, a sense of overrunning extension out of every side of the canvas.[87] The wholeness of Pollock's dense, explosive clouds of energy is replaced by a dispersed, jumpily nervous electricity, as the local structures of both drawing and writing seem continually to pull and tug at the cumulative abstract palimpsest. The character of the drawing, especially in the cartoonish feel of the residual closed shapes that appear here and there, suggests something of Dubuffet—which would make these pictures among the most evident, if neither the first nor last, of Twombly's efforts to fuse the scale, energy, and abstract freedoms of American painting with elements of expressive language learned from Europe.

It is difficult to say whether it was the irrational or the rational aspects of these works that were the more disconcerting for eyes adjusted to Pollock and de Kooning: the apparent mindlessness of a linear activity pursued, both obsessively and indulgently, without concern for the compositional drama of the whole; or the untoward interjection of mind—of something self-consciously, cumulatively cerebral—into what in New York School painting had been a concept of self-expression by the energetic physical release of gestures pressured by unconscious impulse.

•

Though Twombly remembers the early grey-ground paintings as having been done in 1955, some doubt surrounds their date. They were photographed in Rauschenberg's Fulton Street studio (fig. 19), and almost certainly painted there as well.[88] By January 1955, though, Rauschenberg had left this studio to move into a loft on Pearl Street adjacent to Jasper Johns's,[89] and by February, Twombly himself had moved back to Virginia to take a teaching job at a preparatory school for women, Southern Seminary and Junior College, in Buena Vista. He left his small apartment on William Street in Lower Manhattan (where he had been living since leaving the Army) in the care of Ward and her gallery and, aside from a brief return in late March, stayed in Virginia through mid-May.[90]

Given this history, it seems likely that the grey paintings were made in late 1954. There are related drawings from that year (pls. 20–22);[91] and there is also a probable connection between *Panorama* and a critic's reference to drawings presented as a "Panorama" group, in a show at the Stable, in September 1955.[92]

22

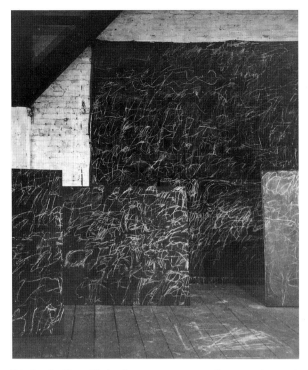

19. Paintings by Twombly (no longer extant, except *Panorama*, pl. 23, at back)
in Robert Rauschenberg's Fulton Street studio, New York. 1955.
Photograph by Cy Twombly

20. Cy Twombly. Untitled. 1955. House paint and pencil on canvas, 28 × 48¼"
(71 × 122.5 cm). Courtesy Galerie Karsten Greve, Cologne and Paris

Whatever the month of their execution, these dark paintings veer away from the figuration that originated in the Augusta drawings, and toward the abstract linearity Twombly would pursue in 1955. A smaller, pencil-on-oil work done in Lexington early that year (fig. 20) still retains some of the Dubuffet-like character seen in the grey pictures, but the canvases in the next one-person show, of January 1956, had expunged it completely.[93]

Those paintings, including *The Geeks*, *Criticism*, *Free Wheeler*, and *Academy* (pls. 26-30), were done in the William Street apartment in New York, most likely during the summer of 1955, when Twombly returned to the city during Southern Seminary's vacation months. (Their unusual titles were derived from a list compiled in collaboration with Rauschenberg and Johns, and were assigned to the pictures more or less arbitrarily.)[94] At first glance, they might appear simply to maintain the vocabulary of all-over linear marking found in the grey paintings, with a reverse to dark lines on a light field, but the changes are in fact more drastic. In place of the thinly coated and relatively clean dark ground, these pictures have dense and variegated surfaces with multiple layers of paint: pencil and crayon lines and colorless scumbling with a blunt stylus are worked into and against the viscosity of the cream field. These thickets of marks (with flecks of terra-cotta color from colored pencils and crayon) have a congested, "hot" frenzy in comparison to the relatively airy work on the grey canvases—even though the stroking itself has changed from the loose and fluid lines of 1954 to more brittle striations. Closed biomorphic forms are all but forgotten, and the residual figuration now comes in the form of elemental signs, such as crosses, X marks, rectangles, grids, triangles, and circles, and especially in the emergent elements of written language. Letters, notably A, E, K, N, V, U, H, and I, alone or in fragments of words, appear on the teasing edge of legibility.[95] The dialogue of inscription and erasure is essential not only to this level of "reading" the works, but to their overall energy. They are intermittently casual, furious, self-

doubling, and self-annulling—attacks against the aesthetic of painterly abstraction, from which Twombly's mature personal style was emerging.

"Personal" is, however, too loaded a term to use without qualification in this case. The idea of a unique individual manner had been a shibboleth of Abstract Expressionism, but similarities among the styles of New York School artists suggest they did share certain ideas, often garnered from European Surrealism, of what inner truth should look like. Their gestural abstraction expressed the notion that the most acute moments of self-realization were epiphanic and to be externalized only by heroic acts of Zen spontaneity, disengaged from control and committed instead to dynamism, risk, and chance. Yet in the same fashion that the deliberately slow, methodical pace of Johns's encaustic strokes belied the idea of such fervor, Twombly's switch from the brush to the pencil eliminated all the signs of splatter, streak, and drip that had become the familiar indices of committed engagement. His process of marking the canvas spoke of more dogged labor, and also (unlike Johns, whose images had a pre-formed wholeness) of discontinuity. Both artists defined their artistic sensibilities with elements of what was, in terms of the conventions they inherited, a determined *impersonality*. Yet while Johns's departures into deadpan, iconic imagery were more obviously drastic, Twombly's apostasy may have seemed the less acceptable, because it stayed closer to the very models of abstraction, and the modern traditions, that it undermined—accepting their freedoms while disrespecting what had appeared to be the attendant responsibilities. A crucial ingredient in the Abstract Expressionist ideal of self-realization on canvas had been some form of resolution, transforming inner chaos and conflict into a highly charged but ultimately balanced wholeness that invited neither subtraction nor addition. Twombly's accumulated scrawlings implied no such drama, and instead adulterated the grand angst of the previous generation with a different kind of anxiety, compounded of impetuosity and frustration, obsessiveness and idle disregard, transgression and self-doubt. The toughness of the pictures thus came not from muscular architecture or bold lyric flow, but from a bristling refusal of those standard graces. Some form of irregular organicism had long seemed the natural language of psychic profundity, and because the inner self was understood to be darkly conflicted, a certain density and gravity were expected in serious painting. The spindly lightness that Twombly's works maintained, despite the thickness of their hatchings, again belied this depth, and insisted on the complexities of overlay on the surface. Johns has said that he did not want his emotions or inner life to show in his work, but Twombly's different kind of "impersonality" was apparently in the service of an opposite task—subverting Abstract Expressionism's generic conventions of individuality until they could fit his particular sensibility.

There were of course precedents for the style Twombly was forging, in the long-standing modern fascination with children's art and the more recent attention to graffiti. In earlier modernity, though, when artists such as Matisse or Kandinsky or Klee turned to the art of children for inspiration, it was typically with admiration for the compressed, schematic economy of the "conceptual" or inherently "logical" renderings, and the supposed consonance of such drawings with prehistoric and tribal art. Twombly, working through and beyond the figurations of Dubuffet into the area of abstract scribblings and doodles, wanted a quality that was not so much about economy as about squandering, recalling childish disorderliness and impatience with boundaries or niceties of logic. Not coincidentally, this concept of early creativity has less to do with mental operations than with instinctual life, and it connects in Twombly's art to the fuller expression of a protean sexuality. In the area of graffiti, he was less drawn to particular pictograms, as evidence of universal elements of mental life, than to the look of accretively scarred walls, with their layers of overlapping marks that subsume individual moments of expression into dense accumulations. Such models allow for a style based not on the ideal of the wholeness of a unique individual temperament, but on the intuition of the self as a society of feelings and impulses that can disgorge themselves, independently and interdependently, into the act of creation; they speak not in the buried code of a dark, primitive consciousness, but in the common inflections that have marked pictorial street slang at least since the walls of Pompeii.[96]

Appropriately, that maturing style emerged not out of some linear, progressive development in Twombly's work, but from a back-and-forth interweaving of contradictory impulses, between the return from Europe and the 1956 exhibition. The 1954 paintings, stemming from the personal approach to Surrealist biomorphism in the Augusta drawings, and arising immediately from the pressures of his Army experience in the deep South, were pulpier and more organic than anything he had done before. Then, in a rhythm that would recur on a grander scale a decade later, the next move was to the cooler grey-ground canvases, conceived and executed in New York, less figural, more calligraphic in their abstraction, and without either sensuous creaminess or surface distress. After that, in the paintings of the next year—connected in some tangential way to both the lushness of the landscape and the loneliness of the life in Buena Vista, though painted in New York—a new style began to assert itself in the deliberate, repetitive, but unplanned piling up of layer over layer of abstract scorings, and in the simultaneous declaration and suffocation of legible signs and words. Along

the way, Twombly had abandoned the romance of darkness and deeply buried things. Working through a fusion of Dubuffet and Pollock, he transformed his early love for naturally eroded and aged surfaces into the embrace of an explicitly human, cultural "patination." He chose graffiti-scarred walls as model sites of intersection between the urgency of graphic impulse and the authority of accreted age, the infantile and the immemorial. There the "automatic writing" beloved by Surrealism relinquished its claims to private privilege and instead spoke of the more complex self shaped through social existence. This aesthetic, tentatively refined into greater spareness and abstract severity during the relatively fallow year of 1956,[97] was the one Twombly took with him when—just turning twenty-nine, after four eventful years in America—he returned to Rome.

ITALY, 1957–58

Accounts of Twombly's career have tended to treat his expatriation to Italy in 1957 as a decisive abandonment of New York in favor of Mediterranean culture. In distant retrospect there may be some truth in this, but human histories as actually lived have a way of being messier and less pointedly strategic. That holds particularly true for this departure, which was longer and more complex in its preparation, yet also more unexpected in its results, than any account has allowed.

Almost as soon as he had started teaching, Twombly had tried to obtain a grant from the Virginia Museum of Fine Arts, which would free his time for painting. When that effort failed, he had accepted a second year at the Southern Seminary post, through the autumn and spring semesters of 1955–56.[98] In that second spring, he began his effort to return to Europe by again applying to the Virginia Museum, specifically for a fellowship to travel abroad. He wrote that he wished to spend time in Paris (especially to see the Egyptian material and the seventeenth-century French paintings in the Louvre) and travel to Egypt, Athens, Crete, and Mykonos.[99] This application was also unsuccessful, and having had enough of teaching, he reluctantly made plans to move back to the William Street apartment in New York for the summer of 1956 and the ensuing winter.[100]

His reasons for wanting to return to Europe clearly involved, beyond his interest in older art, a keen sense of the possibilities of the present. The application made this explicit: "Since having been to parts of Europe," Twombly wrote, "I can renew friendships among the painters, writers and international set that afford invaluable exchange of ideas in creative research and new directions

for both sides. I have also been offered shows in galleries in both Paris and Rome, which show only the more important French and Italian contemporary art. Due to the expense of shipping, I could only do this if I were there."[101] We forget how involved this young artist was, long before his supposed "self-exile," in European art. His training in Boston had pointed him toward Europe, and there was ample opportunity in New York to expand that awareness in the contemporary arena. During his visit to Rome in 1952 he specified that he had chosen a *pensione* "a block from via Margutta where most of the important contemporary Italian painters and sculptors have studios";[102] and during that same trip—when both young artists made contacts with local galleries—Rauschenberg paid a visit to one of the avant-garde leaders, Alberto Burri.[103] Before and after the trip, Italian art had a lively presence in New York, especially at the Catherine Viviano Gallery, but also regularly at the Stable—where, Rauschenberg has complained (with some exaggeration), he was "the only non-Italian artist (except for Cy Twombly) that was showing."[104] Conrad Marca-Relli, who was a bridge between the Italian and American art worlds, showed with Ward, and became Twombly's friend around 1953.[105] Through such contacts, Twombly would have had occasion to meet visiting figures from the Roman milieu, including the painters Afro, Piero Dorazio, and Toti Scialoja, during the early 1950s.[106]

The precise occasion for his return to Rome came, however, from a different area of personal contact. A longtime friend from Lexington, Betty Stokes, had married a Venetian count, Alvise di Robilant, in 1956, and their first child was born in February 1957. Shortly after the birth, and with support from Ward, Twombly went to Italy to be with Betty, and stayed with the di Robilants at their home in Grottaferrata on the outskirts of Rome, near Frascati. He had not planned a lengthy stay, but found Italian life seductive, especially after he was persuaded to spend the summer by the sea, on the island of Procida. More tellingly, he found himself caught up in an unexpected and powerful tide of personal and art-world circumstance, centering on a new nexus of friendships.[107]

Shortly after his arrival, a luncheon was arranged to introduce the artist to Giorgio Franchetti and his sister Tatiana, the young offspring of a prominent Italian family with an illustrious history of patronage in art.[108] Giorgio was taken with Twombly personally as a "natural aristocrat" ("very elegant, very handsome, very aloof, but actually highly emotional"); and the drawings he saw that afternoon struck him instantly and profoundly, "like an electric current."[109] In retrospect the encounter has an air of fatefulness, if not fatedness, about it. Tatiana, who had at the time already established a following as a portrait painter,

would become the artist's wife two years later. In the intervening period, Twombly would sharply change the course of Giorgio's involvement with art, while Giorgio would in turn provide a special entrée into the Roman art scene at a uniquely auspicious moment.

The life of Italian art in the early fifties had been fragmented by politicized debates about issues of nationalism and internationalism, and realism and abstraction, with the communist party consistently hostile to non-objective art as well as toward all things American.[110] In 1956 (the year of the Soviet invasion of Hungary) the hold of the party's strictures began to weaken; younger artists were starting to reassess both the earlier traditions of European abstraction and the contemporary American avant-garde, in their effort to find a progressive form of engagement with their era. A turning point came at the Venice Biennale of that year, when a survey of modern American art was presented at the United States pavilion, and when the painter Afro—who had shed his earlier Picassoesque figuration for a style of lyrical abstraction tied to *art informel* and to New York School painting—was awarded the Prize of the City of Venice as the best Italian painter. In the aftermath of that event, he and others enlisted Plinio de Martiis, whose Galleria La Tartaruga in Rome had been associated with more conservative (and acceptably communist) art, to bring in fresh talent and new ideas. A major protagonist in this shift, and an advocate of the new generation, was the man who would be the gallery's financial backer, Giorgio Franchetti.[111]

In 1957, just at the time Twombly arrived, Tartaruga was initiating an entirely restructured program that especially featured artists with a direct connection to postwar America.[112] At exactly the same time, postwar American painting, which had been making inroads into Italy since the late 1940s, was beginning truly to assert its presence elsewhere in Rome. In February the Galleria dell'Obelisco opened the first one-person show of Arshile Gorky in Italy, and the journal *Arti visive* devoted its entire summer issue to Gorky, with articles by (among others) de Kooning, Scialoja, Afro, and Burri. That same July, the Rome–New York Art Foundation launched its program of showing Italian art side by side with recent American painting, especially by New York School artists. Franchetti's meeting with Twombly, in the late spring of 1957, accelerated the pace of these changes. Prompted in large part by what he heard of the Manhattan art scene from Twombly and Betty di Robilant, Franchetti went to New York at the end of the year and (through the social connections of his in-laws and the introductions of Leo Castelli) made a rapid but productive reconnaissance, purchasing works by Kline (which comprised an important show at Tartaruga just after his return) and by Rothko.[113]

Over the next few years, into the early 1960s, increased collaboration between local and American dealers meant that Rome received the American art of the 1950s in a telescoped rush—so that Pollock, de Kooning, and Kline on the one hand and Rauschenberg and Twombly on the other were all shown in fast, overlapping succession. Between these generations of artists, historians have since tended to draw very sharp lines, but in the late 1950s the borders were less well patrolled, and crossovers seemed not simply possible but desirable. Younger Italian painters were drawn to the previously forbidden freedoms embodied in Abstract Expressionism, but also concerned—in part because their politics were still strongly to the left—to avoid accusations of mere bourgeois subjectivism; they were leery of both the romantic, rhetorical indulgences and the descent into aestheticism that had become the plagues of an aging *informel* aesthetic of gestural abstraction. The desideratum was an abstraction that blended more objectivity and distance into its spontaneity, and stiffened its personal liberties with more attention to the outside, material world. In this regard Twombly seemed a godsend. Cesare Vivaldi's reminiscence, published in a sometimes awkward English translation in 1961, is worth citing at length, for the full sense it gives of that special reception:

Among all the American painters of the latest generation, Cy Twombly holds a particular position of his own, and one of the most recognizable and interesting. Viewing the latest expressionists on the one hand, the new-dadaists on the other, Twombly was able to find a position where the basic motives of these two currents of the American young art are interfused, and furthermore goes beyond them with such a success and seeming easiness as only a pure, exquisite, "naive" poet as he is, could have found.

… [he found] a position which sets him apart from the other American and European artists—of his generation or not—[and] even from the Roman milieu he had at first so much affected, exerting on the elite of young artists a stimulating function full of implications.

The first paintings and drawings Cy brought from New-York startled and impressed all those who had the chance of seeing them, mainly because of that poetic, but almost merciless way in which the extreme conclusions of both action painting and neo-dadaism were drawn. Thin and nervous signs, nearly hysterical, black in general with some yellow and some red-pink, atched [sic] the white canvas with a sort of lucid but bewildered fury. Something was known about Twombly's participation (if we can speak so approximately) in the neo-dadaist group, yet these paintings had none of the literary suggestions so evident by that time, for instance, in Rauschenberg; if a connection could have been found, it was perhaps with the first, the most poetic and bewildered of the great Americans, Gorky.

Above all Cy's canvas reminded us in some way of Gorky's latest drawings (predominance on the pure white paper, of black signs, with some yellow and some red-pink), but as if [dis]solved by a reagent, cut down to his purest and most incorporeal essence. If there was something neodadaist in these paintings of Twombly, it is this sense of absolute, almost devil-may-care freedom, which made the painter able to be delicate, hallucinated but ironic too. A way of approaching the canvas with the attitudes of an action painter, but at the same time with such a shrewd charge of irony as to offset any melodrama possibility, any danger of egotism and unbridled self-exaltation (dangers that are inherent in those attitudes) yet making those values of lyric—the action painting has conquered once and for all—survive.[114]

Twombly's art seemed directly in line with younger European artists' growing predilection for a drier abstraction containing some sense of universal or cultural determinants outside the self—a direction perhaps most clearly indicated by the plaster-white *Achrome* works that Piero Manzoni began around 1958, and reinforced by the exhibition "Monochrome Malerei" ("Monochrome Painting") in Germany in 1960.[115] Twombly had begun reading Stéphane Mallarmé, the prime poet of empty whiteness, shortly after his arrival in 1957,[116] and the increasing self-consciousness of his commitment to white monochrome painting was made explicit in a statement he published a few months later. The Roman artists Gastone Novelli and Achille Perilli had just launched a journal, *L'Esperienza moderna*, to champion the new push to abstract art, and for its second issue, August–September 1957, they solicited one of Twombly's rare texts about his work. It concluded by defending expressive abstract art in general, but began with a reflection on the monochrome quality of Twombly's own work:

The reality of whiteness may exist in the duality of sensation (as the multiple anxiety of desire and fear).

Whiteness can be the classic state of the intellect, or a neo-romantic area of remembrance—or as the symbolic whiteness of Mallarmé.

The exact implication may never be analyzed, but in that it persists as the landscape of my actions, it must imply more than selection.

One is a reflection of meaning. So that the action must continually bear out the realization of existence. Therefore the act is the primary sensation.

In painting it is the forming of the image; the compulsive action of becoming; the direct and indirect pressures brought to a climax in the acute act of forming. (By forming I don't mean formalizing—or in the general sense the organizing of a "good painting." These problems are easily reached and solved and in many cases have produced beautiful

and even important works of art.)

Since most painting then defines the image, it is therefore to a great extent illustrating the idea or feeling content.

It is in this area that I break with the more general processes of painting.

To paint involves a certain crisis, or at least a crucial moment of sensation or release; and by crisis it should by no means be limited to a morbid state, but could just as well be one ecstatic impulse, or in the process of a painting, run a gamut of states. One must desire the ultimate essence even if it is "contaminated."

Each line now is the actual experience with its own innate history. It does not illustrate—it is the sensation of its own realization. The imagery is one of the private or separate indulgences rather than an abstract totality of visual perception.

This is very difficult to describe, but it is an involvement in essence (no matter how private) into a synthesis of feeling, intellect etc. occurring without separation in the impulse of action.

The idea of falling into obscurities or subjective nihilism is absurd—such ideas can only be held by a lack of reference or experience.[117]

The key revelation Twombly had to offer Novelli, Perilli, and other young Roman artists, though, was not in his ideas but in his painting. He began working almost as soon as he arrived, first at Grottaferrata and then on Procida over the summer, producing smaller works on paper that were thickly coated with oil-based house paint, or occasionally white lead, which frequently served to cover all but a few isolated pencil motifs. It was not until the autumn, when he established a studio in Rome overlooking the Colosseum, that he was able to complete larger works on canvas and resume the direction he had set in the paintings of 1956.[118]

These new Roman paintings (fig. 21; pls. 31–33), in contrast to works from Lexington and New York of 1955–56, had less crusty and less harshly striated surfaces, even if the house paint, sometimes worked in with the artist's fingers, was still used to veil or efface earlier layers of pencilwork. The paint itself was now an Italian product known as *cementito*, and Twombly was taken with its specific character, which yielded a more creamily smooth surface. The fields of the canvases seem newly aerated, with a sense of space and light—and color, in crayon passages of yellow, orange, red, and ocher—that contrasts with the more crowded pictures from 1955–56. With less thicketed markings that tend instead to coalesce in separate clusters, the 1957–58 pictures begin, as well, to show a noticeable diagonal "lean," or lower-left-to-upper-right "drift," that would become an enduring characteristic of Twombly's mature work.[119] More impor-

21. Cy Twombly. Untitled. 1958. House paint, crayon, and pencil on canvas, 52⅜ × 62⅝" (133 × 159 cm). Collection Jung, Aachen

sign, or uneven, horizontal figure 8, that appears large at the upper left in pencil and small at the lower left in crayon. At the bottom it acquires a darkened crotch at its juncture, with a scumbled cloud above, while at the top its larger sac is hung with a cursive, looping fringe. Across the canvas, this same basic configuration mutates into double-looped variants which seem to spawn nascent Ms or reclining Bs, bat wings or bow ties, and fluttering hearts. In other works rectilinear and curved passages crisscross in the thickets of strokes teasingly to suggest numbers (2, 101, 0, 8), fragments of letters (A, E), and boxes or framed windows (fig. 21),[120] while cursive strokes flirt with the threshold of legible writing. From the episodic quality of these scattered events arises the works' authenticity, as a model of experience in process: "The imagery," as Twombly had said, "is one of the private or separate indulgencies rather than an abstract totality of visual perception."

In this interplay of private and public signs and levels of meaning, the evident and striking novelty was the unequivocal assertion of words—"OLYMPIA" being only one of the most evident—in fractured or loosely running letters. Uncertainty and partial concealment still characterize some of the word content;[121] we can see, though, that the normally formulaic and marginal elements of a painting's inscription—the signature, place, and date—are often enlarged, becoming inescapable graphic elements. Previously, Twombly had signed and dated his works on the back, if at all; now a new sense of public self-assertion is literally out front, inscribed within the art. In one untitled work, for example (pl. 35), a large scrawling "Cy Tw…" begins from the left, only to be interrupted by a downward S stroke that forms the numeral 5 in a large "58" at bottom center, prior to "ROM" in the lower right corner. Varying configurations of "ROMA" recur frequently, large and small (as at the bottom center of *Olympia*), and once apparently with its palindrome, "AMOR" (fig. 21).[122]

Since Joan Miró's poem-paintings of the twenties and thirties, and Paul Klee's imagery of imaginary scripts and hieroglyphs, the idea of writing as an element of abstract painting had been widely available to painters. Among Twombly's immediate predecessors, the interests of artists such as Kline, Tobey, and Motherwell in Eastern calligraphy, or of Adolph Gottlieb and others in ancient symbolic language, would have been familiar to him. Yet only an occasional and exceptional image, such as Pollock's *Stenographic Figure* (fig. 22), appears to offer any direct anticipation of Twombly's way with disjointed stick letters and scattered letter fragments.[123] Twombly's use of detached words, like his general approach to the heterodox discontinuities in many of his works, may owe at least as much to the tradition of collage he knew through Schwitters. It is

tant than previously, the edges of the works, especially at the top and bottom, become significant zones of activity, and this, along with the drift, evokes the sensation that a gentle wind lifts and deflects the long, grass-like strokes as they rise across these surfaces. Gravity and its absence become, more than ever before, an issue in play.

The discontinuous strokes of these works include a mix of casual meander and insistent repetition, as well as recurrent evidence that the artist has returned to obliterate or embellish—or to encircle, isolate, and "frame"—earlier moments of drawing or casual incidents in paint. The effect is one of unconscious expressive release and reflexive, analytic self-awareness unfolding in unstable concert; aimless insouciance and worried rumination live out a nervous, permanently provisional accord. Within that tangle, an array of recurrent separate signs multiplies, mutates, and metamorphoses, sometimes in echo of the biomorphic figurations of 1954. In *Olympia* (pl. 31), for example, there is a double-looped infinity

the cognitive act of naming, though—the direct citation of the concept in the picture—that is as important as the formal nature of words or writing in general. Twombly's addition of "ROMA" or "OLYMPIA" in stiff script sets up a dialogue between the given associations of the idea and the character of its inscription, in scale, in speed, and in emphasis—an interweaving of complex mental resonance and immediate physical presence that changes both the idea and the picture, as a familiar tune is altered by its rendering in an altered rhythm on a new instrument. Repeatedly in later years, and most notably in his monumental treatment of the *Iliad* (see figs. 38–40), he would take the leap of faith that such acts of inscription alone could hold together his work and the admired ideal in mutual invigoration.

These inscriptions on the paintings of 1957–58 were among the principal cues that convinced viewers and commentators (beginning with Palma Bucarelli in the brochure of Twombly's first show at Tartaruga, in the spring of 1958) that Twombly had opened his art to the abundant graffiti on Roman walls and monuments.[124] That renewed association of the work with graffiti had, however, a very different valence from the criticism of 1953. In the context of European art around 1960, the implications of an anti-aesthetic gesture that connected with the common language of society were entirely positive. In the same reasoning by which Twombly's work was seen as both continuing and subverting Abstract Expressionism, the evocation of graffiti seemed to speak at once of uncensored, expressive personal urgency and of objective engagement with a common, social language; to be of today and yet agelessly ancient.

Specifically in the Roman milieu, works such as *Olympia* and *Arcadia* must have had a special, revelatory shock. For modern Italian artists, Medardo Rosso and the Futurists being the prime examples, the sheer age of Italy and the weight of its classical past had often been deemed a suffocating burden, from which an engagement with the raw life of the street was escape and salvation. The fascists' appeal to Roman glories had only redoubled this prejudice. Twombly, however, was a more innocent initiate into the grand Mediterranean legacies; he absorbed them simultaneously with the pleasures of his expatriate life in Rome, ungirded from the drier constraints of American mores. In his experience and in his art, a new feel for ancient traditions inhabited a new space of lived, contemporary freedoms. He experienced the opposites together, and surprised the Italians by showing them their own ignored or scorned environment, cultural and visual, as the stuff of a truly contemporary and personal art. Rephrasing elevated, mythical notions like Arcadia and Olympia in a rough script resembling that of street writing, he seems to have joined antiquarianism and New Realism, finding a zone of

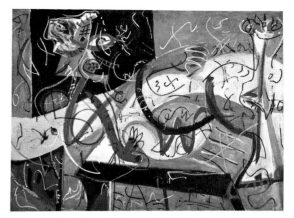

22. Jackson Pollock. *Stenographic Figure.* 1942. Oil on linen, 40 × 50" (101.6 × 142.2 cm). The Museum of Modern Art, New York. Mr. and Mrs. Walter Bareiss Fund

inspiration that was socially conscious and anti-authoritarian, yet immemorially cultured, and at the same time personal. The esoteric elegance with which the canvases seemed to enact those unlikely paradoxes—minimal, Marxist, and Mediterranean all at once—only deepened their impact.

With all this said, it is certainly oversimplified and reductive to imagine that the 1958 canvases, or any of Twombly's subsequent works, simply embody a response to what he "discovered" on seeing the scribblings on Roman walls. He had of course seen those walls long before, and the art he made in Europe is fully (if not seamlessly) consistent with the sensibility and vocabulary he had already formed in America. It was precisely what he had brought with him—an affinity for white, and what he called in 1956 his "deeply aesthetic sense of eroded or ancient surfaces of time,"[125] as well as a recently formed vocabulary of overlaid linear markings—that would have now attuned him to the scarred marble of Rome. Similarly, his feel for the modern tradition of collage would have sensitized him to the many composite walls made from recycled stones with fragments of ancient figures and inscriptions. He also had seen far more than just a formal language in such sites. The implications of the marks he passed by in countless ruins and streets—implications of deep, recurrent patterns of human desire expelled in impetuous graphic motions beyond training, overlaying the great achievements of culture with accretive textures of endurance—were more than enough to lure him.

The idea of approaching and revivifying the culture of the past through

what appeared merely to mar it was a sufficiently personal and instinctive challenge. It encompassed a sense of Roman light, and one of darkness as well. Especially in more traditional societies, graffiti often mixes superstitious dread (evil eyes, curses, and prophylactic signs) with mockery, celebration, and boasts; it often seeks to tame what is feared, by an act of desecration. In Twombly's works of 1957–58, "DEATH" is written at least three times (see for example pl. 35, at the right edge, just above center) and "MORTE" twice (see pl. 31, to the upper right of center).[126] "The reality of whiteness," as he had written, "may exist in the duality of sensation (as the multiple anxiety of desire and fear)." In this respect, the affinity of Twombly's paintings with Roman walls represented a new realization of his earlier primitivism, not just in the use of reductive, archaically simplified forms, nor only in the continued attraction to aged surfaces, but also in his attraction to cultural residues in which the unstable combination of eros with dark, animistic superstition has been deeply invested.

•

Whatever inspiration Twombly drew from the Roman milieu in 1957–58 he repaid by the decisive influence he had begun to exert on younger artists such as Novelli and Perilli. Yet no matter how solidly established he may have appeared to others, he continued to look homeward to America. On arriving in Italy in the spring of 1957, he had judged the gallery scene "nil," and even with the increase in activity the following year, he despaired of selling any of his work in Europe. He continually hoped, throughout 1957 and 1958, to obtain a teaching job in the U.S.—if only to be able to earn enough money to come back to Europe for a longer stay.[127]

Franchetti and de Martiis, however, tried to promote Twombly's work, and eventually found a reception that surpassed even their most optimistic expectations. An initial Twombly exhibition was presented at Tartaruga in mid-May 1958, and then sent to Venice during the summer, with no commercially encouraging results.[128] But in November, when the same exhibition opened in Milan, it turned out to be a stunning success: all the paintings in the show sold in the first two days, with demand for more. An American observer of the Italian art scene reported:

Milan, at least in patronage, is known to be more receptive to contemporary expression than Rome, but it came as something of a surprise when all of Cy Twombly's "difficult," American, wall-sized, white, pinpoint Action Paintings were snatched up by Milanese collectors, at Naviglio's recent exhibition of works which certainly did not have that success in Rome. This was the latest indication of a recent and growing trend toward including

advanced examples of American art in private and public collections. In fact, nothing like it has been seen since Whistler won the first prize at the Venice Biennale.[129]

Twombly himself was delighted, but also caught by surprise. Since the first months of 1958 he had been planning to return to New York in early autumn, and had been corresponding with Eleanor Ward about the best dates for a winter exhibition at the Stable.[130] By the time he was able to sail for America at the end of November, however, virtually everything seemed in flux. For lack of available work, Ward had been forced to postpone indefinitely the plans for a show, while Twombly found himself, with only a week or two before his boat sailed, trying to adjust to the rush of interest surrounding the success in Milan.[131] He had planned only a short stay in New York before going on to Lexington, where he arrived before the New Year.[132] The stopover proved to be an important moment of transition, however: while he was in New York he broke off his relationship with Ward and agreed, following Rauschenberg's move earlier that year, to begin showing with Leo Castelli.

1959, A PIVOTAL YEAR

When Twombly returned to work in Lexington at the start of 1959, he was flush with recent success abroad, looking forward to a timely show with his new American dealer, and anticipating an early-spring return to Rome.[133] Yet over the next four months, he produced ten of the barest, most austere works of his career. The first four, completed by mid-February,[134] moved directly to an extreme of asceticism: they have an echoing airiness dusted over with minute motes and threads of linear energy that share virtually nothing in the way of traditional compositional bonding (pls. 36, 37). The breeze that blew through the works of 1958 has all but ceased, and like sparse stubble in a snow-covered field, an obsessively miniaturized repertoire of graphite lines, points, and familiar signs—hearts, lazy 8s, cloud puffs with central clefts—scatters itself across these eight-foot stretches of white and cream. The scratchy loquaciousness of the Roman canvases gives way to a wordless, whispering delicacy—a pixilated music seemingly keyed up by the most powerful compression. The general idea of this astringency had already been essayed in drawings done in Rome (pl. 34), which in turn only intensified an impetus toward reduction that had marked Twombly's development since 1956. Yet in its realization this merciless constriction may also have included an added element of response to the return home, after almost two years of a very different life abroad.

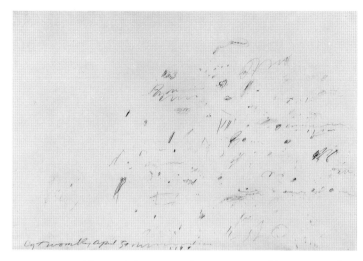

23. Cy Twombly. Untitled. 1959. Pencil on paper, 24 × 36" (60.9 × 91.4 cm).
Collection Gian Enzo Sperone

The pictures are spare in part because a good deal was effaced in the process of their making. Extra layers of paint, used to conceal and erase, articulate the generally dry surfaces in sheets and patches of dripping liquidity, and it is this incipient physicality that increases noticeably in the next group of canvases, done three months later, in May. These slightly smaller works begin to announce a rebound from the wintry ethereality of January: the cream overpainting becomes a more evident part of the composition, just as the penciled elements regain some size and clustering coherence, and the general turbulence of the field increases (pl. 41).[135]

In between the two campaigns in Lexington, Twombly was in New York. Tatiana Franchetti, who had been making yearly trips to America to paint portraits on commission, had at first accompanied him to Lexington, and was then sharing an apartment with a friend in Manhattan; the apartment became an improvised studio where Twombly sat on the floor and—while listening to Vivaldi, as he remembers—made a new series of drawings.[136] These are similar to the paintings but more horizontal and bottom-heavy, with emptied space above an annotated field and a stronger presence of run-on "writing" strokes (fig. 23; pls. 38, 39). Only one of the earlier canvases had been signed, in tiny discretion, in a corner of the surface, but in these drawings the signature becomes a prominent element, and some of them proclaim one specific date in fullness: "NY City / April 20, 1959" (see pls. 38, 39). Five days shy of the artist's

thirty-first birthday, it was a moment worth memorializing; on that date he and Tatiana, with a few invited witnesses, went to City Hall and were married.[137]

Catching family and friends on both sides by surprise, the event brought Twombly formally into the Franchetti family, whose lives had become so intertwined with his since 1957. Giorgio's support had enabled him to work more or less as he wished, without worry over the costs of studios or materials and without undue concern for the sales of his paintings. Simultaneously, Giorgio and Tatiana had also introduced him to a new circle of European acquaintances, invited him to share vacations at the family's castle in the Dolomite mountains near Cortina, and had enlisted him to join them in seaside holidays, travels, and other diversions. Up to 1959 these may have seemed only the holiday pleasures of a wandering expatriate. With the marriage, however, Twombly would find such circumstances a more permanent and consequential part of his life: the "emigration" to Italy, which had begun so tentatively with the 1957 voyage, was now more solidly confirmed.

The couple waited until after the second work period in Lexington, which lasted through late May, to take a honeymoon trip to Cuba and Mexico. They returned to Italy in time to rent a home in the beach town of Sperlonga, on the Mediterranean coast between Rome and Naples, for July and August. That summer, during which it became evident that Tatiana was expecting their child, was immensely important for Twombly as an artist. In a notable change, he abandoned the house paint that had till then been his preferred medium, and began using oil paint from tubes, with its wholly different physical properties. Instead of flowing, this material issued forth in discrete mounds that stood off the surface with a smooth, plump integrity, and required pressure to flatten and spread. These new properties were immediately exploited in abstract collages (pl. 40) and in an important group of drawings.

Rather than only providing a skin to draw into, or a covering veil, the white oil pigment had a "body" of its own. The series of *Poems to the Sea* used this cool, linen-white matter as an independent element of line, shape, and low relief against the drawn indications of open horizons and largely wordless writing (figs. 24, 25). The numerous larger drawings from Sperlonga (see pls. 42–44), though, initiated a more paradoxical combination of elements, which would inform Twombly's paintings for years thereafter. The pencilwork introduced a family of "rationalized," diagrammatic elements: ruled rectangles, singly or in series; sequences of numbers; circles and repeated semicircles; and clusters of forms that suggest overhead, plan views of unknown arrangements. In contrast to such compulsive, analytic schemes, the paint was used in a seminal, newly

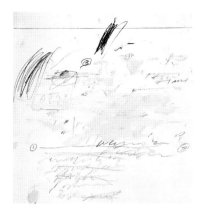

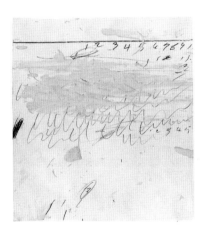

24. Cy Twombly. *Poems to the Sea* (no. 10 in a suite of twenty-four drawings). 1959. Oil, crayon, pastel, and pencil on paper, 13 × 12¼" (33 × 31.1 cm). Dia Center for the Arts, New York

25. Cy Twombly. *Poems to the Sea* (no. 20 in a suite of twenty-four drawings). 1959. Oil, crayon, pastel, and pencil on paper, 13½ × 12¼" (34.2 × 31.1 cm). Dia Center for the Arts, New York

sensual way: for coating and effacement as often before, but also now in multiple small flecks, streaks, and droplets, which often leaked aureoles of oily stain. The resultant drawings—with their long horizontality, dispersed and often miniaturized signs, and references to rational mapping—seem to join the *Poems to the Sea* in opening up a new, specifically landscape-like space in Twombly's work.

That combination of pencil and paint was then translated, on a grander scale, into the canvases of the end of the summer and the autumn. In works such as *Study for Presence of a Myth* and *View* (pls. 45, 46), elements of the Sperlonga drawings (numbers, rectangles, freehand triangles and squares) were joined by a family of more organic signs—tubes with darkened points, double-ended lozenge forms, vertical bars in circles, reclining and extended diagonal 8s—that seem to slide into and away from reference to bodily forms; and the whole field was put into sweeping motion. The gentle lufting of the emptier 1958 pictures is reborn as an upheaval that raises the array of signs from the lower left and sends them pressing and leaping—with the urgency of spawning fish against a tumbling cascade—across the canvas and toward its upper right corner. The paint, meanwhile, spatters the canvas as if from a spray, in droplets, spots, crusts, oozing drips, and compressed blobs, which have often been further demarcated, encircled, or boxed in by pencil lines.

It must have been paintings of this kind that Twombly described to Leo Castelli, near the end of August, as "4 new paintings quite different from those you have, [and] … painted with tube paint." Reluctant to roll these works for shipping, and recognizing the change that had taken place over the summer, he asked Castelli, who was eager to give his new artist a first one-person exhibition, to consider mounting a show of only the Lexington pictures. "[I]n a way," Twombly wrote, "I like the image of seeing just the paintings you have with a few drawings—the obsessive austerity of the idea rather than variation…. The new things are naturally more active and physical so a certain poetry would be lost with juxtaposition with these."[138] (Castelli did not, however, present that show of "obsessive austerity"; the Lexington pictures remained largely unknown, and we are left to speculate on the impact they might have made in 1959, on a New York art world just experiencing the first shocks of emerging Minimalism.)

In the same letter, Twombly warned that the upcoming months would be crowded ones, as indeed they were: he had to move out of his bachelor apartment into new quarters with Tatiana, prepare for the birth of their child, and contend with a flurry of demands for exhibitions of his work throughout Europe—all of which left little time to paint. An extraordinary aggregate of pressures thus surrounded the few large paintings that emerged from this autumn,

and their combination of expansive reach and compulsive nervous energy may reflect some of the tenor of the moment. The most ambitious of them was made at the very end of that season, and of the year. Two weeks after the birth on December 18 of a son christened Cyrus Alessandro, Twombly unfurled a huge bolt of canvas and—as the lone refugee from a family New Year's Eve party—spent the final hours of 1959 and the first moments of 1960 creating *The Age of Alexander* (pl. 47).[139]

This was by far the largest work he had ever attempted, overflowing the limits of the room—it covered one wall and wrapped around the corner to another—and surpassing the height of his reach.[140] Kept in the artist's home and not shown publicly until 1994, the dry, spottily painted picture is more like a grand, operatic drawing, and is far from being a resolved whole. But the scope of the effort, and the complex fertility of its making, are impressive and absorbing. Twombly had named his son for two great conquerors, and some of that epic spirit carries over into this run-on, diaristic conception. Amid a virtual dictionary of Twombly's emerging sign language—personal shorthand devices that occasionally suggest winged forms; phallic signs; graph-like rising and falling lines; circles that become breasts, clouds, and so on—we find notations of time and fragmented words of rumination.[141] Distracted, nervous, and headlong, this teeming rush of disjunctive, largely uncensored moments of engagement with the vast blankness of the fabric includes an element of aleatory development more marked than that in any of Twombly's previous work.

The Age of Alexander seems one of those occasions in modern art (there are others in Matisse, in Picasso, and elsewhere) when what one takes to be basic passages in life—marriage, the advent of a child, the possession of a new home—give rise to such a welling pressure of mingled emotions (procreative joy, ennui, suffocating anxiety) as to evoke a statement of exceptional scope or intensity. In Twombly's case, the swiftness and extent of the dislocations that had separated him from his former life in New York added another factor of magnitude. Some of all of that informs this sprawling journal of a night, which offers an ode to a new birth and a colossal capstone to a year of rapid changes. During 1959, Twombly's art had passed through a dramatic convulsion, closing down to its barest, most minimal baseline in the Lexington pictures of the winter and spring, and then, as if he had backed up to leap the further forward, expanding through the summer and autumn into the prolix comminglings of painting and drawing, word and sign, disclosure and hermetic self-absorption, obsessively private concern and grand cultural address, that would define the style of the next, most lavishly productive years of his career.

Twombly and his family moved into a grand new home on the via di Monserrato in early 1960, and the artist began to adjust to the roles of paterfamilias and master of the mansion with apparent delight. While renovation of the building was still under way, with a month's trip to the Sahara coming up and the prospect of shows at Tartaruga in April and in New York in the autumn, he wrote to Castelli that "my life has become hopelessly and grandly spoiled. I am the owner of a beautiful long grey eyed blond son named Cyrus Alessandro and an enormous 17th Century Palace near Palazzo Farnese.... I have worked wonderfully well and have quite a few paintings now."[142]

Those paintings and the others of 1960 were created in the noble, high-ceilinged rooms of the new residence, and were often titled with florid evocations (*Crimes of Passion*) or homages to art and artists: *To Leonardo*; *Woodland Glade (to Poussin)*; *Garden of Sudden Delight (to Hieronymous Bosch)*; *Study for School of Athens*. Such christenings almost never indicate visual correlations, and can easily be overinterpreted. Twombly is not, for example, a particular admirer of Raphael ("the most boring painter I know, aside from some of the portraits"); and when he cited the *School of Athens* fresco in the Vatican, or even used its prominent archway as a point of departure (see pl. 52), the gestures had some knowing element of irony.[143] The nods to Poussin or Leonardo, while more appreciative, have equally little to do with mimesis. The titles are more useful in the general sense of showing how far the artist had moved—not just from Lower Manhattan loft life but also from his original territory of the prehistoric and tribal—into the halls of high European culture. Yet the paintings themselves suggest he was not immediately at ease in his new—old—world. The white of the new canvases was colder, the colors relatively wan, and the compositions, often center-weighted and organized more in terms of vertical columns than of lateral, narrative movement, became less turbulent and more stiffly iconic (fig. 26). An air of grand rhetoric and formality thus replaced the hot crustiness of works such as *View* (pl. 46).

The familiar mix of schematic forms and numbers with organic pictograms continued, and often the references to the body and its processes became even more active and insistent (fig. 26). Yet the overall feeling of the pictures is clinically diagrammatic. Some of the ambivalently biomorphic shorthand signs are recurrently framed within ruled boxes, as if they were details isolated for detached scrutiny. At the same time, the graph-like passages of rising and falling lines (which are on one level ideograms for Dolomite-like mountain ranges) are typi-

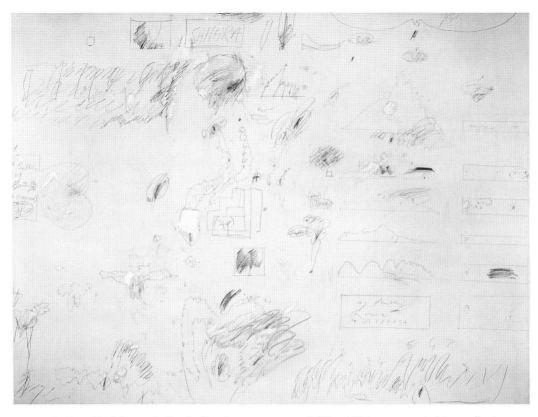

26. Cy Twombly. *Sahara*. 1960. Pencil, oil, and crayon on canvas, 6' 6¾" × 9' ¼" (200 × 275 cm). Private collection

cally underlined with ruled bases and overlaid with counting sequences of numbers. These are parts of a general practice by which Twombly juxtaposes motifs of the irregular, organic, and intuitional with marks connoting the systematic, unyielding, and cerebral. Such oppositions are basic to his work before and after, but in 1960 the pairings seem more premeditated and self-consciously analytic.[144]

In the autumn, when Castelli's first Twombly show brought recent works together with hotter and more active earlier pictures, the contrasts must have been telling, not least for the artist himself. Throughout the early and mid-fifties, he had banished color, taken up house paint, and replaced the brush with the pencil in order to gain—by suppressing what Rauschenberg called the "baroque" side of his art[145]—a willfully uningratiating originality. Yet, as even so contrary a *maniera* can raise the risk of a mannerism, at the other end of this process the devil of virtuosity threatened to return: the sparse linearity could, if unpressured, err into vitiating elegance.

The aggressive drawings of the summer of 1960, done away from the Roman home, on the island of Ischia and in Greece, already began to counter that risk; in the next year, when Twombly moved his studio out of the *palazzo* on the via di Monserrato and into rented rooms on the piazza del Biscione, he made a flurry of works that obviated it altogether. These paintings, from the summer of 1961, are among the most impressive, most emotionally wrought works of Twombly's career, and not coincidentally they bring together in extreme compression the contradictions of "griminess" and "insinuating elegance" that critics had seen cohabiting in his work since his first exhibition in 1951. They reach for a higher level of lyricism, and a greater grandiloquence, precisely through their more aggressive release of explicitly defiling messiness. The insistence on soiling excess is both playful and violently transgressive; when it is joined with glorious color, aerated white space, and a baroque sense of monumental aspiration and exultation, the result is an unfamiliar merger many will find easier to reduce, either to raw chaos or mere lyric splash. Yet in all of Twombly's work, and here most especially, those who focus on the appeal to

cultural grandeur but slight the celebration of bodily physicality, or vice versa, miss what is most distinctive about the art: it wants exactly to convey a sense of life energy that yokes these exalted and debased domains together and makes their energies indivisible.

The different tenor was already clear in January, when *The Italians* (pl. 50) replaced the pristine clarity of the 1960 canvases with a rougher scramble of paint and pencil recalling the works of late 1959. That picture, however, still maintained Twombly's long commitment to an essentially white field covered by graphite and crayon imagery. In the more spectacularly innovative production of the summer, white would be eclipsed by vivid color, and paint would largely supplant drawing (pls. 48, 49, 52–55, 59–61). Across the nearly sixteen-foot extent of *Triumph of Galatea* (pl. 48), for example, virtually nothing depends on either graphic signs or words. There are still some familiar references to lower-body parts and processes, but the dizzyingly rich corporeality in the work derives less from these than from the physicality of the medium itself as it is dabbed, spattered, and smeared across the surface—and from the intensely fleshy palette of roses and carmines offset by yellow-oranges, notes of silver, and pure white. Deeper maroons and scarlets, meanwhile, conjure not just the surface of the body but its interior, rapturously disgorged.

Aside from occasional passages of dripping rivulets, the paint itself does not flow; its drier, separate masses instead show clearly how it was pressed onto the canvas, directly from the tube or in fistfuls and finger streaks. Twombly had worked into painted areas with his fingers before, but now he began to use his hands as the main instruments of picture-making—a change in method that was as transforming as the change in materials at Sperlonga two summers before. For Twombly, the application of the hand (a primordial index of direct engagement with art, from prehistory through Miró and Pollock) had a particular set of pragmatic purposes, side effects, and connotations. Clutching gobs of oil pigment let him work more continuously, uninterrupted by the need to "reload" a brush, and it put him, literally, in closer touch with the picture. For a long time he had been working on canvases fixed to a wall rather than a stretcher, so that the fabric could bear the pressure of his pencilwork. Now, instead of passing through a sharp point, his impulses would meet the surface sensuously, in the broad, flat engagement of the palm, or by fingertip daubs, or through varieties of clawing and caressing (see detail, pl. 54). That sensuality encompassed, too, the most basic and earliest life associations of primal creativity asserting itself through uninhibited play with every substance at hand.[146]

Scanning the almost twenty large pictures Twombly painted in this way

during the summer of 1961 is akin to watching the changing rhythms of an immense fireworks display: their explosive energy is sometimes lyrical and confetti-like in its delicacy, sometimes frenetic and concussive in its impact. Though for some their energies may connote violence, the pictures also have a nervous elegance, derived from the tension between the separate anarchies of local impulses and an overall dance of binding motion. Through all the immensely ambitious and fertile production of that summer, that intuitive choreography helped transmute whatever elements might connote base corporeality into an overall feeling of lightness, staying unfailingly uplifted until the end.

The end came in the five *Ferragosto* pictures, named for the mid-August holiday when Rome is smothered in heat and empty of its residents. The last two of this series (pls. 60, 61), and the last one in particular, have the kind of earthy fleshiness we associate with the Flemish Baroque, and carry uncharacteristic overtones of engorgement and satiation. That heavy, end-of-the-line carnality helps us see more clearly the lighter touch of the earlier color pictures, and reflect on the particular aversion to all that is ponderous in the "expressionism" of the year's production.

The outpouring of fervid color in 1961 might be seen as a resurgence of Twombly's earlier expressionist strain. His former passion for Soutine and Kokoschka has now been aerated, though, by a sense of expansive levitation that denies the heaviness of physical concerns. In this and in his landscape-like spaces, especially in many works on paper, Twombly's often cited relation to the visceral Surrealism of Gorky seems to meld with an affinity for the ecstatic upheavals of Kandinsky's early abstractions (figs. 27, 28; pls. 56–58). That mixed metaphoric resonance between body and landscape may even reverberate through the choice of browns, pinks, reds, and whites Twombly deploys. It is such overlapping associations of external and internal experience, bright openness and intimate physicality, that give the large colored canvases their charge of ecstatic fantasy, and keep their sensual intensity from ever becoming turgid or weighty.[147]

Light and lightness are essential to the look of the works, and to their meaning. Twombly has spoken of an "irresponsibility to gravity" as central to his art, and has described his understanding of classical mythology as a realm of imagination which is not only shadowless but also without weight or constraining center.[148] Yet this sense of floating, and this relationship to the Mediterranean past, is anything but a bloodless flight of fancy: the antique heritage he treasures is one that includes the malicious jealousies in the *Iliad*, the eros of Sappho, and the ribaldry of Archilochus. Precisely because he treasures such myths and poetry as living communications of timeless human experience, he is out to translate

27. Vasily Kandinsky. Study for *Painting with White Border*. c. 1913. Pencil on paper, 10⅞ × 14⅞" (27.5 × 37.8 cm). Städtische Galerie im Lenbachhaus, Munich (GMS 395)

28. Vasily Kandinsky. Study for *Small Pleasures*. 1913. India ink on paper, 9½ × 9¾" (24 × 24.7 cm). Städtische Galerie im Lenbachhaus, Munich (GMS 393)

their spirit fully into the present tense. Through the insistently episodic, uncomposed sequences of marks and signs and names he put on the canvas, such fantasies of time as continuous and open-ended—and of physical pleasure made spiritually immortal in art—were enacted as non-stop sensation. Twombly thus resisted any standard structure of narrative organization that would align these events with a vector that led to a resolved end point, or otherwise threatened their moment-to-moment specificity. In this same regard, weight—all that would be bound together in mass, and ordered by the shared pull to earth—would connote surrender to inertia and mortality.

In its newly exuberant scale and color, Twombly's work of 1961 has also been seen as reflecting his response to the great Baroque spaces of Rome.[149] This formal intuition, whatever its quotient of truth, must still be grounded in some denser reckoning of the various things the city meant to him, beginning with *Olympia*'s scarred wall in 1957 (pl. 31), and deepening seamlessly into the different complexities of the great "baroque" summer four years later. Twombly himself recognizes that he would never have made the large color paintings in America, since they draw on a freedom of indulgent sensual release that only living abroad allowed him.[150] Similarly, the Rome they embody is a matter of visceral experience as much as of grand architectural design, and includes a strain of Neapolitan color and energy. When he moved there, Twombly's home on the via di Monserrato was in a decayed area still infested with petty thieves, and the studio on the piazza del Biscione not only adjoined the crowded open-air food market in the Campo dei Fiori, but sat above a cheap movie house and overlooked a ripe zone of prostitution.[151] Walking from home to studio, Twombly passed not only through the august Rome of the Caesars and the Baroque popes, but also through this environment of coarsely vital contemporary existence. The tense balance in the works, between a light-filled exaltation and a pungently darker sense of human physicality, embraces something of both the grandeur and decadence of that city.

The same could be said in broader terms of Twombly's relation to all Mediterranean culture, in Greece and Egypt as well as Rome. In life as in art, Twombly's responses never entail mere antiquarian nostalgia, but rather a desire to hold the past and present simultaneously. It is the living continuity between the heights of antiquity and the common orders of the day that forms the texture of his experience and the stuff of his work. Affectionately searching for a metaphoric way of describing this special blending of cultured refinement and appreciation for the pithier vernacular of life, a friend once mused that Twombly's ideal abode might be "in a palace," then paused and added, "but in a bad neighborhood."

Twombly began an entirely new cycle of works in 1962. Using squarer formats and emphasizing the vertical midline of his compositions, he more and more abandoned a dispersed "narrative" in favor of the frontal, iconic presentation of prominent, closely massed imagery. Early in the year, this new approach yielded a masterpiece in *Leda and the Swan* (pl. 64). The subject of Jupiter assuming the form of a swan to ravish the beautiful Leda has typically been the pretext for titillating images of incongruity, avian and human appetites confronted amid contrasts of feathers and flesh. Twombly's fantasy of this fateful copulation (from which issued Helen, and thus ultimately the Trojan War) involves instead an orgiastic fusion and confusion of energies, within furiously thrashing overlays of crayon, pencil, and ruddy paint. A few recognizable signs—flying hearts, a phallus—spray off the periphery of this explosion. It is, however, not those energies that were carried forward from this picture; instead, it is the drier comment of the marginal "window" rectangle above that indicates the directions— thinning, slowing, and stabilizing—that Twombly's art was beginning to take.

That rectangular form dominated a series of canvases that showed monument-like motifs standing solemnly in barren spaces, and which bore titles of mortality and debacle from Italian and Roman history: *Death of Giuliano de' Medici*, *Death of Pompey*, *Ides of March* (fig. 29), and so on. In these works, the isolated arrays of pigment were still applied by hand, but only to circumscribed areas and without any of the former sense of scattered urgency, while the fireworks of color faded to a more limited palette of blood-reds, deep maroon-browns, and white. Twombly made several images in this grim genre throughout 1962, suspended it during most of the next year, and then brought it to summation in *Discourse on Commodus* (see figs. 30–32), "a painting in nine parts" whose vertical formats and dark subject—in this case, a psychotic Roman emperor whose reign was one of cruel excess—conformed to the earlier sequence of canvases.[152]

In retrospect, the *Commodus* ensemble has the cautionary mark of something self-consciously intended to be culminating and grand, pushing to extremes the august high-mindedness and morbid pathos that had informed its predecessors. All nine of the "portraits" were painted on canvas with a commercially prepared, dove-grey ground that lent a note of smooth elegance; in each, two side-by-side clumps of thickly scumbled, often streaked or dripping paint conjured a variety of moods, from cloud-like lightness to agitated, bloody violence. One of the prime guiding spirits behind the combination of the decorative and

29. Cy Twombly. *Ides of March.* 1962. Oil, pencil, and crayon on canvas, 66¾" × 6' 6¾" (169.5 × 200 cm). Courtesy Galerie Karsten Greve, Cologne and Paris

the gruesome in the series, and likely behind the whole extended project of imagined portraits from history, was the painter Francis Bacon.[153] Twombly's admiration for the British artist—whom he considers "the last great European painter"—has its grounding in his long-standing dialogue with the tradition of European expressionism. Bacon's efforts to bring the meaty power of that kind of painting into the barer existential spaces of postwar experience, and to make a personal poetry by mixing lush painterly aesthetics with a sense of the gross materiality of the life of the flesh, were ready avenues of affinity.

Though likely plotted beforehand, the *Commodus* ensemble was painted in December 1963, soon after the assassination of President Kennedy—an apt moment to be reflecting on leaders, disasters, and the fate of empires—and it became, ironically, a grim milestone in the artist's personal history as well. Its debut in March 1964 at Castelli's gallery was Twombly's first New York show

30. Cy Twombly. *Discourse on Commodus (Part IV)*. 1963. Oil, pencil, and crayon on canvas, 6' 8¼" × 52¾" (204 × 134 cm). Private collection

31. Cy Twombly. *Discourse on Commodus (Part VII)*. 1963. Oil and pencil on canvas, 6' 8¼" × 52¾" (204 × 134 cm). Private collection

32. Cy Twombly. *Discourse on Commodus (Part VIII)*. 1963. Oil, crayon, and pencil on canvas, 6' 8¼" × 52¾" (204 × 134 cm). Private collection

in four years. In the interim, while the New York art world had been changing swiftly, he had acquired an aura of mystery by his absence (and by rumors of his success abroad), and expectations were high. The crash was thus all the more precipitous: in print, Donald Judd called the *Commodus* show a "fiasco," and apparently the word-of-mouth reaction was even more damning than press commentary suggests.[154] Arriving at a moment of ascendancy for Pop art and hard-edged Minimalism, these works were seen as woefully out of step—embodying everything that was at best suspect, at worst loathed, in the *art informel* of 1950s Europe. Warhol's grainy, drumbeat images of the police dogs of Birmingham and of the mourning Jackie Kennedy, not to mention the events they reflected, were

just then altering the terms in which murderous history might be viewed, and the coin of both subjective expressionism and high abstract metaphor was in a free-fall of devaluation.

Worse than a momentary misstep, the ill-fated encounter between these paintings and that critical climate hobbled Twombly's reputation in America for years to come. Neither the spare, white canvases of 1959 nor the major color works of 1961 had been shown in New York or were known to Americans outside a tight circle of dealers and friends of the artist. Many critics, collectors, and curators thus saw *Commodus* virtually in a void, and, caught up in an especially chauvinist moment in American art, used their dislike of it to cement their suspi-

 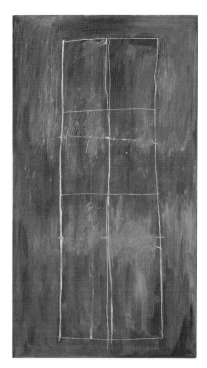

33. Cy Twombly. *Problem I, II, III.* 1966. House paint and crayon on canvas; three panels: 6' 6¾" × 42½" (200 × 108 cm); 6' 6¾" × 44⅛" (200 × 112 cm); and 6' 6¾" × 44⅛" (200 × 112 cm). Museum für Moderne Kunst, Frankfurt am Main

cions about Twombly's move to Rome. The same painter who had been criticized in the late 1950s for insulting high art with his lack of aesthetic organization was now accused of being over-refined and arty in a damningly old-world, European way.[155]

News of that reception stunned Twombly's Italian supporters.[156] When Rauschenberg won the Grand Prize at the Venice Biennale that June, it appeared the European embrace of postwar American art had finally been sanctioned at the highest level, and that the efforts of Franchetti, de Martiis, and many others who had promoted it were now to bear fruit. Yet at the very moment of this triumph, Twombly, who had been among the first of the young American artists to succeed abroad, seemed to be castigated as a passé foreigner and set outside the forming canon that positioned Johns and Rauschenberg, with their "American" irony, imagery, and use of mixed mediums, as the crucial precursors of the aesthetics of the 1960s.

GREY PAINTINGS AND RELATED WORKS, 1966–72

In wry and somewhat rueful reminiscence, Twombly has said that the *Commodus* episode made him "the happiest painter around, for a couple of years: no one gave a damn what I did."[157] For a long stretch, he in fact did much less. After the astonishingly fertile period of the early 1960s, his production had begun in 1963 to revert to the slower pace of the 1950s, and after *Commodus* it fell off even more. The catalogue of his work shows twenty canvases from 1964, and virtually none from 1965. When he resumed in 1966, it was to pursue a sharply different direction, in a new cycle of grey-ground canvases that would dominate his work into the early 1970s.

Expressly for a show in Turin in early 1967, he created three dark-ground pictures (figs. 33, 34; pl. 65), the first since the lost chalked canvases of the mid-1950s.[158] Just as those earlier pictures had represented a cooling shift away

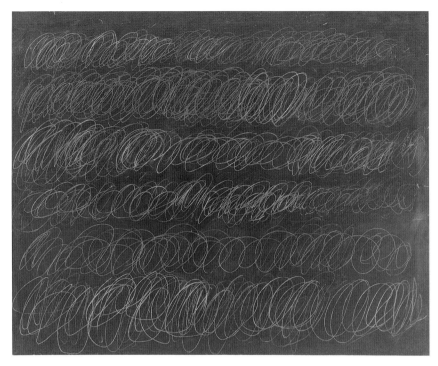

34. Cy Twombly. *Cold Stream*. 1966. Oil and crayon on canvas, 6' 6¾" × 8' 3¼" (200 × 252 cm). Courtesy Galerie Karsten Greve, Cologne

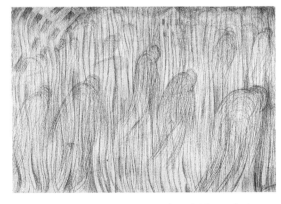

35. Umberto Boccioni. Study for *States of Mind: Those Who Stay*. 1911. Charcoal and chalk on paper, 23 × 34" (58.4 × 86.3 cm). The Museum of Modern Art, New York. Gift of Vico Baer

from painterly and erotic energies, these new canvases were lean and unemotional, in contrast to the baroque color and violence of the work of the early 1960s. In the three-part *Problem* (fig. 33) and the other works done for the Turin show, geometrical and gestural elements of Twombly's previous style were stripped down and isolated, translating them into a bare baseline to find a new point of departure.

In that sense, this small series represents a hinge point, analogous to the Lexington works of 1959. Then, the primary issue was space—emptying out as a way of moving from the congested wall toward an open landscape whose scale would accommodate a fresh diversity of scattered, discontinuous forms. In 1966, time seems to have been the more central concern. In the nine "installments" of *Discourse on Commodus*, and in a 1964 triptych on a battle theme (fig. 45), Twombly had already been exploring new structures of storytelling; now, stripped of literary or historical associations, some of those same issues—of flow, segmentation, development, and change—would themselves become the story. The *Problem* pictures are a three-part chronicle of the variation and transformation of a basic shape, and *Night Watch* (which has nothing to do with the Rembrandt picture of that title) presents a cinematic, time-lapse image of a box form advancing and turning in space (pl. 65).[159] That temporal aspect was then extended throughout the grey-ground works of the next few years, in the frequent imagery of analytically segmented movement, while the rolling scrolls of the third 1966 picture (fig. 34) established another enduring, and complementary, motif of continuously flowing energy. Twombly's previous attraction to the evidence of deep, slow, "vertical" time, in scarred surfaces, here is translated into a fascination for the forms of "lateral" speed, forms and forces rushing by with their proliferation of marks more rationally divided than confoundingly layered.

In numerous grey-ground works between 1967 and 1971, Twombly sends a repetitious flurry of lines—bulging curves or slashes—spilling diagonally down and across the surface, and then slices it with a regular beat of vertical "measuring" markers (pls. 68, 79). That language of flow and fracture draws directly on the early modern fascination with the "cinematic" decomposition of forms in motion, in Duchamp (*Nude Descending a Staircase*, 1912) and most notably among Italian Futurist artists, particularly Giacomo Balla. While the reference is novel in Twombly's work, the Futurists and that kind of time/motion imagery had been of principal importance to the Italian painters around him for more than a decade. In rejecting both Stalinist realism and fascism, the younger Italian artists of the 1950s had revived early Futurism as an alternative, usable past—a model of modernism in which revolutionary social concerns were legitimately con-

nected with the push to abstraction. In this context, the "rational" side of Futurism—its analytic, semi-scientific decomposition of movement—was stressed.[160] Twombly seems, though, to have responded more intuitively to the way the Futurists dispersed forms into linear sequences and made analytic rigor collide with onrushing flux. Umberto Boccioni for one had seen that these fractured dissolutions were a way to represent the agitations of the spirit (fig. 35), and this metaphorical aspect is unlikely to have been lost on Twombly.

Something similar could be said with regard to the influence of Leonardo da Vinci, which also affects Twombly's work in this period. First signaled in 1960 by the title *To Leonardo*, this interest initially centered on the Renaissance master's notebook pages, where the combination of scattered drawings, geometric signs, and passages of mirror-script writing connected with Twombly's aesthetic.[161] Yet while Twombly's interest in Leonardo's studies of nature and mechanics became even more evident when he later used reproductions of them in collage-drawings (fig. 36; pls. 67, 71, 72), it should not be understood as simple admiration for an analytic or scientific outlook. Joseph Beuys was apparently attracted to the same aspects of Leonardo's drawings, because he saw in these innumerable dissections, diagrams, and codes something irrationally driven, by a demon of secret knowledge, and freighted with a private poetry of obsession. Twombly's response involves a similar intuition.[162] He recognizes that Italian art, often talked about in terms of sunlight and Renaissance clarity, also has a dark, neurotic, and obsessive side—and he situates Leonardo there.[163] The imagery of Leonardo's work to which he was most consistently drawn during the late 1960s was that of maelstroms and cataclysms (see pl. 67). Their destructive turbulence has an obvious expressive dimension that overlaps with the Futurist metaphors of spiritual agitation, and Twombly melded it with the forms of Futurist imagery in many of the canvases of the late 1960s.

Despite these elements of Italian art, and although the first examples were made in Italy, Twombly found that the new dark-ground style seemed, in its relative coolness, an appropriate form of work to pursue in New York, where he spent long stretches of time in the late 1960s, working in studios on the Bowery and on Canal Street.[164] In contrast to the misfortunes of *Commodus*, this new aesthetic seemed in step with favored contemporary currents in America; it had a chaste severity that suggested the artist had ceased being erudite and had gone back to school, renouncing former pleasures and submitting himself to a penitent discipline many Americans found more admirable and less discomfiting. When he had his first one-person museum exhibition in America, at the Milwaukee Art Center in 1968, Robert Pincus-Witten approvingly called the new work

36. Cy Twombly. Untitled. 1971. Collage, crayon, pencil, and cellotape on paper, 31¼ × 30" (79.3 × 76.2 cm). Private collection

"heroic." "With it," he wrote, "Twombly casts down all that was grandiose in his mature style, rejecting a lush manner for simple and stringent exercises."[165]

It would be misleading, though, to connect the black paintings only to the asceticism of Conceptual art or Minimalism. Their thinly washed surfaces, which vary considerably from dark green-blacks to lighter and chillier greys, often have great atmospheric subtlety in the layered complexities of their application (pls. 65, 70; see detail, pl. 69). In their linear motifs also—drawn into the thin wet surfaces with a special white crayon—neither geometry nor straight edges ever dominate the variations of the hand as it moves, from tremulous slowness to headlong impulse to casual meander. Fluctuating individual energies invariably take precedence over rigorously systematic ideas.

Among the most characteristic of these images are those banded with rows of running loops that have been compared to basic Palmer Method exercises imposed on schoolchildren as a part of learning to write (fig. 34; pl. 66). These are "signature" images in several senses—because they ostensibly present an abstracted, wordless essence of the handwriting that is associated with so much of Twombly's work; and because they vividly embody, again and in renewed form,

the artist's willingness to take on the most unpromising premises as the basis of his art. In the internal terms of his work, what is striking about these images is their insistence on the kind of driving linear continuity that had heretofore been specifically excluded: the gesture that formerly closed on itself to produce the looping breasts, or the heart, or the figure 8, as isolated bursts suspended here and there in white space, now never closes but runs on without cessation. Personal expression becomes no longer something realized in the impulses of scattered, separate moments, but something subsumed within a stream.

In broader terms, what is remarkable is the project of trying to make a personal art—or art, period—out of means which appear so studiously, so implacably artless. As before, Twombly courts the accusation that there is no mind involved—previously, because the manner seemed chaotically subjective, without sufficient ordering control, too episodic and too little marked by work; and now, because it seems mechanically rote and impersonal, too monotonous and too completely a matter of work. No familiar evidence of heroic spontaneity or intuited compositional judgment, nor any universal coordinate such as geometry, anchored the pictures' claim to attention. When Twombly first showed them at the Leo Castelli Gallery in the autumn of 1967, Max Kozloff described the ongoing difficulty of trying to reckon with Twombly's work, old and new, in terms of traditional expectations.[166] The lines, for example, offered him none of the familiar cues that advertised Surrealist automatism or Expressionist gestures as involuntary indices of psychic pressure. The work's contrary quality of self-aware detachment might, along with a "hidden iconography," point up possible affinities with Rauschenberg and Johns; but the grey paintings' sense of "distraction," and their singular mix of a "fastidious" artfulness with implacably lean and self-evident systems of marking, resisted any ready labeling by *ism* or school.

Later, after the close of the grey-ground series, Robert Pincus-Witten restated the same dilemma in terms of Twombly's failure to satisfy the available repertoire of critical categories: too anti-heroic and impersonal for Abstract Expressionism, he was also too subjective and undisciplined for Minimalism or systemic art. Twombly's late 1960s work might better be located, though, in relation to aspects of the Post-Minimal aesthetics that had then just begun to emerge. In such art, doggedly programmatic activity—nailing nails, filling in circles, drawing rows of loops—was used by many artists as a way to give voice to, rather than suppress, a distinctive psychic individuality.[167] Stepping aside from familiar ideals of spontaneity or invention, this approach experimented with the meaning and personal inflection that can emerge—shaped less by premeditation, and thereby perhaps the more authentic—in the process of pursuing a repetitive

task. The scheme or system in such art may be banal: it exists not for its own authority but as a way to get into the work without preconsideration, so that other, unplotted things can begin to happen.

In Twombly's case, the adoption of the idling run-on scroll is consistent, in the terms of a very different aesthetic, with the earlier decision to enlarge and use his signature as an expressive element. Then, he had unmoored a legibly meaningful but formulaic piece of language and pulled it back into the realm of abstraction; now, he took something prior to language, the unformed exercise of proto-handwriting, and pushed it up to a communicating role. In both instances, as indeed in a great deal of modern art previously, the artist takes what others see as inert and merely instrumental adjuncts to creativity—wrap-up conventions or warm-up exercises—and proposes them as the principal drama of art. In the modern tradition, this confounding practice has typically been a gesture of aggression against tradition, but with equal frequency it has proved to be a means by which respected older values get remade in terms that respond to contemporary experience. Thus, for instance, the seeming denial of subjectivity in Minimalism defined the terms on which some of the most poetically personal and intimate works of the late 1960s were made (in the sculpture of Eva Hesse, to cite only one example). In Twombly, Kozloff rightly saw the rejection of familiar signs of personality and the denial of a former "heroic" subjectivity. What we may see with longer familiarization is how those same gestures could come to communicate their own specific, nervously headstrong temperament, enacting a risky dance along the edges of meaninglessness that is at once unrelenting, maddeningly casual, and absorbingly uncertain.

As we have seen in music, too, the apparent "impoverishment" of reductive repetition could serve not just as the grounds of such delicate and nuanced subjectivity but also as the basis for new forms of monumental, operatic ambition. In trying to combine such reformed intimacy with such redefined grandeur, Twombly's grey-ground series, which continued through 1971, reached a peak moment in two huge paintings executed in his home on the via di Monserrato in 1970 (pls. 77, 78). Here, as in the work of other artists as diverse as Hesse and Richard Serra, one of the challenges of the late 1960s and early 1970s was the recovery or reinvention of important parts of Abstract Expressionism, and especially Pollock's legacy, that had been suppressed by Pop and Minimalism.

The smaller and squarer of these 1970 pictures (pl. 77) draws on the unlikely, idling vocabulary of the "Palmer Method" images. On a ground rich with the layering over of previous networks of lines, three tense rows of loops,

37. Cy Twombly. Untitled. 1969. Pencil and crayon on paper, 22½ × 30¾"
(57.1 × 78.1 cm). Whereabouts unknown. Formerly collection
Mr. and Mrs. Donald Judd

choreography of pouring, he offers a labor of marking so furiously repetitive, so unconcealedly relentless and unvarying, as seemingly to preclude all sense of lyricism. The results are, however, transporting. The picture brims over with a nervous, obsessed energy, yet its trance-like monotony also opens out into a sense of serene, oceanic dissolution, in a nebular cloud of great depth and infinite complexity. Here, the fusion of sensual body with sunny landscape in the summer of 1961 finds its counterpart: a no less moving metaphor of oneness joins the shuttling loom of the mind and the fathomless expanse of the night sky.[168]

•

Though the dark-ground work dominated in Twombly's production well into the early 1970s, it never held exclusive sway. As in the early part of his career, Twombly often tried reversing himself, using the same linear vocabulary in pencil or crayon on light-ground canvases either white or tinged with rubbed blue-white or red-white tints. He also produced, in 1969, one large body of paintings that broke the continuity of the dark-ground phase and introduced a different space, surface, color, and vocabulary of moving form (pls. 75, 76). These pictures had their origins in a set of drawings done at Grand Case, on the island of St. Martin in the Caribbean, in January 1969 (fig. 37; pls. 73, 74). Frequently covered with tracings of small seashells, the drawings surround their elements of system and geometry—tumbling squares, sequences of rectangles, and so on— with a vivid, lively jumble of confidently baroque draftsmanship which often includes a peppering of verbal notations and a strong proportion of sexual imagery. By the time these drawings were translated to canvas, however, the surroundings were completely changed. The paintings were done in a long and often lonely siege of work in August and September, at a large stone palace owned by Twombly's friend Giovanni del Drago, overlooking the Lake of Bolsena, north of Rome. Though Twombly purposefully made the ground of these paintings an ocher-white to give them more warmth, the vitality of the seaside drawings was generally subdued, as the element of tumbling geometry and insistent analysis—measurement, segmentation—dominated the typical movement of their forms, from upper right to lower left. The sexualized energies of works around 1960 had defined this diagonal as an uphill course of leaping thrusts, but now, a decade later, it returned as a downward-spilling cascade. The shaping of that final imagery owed neither to beach life nor to the more somber scenery of the deep volcanic bowl around the lake at Bolsena, but rather to Twombly's preoccupation with the Apollo space flight that summer, which landed the first men on the surface of the moon, in July. All the talk of vectors, orbits, rocket segments, and distances in space filled his thoughts as he painted.

like coils of brittle wire extended in tangles, are stacked one above the other. A top row, relatively small, pale, and open, has beneath it a larger, more tangled, matching line of rolling strokes; and finally, the bottom half of the canvas is dominated by a swirling, triply worked tumbleweed cluster whose strokes encompass the height of a body. The increasing scale and intensity, combined with the particular tautness of the alternately stumbling, halting, and grandly sweeping strokes, give this work a sense of colossal address and absorbing drama. Standing before it can be akin to hearing a series of musical movements, each one a grander and more complex variation on the previous, an urgent, heroically shaped and slightly crazed crescendo.

The other of these two giants (pl. 78) is dramatically different in feeling: its edge-to-edge, top-to-bottom overlapping of layer on layer of open, running strokes creates a constant, all-over inscription of motion; it permits no comparable sense of developing time, and dissolves all ready reference to scale. Here, even more than in the earlier *Panorama* (pl. 23), the legacy of Abstract Expressionism is at issue: Twombly ventures into the area of an engulfing abstract sublime that Pollock had defined, and that had seemed off-limits to the art of the 1960s. The prospect of extending and remaking Pollock's legacy by changing everything deemed essential to his art might appear as perverse as the notion of a grand subjective expression built on Minimalist reduction, and yet both are here, remarkably realized. Twombly replaces the colored organicism of Pollock with colorless lines whose steady, progressive rise and fall insists on their attachment to the drier constraints of writing, will, and culture. Instead of the varied, looping

 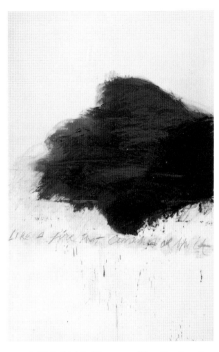

38. Cy Twombly. *Heroes of the Achaeans* (from *Fifty Days at Ilium,* painting in ten parts). 1977–78. Oil, crayon, and pencil on canvas, 6' 3½" × 59" (191.7 × 150 cm). Philadelphia Museum of Art. Purchased

39. Cy Twombly. *Achaeans in Battle* (from *Fifty Days at Ilium,* painting in ten parts). 1977–78. Oil, crayon, and pencil on canvas, 9' 10" × 12' 5½" (300 × 380 cm). Philadelphia Museum of Art. Purchased

40. Cy Twombly. *The Fire That Consumes All Before It* (from *Fifty Days at Ilium,* painting in ten parts). 1977–78. Oil, crayon, and pencil on canvas, 9' 10" × 6' 3½" (300 × 192 cm). Philadelphia Museum of Art. Purchased

FROM EPIC TO PASTORAL: THE LATER 1970s AND THE 1980s

After 1971, the dark-ground cycle ended, and Twombly began working much less frequently. Through the seventies and the eighties up to the present he has averaged only a few pictures per year, even when we include three multi-canvas ensembles. In part this reduced production owes to the time taken away by two extensive programs of architectural reconstruction: beginning in 1972, he restored as his first country home a decayed *palazzo* on the edge of the village of Bassano in Teverina, north of Rome in the area of the gardens of Bomarzo; and then in the late 1980s he partially gutted and rebuilt a hillside house in Gaeta, a port town on the coast between Rome and Naples. In these residences, the present "natural" and apparently venerable order was in fact won by labors of rearrangement that absorbed him, pleasurably, for more than a year in each case.

Still, such specific distractions cannot fully explain the overall slowing down, which is one instance of a general pattern of sharply varying production that has characterized his entire career. Twombly does not consider himself a "professional" painter, in the sense of someone whose life always centers on the work of making art; he feels no need to be in the studio regularly, and can happily go long stretches without a picture. Nor does he work comfortably within the clutter of daily existence: since reaching maturity, he has been predominantly a "summer painter," working only when the rest of the world leaves him alone. He has left most of the business and practical concerns surrounding his work in the hands of various dealers and friends in a close personal circle, while maintaining an almost archaic purity at the center of his life, with none of the usual trappings found around even moderately successful painters of a younger generation. With no studio assistants, no secretary, and no typewriter (much less a fax or computer), he answers his own phone, organizes his own studio, and paints (or doesn't) according to the pace he sees fit.

Brancusi is reported to have said, roughly, "It is not difficult to work; it is

difficult to get in the mood to work," and there is perhaps no artist for whom this holds more true than Twombly. His art brings little with it in the way of set compositions, prepared formulae, or determining tasks that can be carried over from one work to the next. An exceptional portion of its reason for being lies in the unstable emotion that can be made to live in momentary inflections of line, or in hesitations and erasures concealed or not. Precisely because this is an art that traffics in what appears to be casual, formless, and undisciplined, it may be one of the hardest to bring forth on any regular basis, with the level of saving tension and authentic engagement it requires. Twombly typically develops a slowly mounting readiness during periods of other activity (especially travel), and then, as he puts it, "gets into a state" to work, through focused periods of reading. Phrases or lines of poetry, jotted on studio scraps, become particular spurs to initiating a painting. In what some would consider indolence and others anxiety, this intuitive rhythm is one he respects and refuses to overrule.

Yet when the moment arrives to work, he may be seized with huge ambition, as his major project of the 1970s demonstrates. In the summers of 1977 and 1978, while preparations were under way for his retrospective exhibition at the Whitney Museum of American Art, he created, for the first time since *Discourse on Commodus*, an historical ensemble: *Fifty Days at Ilium*, a treatment in ten monumentally scaled canvases of the Trojan War as recounted in the *Iliad* (see figs. 38–40). He had broached this subject in a 1964 triptych (fig. 45), and one of its heroes, Achilles, had figured in a 1962 "portrait" (fig. 41). In opposition, though, to the triptych's busily detailed story of a battle clamorously waxing and waning, this series imposed a solemn drumbeat of iconically isolated moments, and in place of the spidery line and airy rhetoric of blood in the previous *Vengeance of Achilles*, it presented densely worked motifs on a heavily painted, wall-like surface. The formality and smooth glamour that had intruded on the *Commodus* ensemble is absent from *Fifty Days*. Instead it translates onto a monumental scale the elliptical address, the pleasure of line and writing, the magic resonance of the iterated name, and the evocative texture of surface that had marked Twombly's more intimate works since the days of *Olympia*. If *Commodus* sought to be grand, this effort reached for the epic, and—in part because of the intransigent simplicity of its unlikely means—reimagined that term more successfully.

The character of these paintings is fundamentally different from that of the works Twombly has made in Rome, and part of that difference may have involved his intuitive response to the environment at Bassano, where the canvases took over his normal studio and two adjacent rooms in the course of their

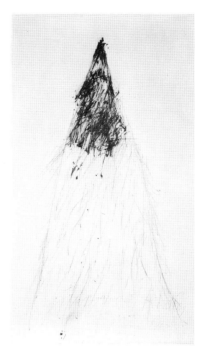

41. Cy Twombly. *Vengeance of Achilles*. 1962. Oil and pencil on canvas, 9' 10⅛" × 68⅞" (300 × 175 cm). Kunsthaus, Zurich

creation. Though these rooms open onto a light-filled vista, the building itself is immensely weighty and silent, with massive stone walls and a dark *gravitas* not found in the artist's urban home. For Twombly, the house has a "charge" that is conducive to painting.[169] Add to this its decor of fragmentary Roman sculptures and tapestries of military conquest, and the music of Wagner that played in the studio while he worked, and one has a propitious setting for a rumination on Hector and Priam.[170]

For direct inspiration, however, Twombly depended on the Alexander Pope translation of the *Iliad*, which he appreciates for its "frenzied energy" and "headlong forward rush"—qualities directly rendered as sweeping horizontal clatter in the 1964 attempt, but sublimated in the memorial, tombstone verticals of this group.[171] Pope's neoclassical version is far from the most faithful rendering of the story, but that matters little to the artist. A lover of antiquity, but precisely for that reason no antiquarian, he has often approached classical civilization

through the imaginations of intermediaries, whether through the Renaissance or later classical revivalists, Poussin being one obvious example. The act of translation, of reconceiving the past in contemporary terms and by this traduction insisting on its presentness—or in general of crossing over from one form of "language" to another to capture complex meanings—has been central to his pursuits.

As opposed to the 1964 exhibition of the *Commodus* pictures, the New York showing of *Fifty Days at Ilium* in early 1979 (at the Heiner Friedrich Gallery) arrived ahead of its optimum moment. A certain strand of bemusement ran through the critical response, as the whole enterprise seemed far away from the larger frame of contemporary artistic concerns; John Russell found analogies in modern opera or poetry, but had to look to nineteenth-century Salon painting for comparable themes on canvas.[172] Within a few years, the connections would have been more easily made: Anselm Kiefer's resurrections of both epic battles and ancient myths, and the specific involvement of younger Italians such as Sandro Chia with Mediterranean myth, would have shown the immediate "relevance" of Twombly's cycle to the art of the 1980s. His influence on painters such as Kiefer—as on Julian Schnabel's more operatic rephrasings of combined words and abstraction, or on aspects of Francesco Clemente's erotically elegant draftsmanship, and on other younger artists—would become steadily clearer throughout the eighties.

By the time the eighties' concern with history caught up with Twombly, though, he had already moved on, away from the realm of myths, bards, and battles toward water, sky, and flowers. He has always had what he calls a pastoral streak in his temperament, reflected in his love of Virgil's *Eclogues* and Spenser's *The Shepheardes Calender*; life at Bassano reinforced this. The land around the house and the (then depopulated) village was thoroughly rustic, and shepherds would come with tinkling bells on their flocks to play music on the hillside directly below the studio windows. Whether from these or other, internal cues, Twombly's art changed as he moved between his fiftieth and sixtieth years. For a long time his work had been so strongly marked by metaphors of the body and a concern for manmade surfaces that landscape acted only as a generic format or an abstract spatial stage. After 1980, a more specific imagery of nature began to appear, given less to upheaval in the manner of Kandinsky and more to atmosphere, enveloping effect, and contemplation, in the vein of Turner or Monet.

Twice in that decade, Twombly returned to the idea of a group of paintings made to be seen as an ensemble in one room; but instead of epic narration from history, the new subjects were ephemera of the seasons—roses, clouds, and reflections—realized not in the panoramic sweep of moving time and landscape, but in the stasis of vertical "portraits." In the major ensemble of the mid-1980s, an untitled five-part group, inscribed "Analysis of Roses as sentimental as despair" (see figs. 42–44), the former scarlets and carmines of blood became the red of the rose and lovers' poetry. This ensemble, now at The Menil Collection in Houston, found its chromatic complement in an entire room of green abstractions, very much under the spell of the water imagery of Monet's later life, painted for the 1988 Venice Biennale. Just as the *Fifty Days at Ilium* pictures were painted in the year before the Whitney retrospective, these green decorative canvases were made at the time a large Twombly exhibition was being prepared for Zurich, London, Paris, and Madrid, and represent a summation and closure of a certain line of inquiry.

A new quality in both 1980s ensembles is their liquidity, in one case in subject, but in both cases in material. We may think of Twombly primarily as a "dry" artist, more given to drawing than painting, and desiccating the organic smoothness of Pollock's or de Kooning's luscious surfaces. Fluidity and viscosity have nonetheless been basic concerns of his work technically and thematically from the earliest days, when his keen understanding of the use of material as meaning was already evident. One of his most enduring personal practices has involved working in wet areas of paint, and the nature of that meeting of hard and pliant elements has been a crucial variable: the texture of the paint as it dries, its density as a skin in resistance to the running pencil or crayon, its thinness as a veil over things below, the effect on it of gravity, all these factors informed and collaborated in Twombly's imagery of flux—spurting, streaming, spotting, and cascading—as an essential sign of life. This concept of flow is as important to the spirit of many of the grey-ground canvases, with their imagery of roiling turbulence, as it is to the more obviously geysering releases of the early 1960s. In the 1980s, though, Twombly's new vein of aquatic imagery tended away from such agitation, toward the evocation of profound depths and still, reflecting surfaces. In the untitled "Analysis of Roses" painting of 1985 (figs. 42–44), the thinned liquidity of paint itself became more and more pronounced, and gravity assumed full dominance over its streaked, dripping descent.

The major "story" picture of the decade, executed principally in 1981, was that of *Hero and Leander*, a classical legend of doomed love and tragic drowning which Twombly had found revived in a poem by Marlowe (pl. 91). The event is told in three panels, and in thick sea-greens mixing into foam whites; the wave that swallows and drowns the lover rises in its crest in the left-most canvas, at the beginning of the story, and then tails down to an expiring wash in the near-

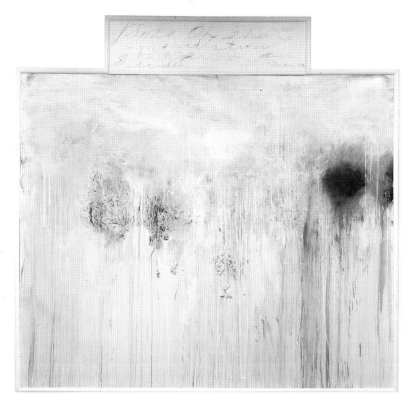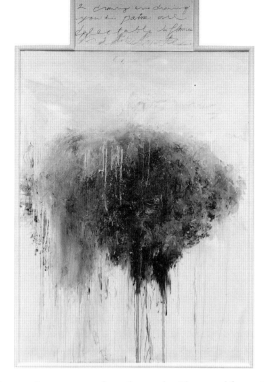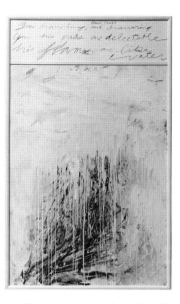

42–44. Cy Twombly. Three panels from an untitled painting in five parts. 1985. Oil, crayon, and cementite on canvas and wooden panels with engaged frames: 8' 3" × 9' 3¾" (251.4 × 283.8 cm); 8' 3" × 65¾" (251.4 × 167 cm); and 6' 1¼" × 46" (186 × 116.8 cm), with frames. Private collection. On loan to The Menil Collection, Houston

empty panel on the right.[173] The aftermath, and the return to a mournful peace, dominates the imagination of the tale. In such works, and finally, in the green decorations of the 1988 Venice "Monet" room and related canvases, Twombly's ongoing involvement with fluidity as a metaphor of life and spirit seemed to seek a level, in gentle melancholy and tranquilly oceanic absorption.

•

At the opposite extreme from the monumentality of *Fifty Days at Ilium*, the late 1970s also saw Twombly resume production of the small, makeshift sculptures that had been a recurrent adjunct of his work from the beginning (pl. 87). Nothing could seem further in spirit from the epic militarism of the paintings of Troy than these fragile constructions—including a slender wooden war chariot produced in the same period (pl. 84). Yet without putting more weight on this little vehicle than it can bear, we should see that its basic geometry is as indis-

pensable to understanding Twombly as are the massive canvases. He pursues such reductive simplicity of form, as many modern artists have, not because elemental shapes have more secure and firmly delimited meanings, but for the opposite reason: because basic shapes are more pregnant with possibility and contain within themselves the potential for many simultaneous allusions. We saw this in earlier paintings where looping 8s and circles often metamorphosed into erotically charged ideograms. Here, the simple opposition of a circle and a straight line conjures something elemental about thrust, directionality, and narrative flow; elsewhere, these associations expand further, and the chariot merges with a schematic phallic sign (see fig. 45). The point is not that the recurrent form, in any particular work, is only one or the other, but that its simplicity is such that it may evoke all (see pls. 85, 86). The lability of meaning in such simple forms entails the element of metamorphosis that Twombly is so drawn to in classical

45. Cy Twombly. *Ilium (One Morning Ten Years Later)* (painting in three parts). 1964. Part I: Oil, pencil, and crayon on canvas, 6' 6¾" × 6' 9¼" (200 × 206.3 cm). The Eli and Edythe L. Broad Collection, U.S.A. Part II: Pencil, oil, and crayon on canvas, 6' 6⅜" × 9' 5⅝" (199 × 288.5 cm). Private collection. On loan to The Menil Collection, Houston. Part III: Oil, pencil, and crayon on canvas, 6' 6½" × 6' 1¼" (199.5 × 186 cm). Private collection. On loan to The Menil Collection, Houston

myth: the fantasy, inspiring to his imagination, of the easy, weightless transformation of one thing into another. (In the case of the chariot specifically, the combination of the wheel and the flange or wedge may be, still in a playful spirit, a more personal symbol: the title he gave to one drawing of these shapes, *Anabasis* [pl. 85], refers to a legendary military drive from the coast of Asia Minor into the interior in the fourth century B.C., by the conqueror Cyrus the Younger.)

At another level, the "punning" of the chariot's particular shapes carries with it a familiar psychoanalytic concept by which armaments and aggression are linked to male sexuality, and the more general notion that underneath the welter of our technologies and languages lie some elemental exchanges between the desiring body and the productive mind. These kinds of verbalizations are, however, antithetical to the white simplicity of the toy, which "illustrates" nothing and says what it says wordlessly and with a strict avoidance of labored complexity.

This chariot, a wagon bearing flowers (pl. 87), and a slightly later boat (pl. 94) are based not only on the toys Twombly made and collected in his own childhood, but also on aspects of Egyptian art, which has been consistently undervalued as a part of the artist's connection with ancient cultures. Less full in the imagery of the body than Greek art, Egyptian imagery is far more attentive

to the particulars of flora and fauna, and its schemas for encoding trees, gardens, lakes, and so on had a relevance to Twombly's visual language beginning in the late 1950s. When he eventually visited Egypt, in 1962 and again in 1985, he was taken less with the gold masks of the pharaohs than with depictions of daily life in tomb paintings, and he focused especially on the humble miniatures of vehicles and furniture that crowd the less frequented vitrines in the Cairo Museum.[174] These fragile wooden structures, often painted flat white, suggest a complex overlay of associations among childhood, play, fantasy, and the immemorial element of hopeful magic that can underlie the simplest acts of marking and stick assemblage as well as the grandest monument of culture—the drive to cheat death by representing life. A confluence of these associations, and the symbolism of the lotus as a flower of transcendence and eternally renewed life, came together in the little flower wagon, which the artist originally made as a gift for Tatiana when she was seriously threatened by illness.

Connoting the child's ability to build rich fantasy worlds from simple shapes and found materials, such toys raise again the question of childhood and "childishness" as it applies to Twombly. As suggested earlier, he is far from being the first modern creator to look backward within both human ontogeny and human history for unspoiled and more elemental expressions. The more familiar modern

motive for that regression, however, has involved an urge to escape the chafing, decadent confines of high Western culture into a zone of more authentic "primitive" expressions; Twombly has a deeper affection for the vitality of that culture, from Homer through Rilke and beyond, and no such interest in chest-thumping "savagery." His interests in the links between childhood and adult expression come closer to Baudelaire's belief that "genius is only childhood recovered at will";[175] and his implied alliances between the ancient world and infantile experience may have their closer parallels in Freud. When we consider his splicing together of heroes from the *Iliad* with graffiti-like renderings, for example, we might think of Freud's similar push (most famously in naming the Oedipus complex) to show that the figures and structures of classical myths were coded expressions of immemorial, still-recurrent aspects of children's early sexual experience. Twombly's "regression" has less to do, though, with baring the roots of repression than with tapping the font of rejuvenating energy. For him, the quality of the infantile is central to understanding the sensual, instinctive dimensions, and the "irresponsibilities" which he feels are the grounds of a liberating affinity between aspects of his own temperament and Mediterranean culture.[176] There is a necessary and close exchange in Twombly's work between his affection for the venerable and timeworn and for the fresh and simple; in the fantasy of the work they fuse to their mutual benefit. His experience of the ancient world as continuously, sensually alive in layers of translation is in some senses consistent with a lush decadence properly called Alexandrian, and it needs constant refreshment by his parallel love for a crude, naive, and uninitiated manner of expression.[177]

FLOWERS AND LIGHT: GAETA, 1990–

Like the simplicity of the child, the floral motif in Tatiana's toy wagon has been a matter of deepened importance to Twombly in the past decade. In the mid-1970s, he made two collages, *Apollo and the Artist* and *Mars and the Artist* (pls. 82, 83), in which a blossom represents the creative spirit. No evidence of such pointed symbolism is needed, though, to see how flowers have become meaningful for Twombly in recent works. This artist began his career with a deeply aesthetic feel for human artifacts which had been buried and corroded, and he continued throughout most of his work to manifest a love for all that was worn, scarred, and enduring. Now, past sixty, he has come to a fascination with the most delicate and ephemeral form of beauty, a sign not of survival but of renewal, that comes out of the ground not to bear witness to past time but to seek the sun (pls. 111–16).

Both in sculpture and in painted works on paper, Twombly has been especially drawn to a motif of flowers emerging on spindly stalks from a massive mound of earth (pls. 115, 116). In the sculpture *Thermopylae* (pl. 115), one might read a specific reference to the Spartan king Leonidas and his elite troops who, after carving their testament in rock, gave their lives in battle against the invading Persians to hold the mountain pass at Thermopylae so that Greece might survive. What Twombly has inscribed upon his "rock," however, are lines from the poem "Thermopylae" by the modern Greek poet C. P. Cavafy, which invokes the ancient legend metaphorically, in honor of all those whose personal integrity is shown in the self-sacrificing defense of ideals, even in the face of impossible opposition.[178] The motif exists independently of either reference, though, and like all Twombly's signs, mutates and acquires new meanings as he uses and reuses it. In the very similar motif of *Summer Madness* (pl. 116), for example, the frailness of radiating stems against an obdurate mass of earth, so much at issue in the sculpture, is no longer seen amid the riotous blossoming of color.

Early in his career, Twombly had given up the brush for the pencil to suppress virtuosity and gain a childlike immediacy; in *Summer Madness* and related groups of flower drawings from the last few years (pls. 110–14, 116), he has pursued the same goal, in reverse. Smothering the fine linearity that has been the most personal essence of his work, he has adopted the broad daubs and bright colors we associate with the kindergarten paint pot. For a theme of freshness and renewal, nothing stale or practiced would do, but only a reconquered "beginner's" simplicity.

•

These recent flower drawings have been executed in other places, such as the Seychelles islands, but their heightened color and vertical energies are linked to the home Twombly established in Gaeta, only a few miles from Sperlonga, in the late 1980s.[179] Twombly's white-stuccoed house there has an entirely different character from the stone Renaissance palace in Bassano: clinging to a hillside, it has been built in the organic fashion of a small village of intimate spaces, courtyards, and gardens on several levels, and it seems to look less to Italianate grandeur than to the vernacular of the Greek islands or North Africa. Above all, it and its environment are brighter and lighter, and Twombly paints in a breezeway room next to tall windows overlooking the full sweep of the harbor of Gaeta, a legendary port in antiquity, where boats of all sizes and kinds still come and go throughout the slightly misty warmth of the day. Though this increase in brightness and noise worries him as a possible distraction from his work, the proximity to the sea has also been rejuvenating. One need only compare two smaller drawings of

flowers from Bassano (pls. 113, 114) to *Summer Madness* (pl. 116), done at Gaeta, to measure the increase in luminosity and hue this new setting has encouraged. Beside this bay over the last few summers, Twombly has also produced several freshly conceived paintings on an impressive scale (pls. 117, 118, 120, 121–23).

Two of them revive several of the elements of earlier work: most evidently, the white ground and pencil writing, but also handwork with paint in bright yellow, red, and blue (pls. 117, 118). With these turns against the monochrome imagery of a few years previous, Twombly celebrates light and air: working in color principally on the edge of the large field, he evokes an openness that suggests sky more than sea, and regains the sense of floating or uplift that had been submerged in the "aquatic" work of the 1980s. The vertical "portrait" format once given most often to frontal, iconic subjects now receives some of the dispersal, and omnidirectional movement, of landscape; standing before them, one has the sensation of looking into the central, cloud-surrounded spaces of an eighteenth-century ceiling painting. That sense of flight and of floating reverberates in the inscription on one of the works—"Victory / outside, an amazing space / on the other side of / Air" (pl. 118)—while both canvases are inscribed with a more ambiguous reference to zephyrs and flight as cautionary spiritual metaphors, in Baudelaire's confession, "I have felt the wind of the wing of madness."[180] These phrases conjure both exultation and foreboding, achievement and anxiety, and thus add to the difficulty of defining the mood of the pictures—for despite the abundance of air and light (visually as well as thematically), the two works have a streaking downward pull to the richly dripping surface that undercuts the rhetorical boldness of the broad, scrawling script.

A repeated painted motif in one of the works (pl. 117), spouting color at both ends, may recall the lusty, spraying tubes that reigned from 1954 into the early 1960s. Canceled with downward lines, however, the form also becomes a code for a boat with oars—a form as simplified as the homemade toy boats the artist collects, and as basic as the representations on Greek vases and in Egyptian tombs. The "barge" he made in Luxor is its ancestor (pl. 94), and more recent experiments in simplified forms of modeled sculpture are its immediate companions (pl. 119). Compared to the chariot of military thrust and narrative progress, this is an ambivalent icon. It is on the one hand an appropriate sign for an inveterate traveler. On the other, such barges and barques which ferry to the other side are, as vehicles of transition, also frequent emblems of the voyage from life to death. It is this elegiac implication which seems to dominate another of Twombly's most recent paintings, where the boat with its oars in a resting position forms the central motif (pl. 120). The piece is inscribed with several lines

and fragments from three poems by George Seferis. Above, on the right side, Twombly has written: "years ago you said: / Fundamentally / I am a matter of Light"; and below: "(The light is a pulse / continually slower and slower / you think it is about to stop)."[181]

•

Despite such intimations of mortality, Twombly's art is certainly not about to cease. In 1994 he brought to conclusion a monumental new series, *The Four Seasons* (see pls. 121–24), on which he had been working for almost two years. He thinks of the series as beginning not with the fresh promises of April, but with the richer mellowness of October; the deep reds and purples of the *Autumn* canvas (pl. 121), and its outpouring of energy, resonate with the intoxication of the yearly wine festivals at Bassano, where the series was initiated. The panels *Winter* (pl. 122) and *Spring* (pl. 123) both continue the motif of the "ship" from previous Gaeta canvases, but each in a sharply separate spirit: somber, in the deep black, chilly white washes and stately, tough rhythms of the former, densely layered with lines of poetry from Seferis; more soaring and open, with brighter space and warmer hue, in the latter. Flowers and sun-warmed lyricism naturally attend *Spring*, but Twombly has also been reflecting on Stravinsky's *Rite of Spring*, and its inflections of more rasping sharpness, in his choice of color combinations. *Summer* (pl. 124) is the most purely abstract and most liquid of these tall and exceptionally (within Twombly's career) vertical canvases. An image of engulfing heat, it sets notes of fiery red within a field of humid, dripping yellows and whites—evoking, by a Turner-like density of water-laden atmosphere, the lassitude of torrid days beside a sun-dazzled sea. The subject of the seasons' cycle is, of course, traditionally associated with quiescent or even melancholic retrospect; but the grand scale and ambition of these canvases speak more forcefully of new confidence and freedom—savoring the pleasures and mournfulness of each part of the turning year, but drawing special energy of renewal from the season of Silenus, heady with autumn's deepened wine and the sustenance of the harvest already gathered. As he approached the inauguration of a special building dedicated to a survey of his work, at The Menil Collection in Houston, Twombly further applied these energies to the completion of three sections of an enormous untitled painting (13' 1½" × 52') that had been in the works for years, under the alternative titles *The Anatomy of Melancholy* and *On Wings of Idleness*.

A final assessment of this already tremendously distinguished career will thus, happily, have many more developments to account for. At this moment in a long and wonderfully productive life in art, however, Twombly's work already

has given us far more than can be readily articulated, or trapped within the ready categories of contemporary criticism. Certainly it gives the lie to the shopworn notion that modern art advances by a series of ever more drastic breaks with the high traditions of Western culture. Beginning with Cézanne's ambition to "redo Poussin after nature," modern artists have been consistently motivated by the desire to reformulate the admired values of the past, and of great traditional art, in terms that would make them come alive to the eyes and sensibilities of our own time. Twombly belongs fully to this lineage; his efforts to rescue the classical world from the confines of academicism and translate it into the present tense extend a pursuit that has concerned modern Western culture from the time of the French Revolution. Since Léger's metallic rigor followed closely on Matisse's visions of arcadian abandon (if not since J.-L. David painted *The Oath of the Horatii* and the *Portrait of Madame Récamier* in swift succession), it has been clear that the modern imagination of antique "simplicity" entails two contrasting fantasies, of armored idealism on the one hand and of ungirded, "natural" sensuality on the other. Twombly's art includes, but polarizes, that dichotomy. Spare austerity is moved higher, aestheticized into a poignantly fragile, personal poetics, in the unornamented, scrawling invocations of Apollo and Achilles; while natural candor is moved lower, out toward scarred public walls and transgressive affirmations of nether-body life. Too aristocratic and at the same time too demotic, the results refuse either to buttress bourgeois idealism or to flatter bourgeois pleasures in any familiar fashion. They want a sense of revived classicism, and of modern life, that operates outside those bounds.

That rebellion has its more immediate context in Twombly's personal tussle with his elders and his surroundings. As a young man, he inherited the challenge of an avant-garde that sought the values of an ancient mythology and the universal fundamentals of culture by drawing on each artist's individual, inner resources. It seemed that his prime goal in maturing was to kill off this darkly heroic notion in painting, and to replace it with something more impersonal, grittily debased, dry, and insistently hostile to such idealism. Yet he used the new art he created precisely to reforge, in a wholly different poetics of light and sexuality that was specific to his experience, the link between the heritage of the human past and the life of a personal psyche.

In this pursuit Twombly has at times cited, and must in some sense identify with, Goethe, Keats, and other visitors to Italy from the North—artists who have contended with the link between a mind full of Romantic ideals and a body touched by unaccustomed warmth, and with the tensions between distanced understanding and the lure of decadence. Closer in time, he may share loose bonds of affinity with Joyce, in the effort to fuse antiquity's epic spirit with the slang, raw data, and fragmented time of modern experience; the headlong run of *Finnegans Wake*, with its metamorphosing overlays of language and its covert combinations of earthiness and erudition, seems particularly relevant. Perhaps the most obvious and most telling of the frames of reference in which we should consider the work, however, involves Twombly's place within the long dialogue between America and the European tradition.

The American lineage Twombly most admires is that shared by Whitman and Pollock; his idea of genius is exemplified by their model of troubled psychic energies transcendently externalized into a flood of all-leveling emotive lyricism. One part of his effort as an artist has been to put together their sense of *now* with a European sense of *then*, wedding appetite to taste, and the raw permissions of innocence to the knowing tolerances of sophistication. His willed naiveté, erudite but never false, draws on a fantasy of living in high refinement and at the same time in great, unprejudiced indulgence, experiencing the tremendous force of human time and cultural memory not as a snobbish burden but as a focusing, liberating, confirming presence within the immediate apprehension of sensual life.

As he pulls together the fresh and the ancient, Twombly deals simultaneously not only with opposite spheres of culture, but with upper and base body functions as coexistent and interdependent. It would be wrong, though, to credit the art with bringing these disparate things together: they are together, always, even if other orders of art do not allow for their collisions or coexistence. Nor does the work "represent" their intersection: as does a great deal of modern art, it adds something apparently gratuitous and disorderly to the world, by presenting marks, colors, words, and signs in a unique array that we are then challenged to match with our understanding of the world's possibilities. In this fashion, for almost a century now, new parameters for art have been constantly re-formed, and private obsessions have created public languages that have widened the domains of feeling accessible to us. Twombly's work, and our response to it, involves acts of faith in this modern experiment to renew a basic magic of art, immemorial, endlessly uncertain, and always open to discovery. For all the complex linguistic structure of his aesthetic and the rich web of his references, what his achievement may ultimately depend upon most heavily is the power he has drawn from within himself and from so many enabling traditions, to isolate in a particularly raw and unsettled fashion that primal electricity of communication, in his apparently simplest acts of naming, marking, and painting.

He reminds us, too, that under the skin of modern art's parsimony, its constantly renewed urge to see what it can do without, lies a matching and par-

allel aspiration toward globally expansive forms of idealism. The two have gone hand in hand through the century, and the panoramic range of subjects and areas of emotion mapped out by Twombly's reduced means—reaching from atonal barrenness to grand opera, and enfolding along the way idle anxiety, obsession, explosive eroticism, epic heroism, melancholy, and pastoral idyll—reconfirm the possibility that art can pull the fullness of the world back in through portals of the most stringent simplicity.

•

Twombly's work, of course, "illustrates" none of this. It has no calculated political agenda and is made according to no historical strategy. It has created and still creates its own justification, which our explanations threaten only to belabor or artificially delimit—as I was reminded on my last visit to the artist's silent and empty studio at Bassano. Ruminating on the nail holes and flecks of paint on the stone walls and floors, the remnants of works long since gone to other corners of the world, I saw the edge of a paper scrap, with writing on it, jutting from beneath a stack of boxes of crayons and oil sticks. Uncovering the paper and turning it over in the slant of afternoon light through the half-closed shutters, I picked out a rising and falling graphite script in cursives and capitals, mingled into obscuring smears and casual splatters of color (fig. 46). Finally I made out the line; it is among the least poetic, perhaps, of many that have struck this most literate yet least literal of artists, but it is tersely apposite for every writer about art, and as penciled on this fragment it seemed at that moment the embodiment of its own truth.[182] In crude imitation of an inimitable orthography, we would print it as: "The Image cannot / be dis possessed of a / prIMORdial / freshness / which IDEAS / CAN NEVER CLAIM."

46. Cy Twombly. Untitled (Studio Note). c. 1990. Pencil and paint on paper, 4¾ × 6¾" (12 × 17 cm). Private collection

NOTES TO THE TEXT

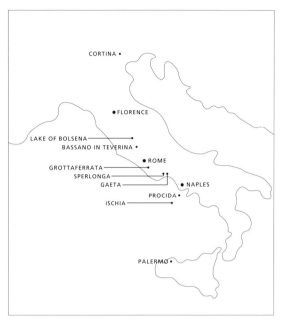

47. Map of Italy including sites where Cy Twombly lived or worked

The standard reference texts for Cy Twombly's paintings are the two volumes prepared by Heiner Bastian: *Cy Twombly: Catalogue Raisonné of the Paintings,* vol. I: *1948–1960* (Munich: Schirmer/Mosel, 1992), and vol. II: *1961–1965* (Munich: Schirmer/Mosel, 1993). In the present publication, references to the catalogue numbers in those volumes are preceded by the abbreviations *Bastian I* and *Bastian II.*

There are three principal archival sources for Twombly's career up to the early 1960s: (1) The Virginia Museum of Fine Arts has a file containing correspondence, applications, and letters of recommendation relevant to four applications Twombly made for fellowships. The first two applications, in 1950 and 1952, were successful, and the files therefore include extended correspondence with Twombly regarding his use of the grants; the latter two, in 1955 and 1956, were unsuccessful. All material cited in connection with these applications and fellowships, including the artist's statements, letters of recommendation, and correspondence during the tenure of his two grants in 1950–51 and 1952–53, is in this file, unless otherwise indicated. (2) Correspondence between Twombly and the dealer Eleanor Ward in the years 1955–58 is preserved (but not yet microfilmed) among the Eleanor Ward Papers, at the Archives of American Art, Smithsonian Institution, Washington, D.C. All cited letters between Twombly and Ward are among these papers, unless otherwise indicated. (3) The archives of Leo Castelli preserve correspondence between Castelli and Twombly, beginning in early 1959 and continuing through the 1960s. All cited letters between Twombly and Castelli are in this archive, unless otherwise indicated.

All information cited as "conversation with the artist" is based on notes taken by the author during informal discussions with Cy Twombly in Rome, Bassano, and Gaeta between June 1992 and July 1993.

1. The remark attributed to Degas, "Je voudrais être illustre et inconnu," is cited in Françoise Sevin, "Degas à travers ses mots," *Gazette des beaux-arts,* ser. 6, vol. 86 (July–August 1975), p. 44, quotation no. 341. My thanks to Theodore Reff for his help in tracking down this reference.

2. Conrad Marca-Relli, from a letter of recommendation he wrote in connection with Twombly's application for a fellowship in 1955. See note 99, below, for a fuller citation of this letter. A copy of the letter is in the Eleanor Ward Papers.

3. See the headnote, above.

4. An article written on the occasion of Edwin Parker Twombly, Sr.'s retirement as athletic director of Washington and Lee University offers these details of his baseball career: He started playing semi-pro baseball at the age of fourteen. In 1917, after beginning his college education at Lehigh, he spent spring training with the St. Louis Cardinals, and was signed to a contract by Branch Rickey, but then the war and military service intervened, and after that Mr. Twombly decided to finish his education (at Springfield College) and did not follow up on the contract. He graduated in 1921, and pitched for the Chicago White Sox that summer. Immediately after his marriage, in the autumn of 1921, he took a coaching job at Washington and Lee, which precluded his participation in 1922 spring training. His contract was therefore sent to Minneapolis, where he did not wish to play, and he then had himself optioned to Danville in the Piedmont League. The article relates that during his career, "he played with or against players like Walter Johnson, Tris Speaker, Babe Ruth and Ty Cobb" ("Twombly Has Not Regretted Giving Up Big-Time Baseball for College Work," *Lexington* [Va.] *News-Gazette,* March 26, 1969).

Another, undated article (apparently from a Massachusetts newspaper in 1969), in the possession of the artist's sister, specifies that after his stint in the major leagues Mr. Twombly continued to pitch during the summer with teams in Danville, N.H. (1922–23); Manchester, N.H. (1924–25); Newark, N.J. (1926–27); Providence, R.I., and Worcester, Mass. (1928–29); and Lewiston, Maine (1930).

5. The artist's father, Edwin Parker Twombly, Sr., was born in Groveland, Mass., June 15, 1897, and died December 3, 1974. His mother, née Mary Velma Richardson, was born in Bar Harbor, Maine, May 11, 1897, and died December 28, 1988. They were married September 13, 1921. The artist has one sibling, a sister, Ann Leland, four years older. In regard to Twombly's later involvement with classical culture, it should be noted that his older sister studied classical languages extensively, through eight years of Latin courses and six years of Greek. His father, who knew Latin, would joke with the artist's sister in Latin (conversation with the artist).

6. The artist's father was hired as a golf and swimming coach at Washington and Lee in 1921. During his long tenure there, he also coached football, basketball, and baseball. From 1954 to 1969 he served as athletic director, and remained as golf coach after his retirement. In the Doremus Gymnasium complex at Washington and Lee, a swimming pool is named in honor of him.

7. Thomas Jonathan ("Stonewall") Jackson taught natural philosophy and artillery tactics at the Virginia Military Institute for ten years before the outbreak of the Civil War. The bullet-pierced coat he wore

at the battle of Chancellorsville, and the stuffed remains of his war horse, are enshrined in the V.M.I. Museum. The local cemetery where he is buried is named for him. Robert E. Lee took over the presidency of what was then Washington College in 1865, less than six months after the surrender at Appomattox. The Robert E. Lee Chapel in Lexington includes a recumbent effigy of the general, and his horse is buried just outside. V.M.I. cadets were during Twombly's youth under orders to salute on passing the chapel.

8. Conversation with the artist.

9. Conversation with the artist's sister, Ann Leland, December 1993. In the speech read at the conferral of Twombly's honorary Doctor of Fine Arts degree by Washington and Lee University on June 4, 1993, it was said that "Mary Monroe Pennick once recalled that his talent was apparent even in high school, and she put him to work creating backdrops and set designs for musical productions."

10. Twombly took private lessons from Daura for four years, until he graduated from high school. Daura's wife, Louise Blair, studied the cave art of prehistory and—in the 1940s, when the first photographs of Lascaux paintings began appearing—may have helped fuel Twombly's fascination with the primordial signs of art (see below). On Daura and his wife, see Virginia Irby Davis, *A Retrospective Showing of Works by Pierre and Louise Daura* (Lynchburg, Va.: Lynchburg College, 1990). Daura had a joint exhibition with Jean Hélion (also residing in Virginia during the war) at the Virginia Museum of Fine Arts in Richmond in 1942.

There is virtually no published record of Twombly's work at this time, though he did show it. The artist's 1950 application for a grant to support his study in New York included the notice: "Exhibited three paintings in the Scholastic Art Show in Richmond while in High School / two paintings have been published in the Washington and Lee literary magazine" (see note 20, below).

11. Sheldon Cheney, *A Primer of Modern Art* (New York: Tudor Publishing Company, 1939). This was the tenth edition of a work originally copyrighted in 1924.

12. Between high school in Lexington and the studies in Boston, Twombly spent one year at the Darlington School, a college preparatory school in Rome, Ga. He also spent the summer of 1947 with an aunt in Ogunquit, Maine, where he came in contact with a summer colony of artists and painted "abstract seascapes" (conversation with the artist).

The choice of the School of the Museum of Fine Arts may have been influenced in part by family ties, as Twombly could live in an unoccupied caretaker's apartment in his grandfather's Boston home while attending the school—night classes in his first year and daytime classes in his second. On his 1950 application for a Virginia Museum fellowship (see note 20, below), Twombly listed his courses at the Boston school as "perspective, anatomy, design, drawing, History of Art, painting, and sculpture."

13. On art in Boston in this era, see Frederick S. Wight, "New England," *Art News*, vol. 45, no. 9 (November 1946), pp. 16–21; and Piri Halasz, "Figuration in the '40s: The Other Expressionism," *Art in America*, vol. 70, no. 11 (December 1982), pp. 110–12, 145, 147. My thanks to Thomas McDonough, who provided these references in the context of a seminar paper for the Institute of Fine Arts, New York University, autumn 1993.

14. From December 1985 through June 1986, The Institute of Contemporary Art in Boston presented three anniversary exhibitions which examined its history. The first of these was titled "The Expressionist Challenge." The press material released by the Institute on October 1, 1985, summarized the exhibition's thrust succinctly as

follows: "During the '30s and '40s the ICA mounted several exhibitions of Northern European Expressionists including the first major exhibitions in America of Kokoschka, Munch, and Ensor and an exhibition of artists whose work was forbidden by the Nazi government in Germany. These shows bespeak a strong cultural exchange between Boston and Northern European cultures. Unlike institutions elsewhere, notably in New York, the ICA chose Expressionism rather than Cubism, Surrealism and de Stijl as the European cornerstone of international modernism. This choice has had a major impact not only on Boston's artistic community, but also on the nation's introduction to modern art."

For further discussion of the situation in Boston at the time, and particularly the issue of the relationship between the Institute and The Museum of Modern Art, see Serge Guilbaut, "The Frightening Freedom of the Brush: The Boston Institute of Contemporary Art and Modern Art," in *Dissent: The Issue of Modern Art in Boston* (Boston: The Institute of Contemporary Art, 1985), pp. 52–93.

15. On Hyman Bloom's possible impact on Twombly, see Robert Rauschenberg's mention of early Twombly works called "Chandeliers" and "Torahs"—titles closely associated with Bloom's work—in note 44, below. On Karl Zerbe, see "From Hitler-Land to the American Scene," *Art Digest*, vol. 8, no. 15 (May 1, 1934), p. 15; H. W. Janson, "Karl Zerbe," *Parnassus*, vol. 13, no. 2 (February 1941), pp. 65–69; "Boston's Karl Zerbe: A Generation of Influence," *Art Digest*, vol. 26, no. 2 (October 15, 1951), p. 13; Frederick S. Wight, "Zerbe Paints a Picture," *Art News*, vol. 50, no. 10 (February 1952), pp. 26–29; and Horst W. Janson, "Obituary," *Art Journal*, vol. 32, no. 4 (Summer 1973), p. 486.

In March 1948, Max Beckmann showed recent paintings at the School, and had his "Letters to a Woman Painter" read to a student audience during his visit (see *Museum of Fine Arts, Boston: Seventy-third Annual Report, for the Year 1948* [Boston: T. O. Metcalf Co., 1949], pp. 75–76). The Beckmann letter was published in *College Art Journal*, vol. 9, no. 1 (Autumn 1949), pp. 39–43.

Oskar Kokoschka then had a major exhibition at the Institute in the autumn of 1948, and visited the school in January 1949. He lectured on January 25, 1949 (see *Museum of Fine Arts, Boston: Seventy-fourth Annual Report, for the Year 1949* [Boston: T.O. Metcalf Co., 1950]).

My thanks to Thomas McDonough, who provided these bibliographical citations in the context of a seminar paper for the Institute of Fine Arts, New York University, autumn 1993.

16. Conversation with the artist. Twombly remembers a phase in the late 1940s when he painted "like Soutine, only crazier." This period of involvement with Soutine may have actually come later, or lasted into 1950. In that year, when Twombly was in New York, a Soutine retrospective was shown at The Museum of Modern Art. See among other references the article by the painter Jack Tworkov, "The Wandering Soutine," *Art News*, vol. 49, no. 7, Part 1 (November 1950), pp. 30–33, 62. Tworkov was a close associate of Willem de Kooning's, and Twombly remembers with pleasure that during a visit to de Kooning's studio, he saw the same book on Soutine which he himself had treasured. More important, perhaps, Tworkov also became a friend and supporter of Robert Rauschenberg in the early 1950s; through this connection, his enthusiasm for Soutine could certainly have been communicated to Twombly, if only to reinforce an affection already formed.

17. The references to Twombly's early experiences of Schwitters and Giacometti are both from a conversation with the artist. In an unpublished paper for a seminar at the Institute of Fine Arts, New York University, autumn 1993, Thomas McDonough points out that

Schwitters's death in 1948 initiated a period of revived interest in his work. Carola Giedion-Welcker published "Schwitters: Or the Allusions of the Imagination," in *Magazine of Art*, vol. 41, no. 6 (October 1948), pp. 218–21; and the artist's first one-person show was held, from January 19 through February 1948, at the Pinacotheca Gallery in New York.

18. From Twombly's application for the Catherwood Foundation Fellowship in 1956; see note 99, below.

19. On Marion Junkin, see *Marion Montague Junkin, 1905–1977*, the catalogue of a memorial exhibition presented by Washington and Lee University, January 8–February 2, 1979, and especially the biographical essay by Pamela Hemenway Simpson, "Marion Junkin, 1905–1977." Junkin's massive mural *The Struggle for Intellectual Freedom*, completed in 1952, is in the School of Commerce, Economics, and Politics.

20. Daura's letter is dated May 6, 1950; Junkin's, May 10, 1950. Junkin's letter includes the following:

He is by all odds the most promising young artist I have had in the past ten years.... Twombly has been painting and drawing from about the time he could walk. His first formal training was with Pierre Daura, in his private class. Later Twombly went to the Boston Museum School for two years and this past year he has been a special student at Washington and Lee. He has not only been the leader of the art class but has helped teach the adult and children classes offered to the townspeople of Lexington. In the matter of art knowledge and history Twombly knows his field very thoroughly and is interested in the modern direction of creative art yet has not shown any great tendency to be carried away with any particular ism....

Note that none of Twombly's early, student work has been published in any of the catalogues or books devoted to his career. *Shenandoah*, the literary magazine of Washington and Lee University, published a reproduction of one study of a woman's head, titled *Julie*, in the summer issue of 1950 (vol. 1, no. 2). In the previous issue (vol. 1, no. 1), Marion Junkin had been asked to submit three representative examples of work from his new class, and submitted an *Abstract Composition* by Twombly; the latter, also illustrated in the magazine, is recorded as Bastian 1, no. 1.

21. Letter to Leslie Cheek, Jr., Director of the Virginia Museum of Fine Arts, September 27, 1950:

The League is full of diverse talent—and I learn as much from watching the students work as I do from the instruction—Barnet and Kantor are both sensitive and sound teachers—and I feel they were a good choice. I draw from the model for an hour each morning—then paint the rest of the period and afternoon. At nite I usually work on small tempera compositions. Sat. there are no classes so I have a chance to go to the galleries....

22. Letter to Leslie Cheek, Jr., January 21, 1951. Twombly has since made clear that he had virtually no contact with Stamos or Gottlieb.

23. According to the chronological notes Twombly prepared for Heiner Bastian (see *Cy Twombly: Catalogue Raisonné of the Paintings*, vol. II: *1961–1965*, p. 276), during his time at the League, he was able to see at first hand shows or work by Jackson Pollock, Mark Rothko, Barnett Newman, Clyfford Still, and Robert Motherwell, and to see for the first time, at the Charles Egan Gallery, works by Willem de Kooning and Franz Kline.

In a letter to Leslie Cheek, Jr., April 30, 1951, Twombly assessed his experience at the League:

My only objective this year has been the developing of my art. This process depended largely on work, but also on the sound suggestions of my teachers at the League, the stimulation by the students, and the inspiration of coming in contact with so much art of all periods.

Under these conditions my painting has developed beyond my own

hopes for a year's work. My direction has become consistent and more personal—being in the realm of semi-abstraction and abstraction—simple in form and color with great stress on movement and power.

My new work is a long way from the poetic portraits and landscapes of last year....

24. Conversation with the artist.

25. Letter to Leslie Cheek, Jr., March 27, 1951:
Have had a productive period in painting the last few months. I wish I had photographs of some of my things to show as it is hard to explain in a letter.

Kantor is using two of my pictures in a group show at the League the 1st of April.... I have a chance to have a one man show next season but I feel it's too early yet to think of that.

26. On Rauschenberg in these years, see Walter Hopps, *Robert Rauschenberg: The Early 1950s* (Houston: The Menil Collection, 1991). Rauschenberg appeared with his wife in an article dealing with their blueprint works: "Speaking of Pictures," *Life*, April 9, 1951, pp. 22–24.

27. The statement about shared interests is from a conversation with the artist.

Compare Twombly's untitled sculpture of 1947 (pl. 2) with the sculpture assembled from a pole and two Chianti bottles, *The Man with Two Souls*, shown by Rauschenberg in his joint exhibition with Twombly at the Stable Gallery in 1953 (Rauschenberg's sculpture is illustrated in Hopps, *Robert Rauschenberg: The Early 1950s*, p. 55). In January 1952, Charles Olson, the rector at Black Mountain College, described assemblage sculptures Twombly made from found materials—sculptures that seem to anticipate Rauschenberg's fetish pieces in Rome, or even more pointedly his rock and string pieces in New York in 1953: see note 63, below.

28. Letter (sent from Lexington, Va.) to Leslie Cheek, Jr., June 11, 1951: "... I hope to go down to Black Mountain College for July and Aug—to study with Ben Shahn and Bob Motherwell."

29. On Black Mountain generally, see Martin Duberman, *Black Mountain: An Exploration in Community* (New York: E. P. Dutton, 1972); and Mary Emma Harris, *The Arts at Black Mountain College* (Cambridge, Mass.: MIT Press, 1967). For a specific account of the college at the time Twombly attended, see Francine du Plessix Gray, "Black Mountain: The Breaking (Making) of a Writer," in *Adam and Eve in the City* (New York: Simon & Schuster, 1987), pp. 323–34. See also the discussion of Rauschenberg's and Twombly's time at Black Mountain in Hopps, *Robert Rauschenberg: The Early 1950s*, pp. 62–71.

30. According to Twombly, Motherwell conveyed the impression that he was there for the summer to relax, and did not want to see other painters. This antipathy toward fellow artists became especially clear when Motherwell had a party to which he invited everyone in the summer session except Twombly and Rauschenberg. Twombly remembers that when Ben Shahn asked him which painters he liked, he said: "De Kooning and Ingres." When Shahn said in reply that he thought that split in tastes was schizophrenic, Twombly cited the early de Kooning drawings of his wife, Elaine, as being like Ingres in their neoclassicist linearity (conversation with the artist). Rauschenberg also remembered that Twombly was the "darling" of Ben Shahn during this summer (conversation with the artist).

31. Rauschenberg owns an early collage by Twombly that includes as its central motif an unfolded cut-paper element which is symmetrical, or nearly so, top to bottom and side to side, somewhat in the fashion of a Rorschach blot.

32. Letter to Leslie Cheek, Jr., April 30, 1951 (see note 23, above).

33. See note 10, above.

34. Letter to Leslie Cheek, Jr., November 26, 1950:

My work goes on. It has changed quite a bit since the paintings you saw in Richmond (for the better I hope). I've been very interested in the primitive art of the American Indian—of Mexico and Africa. So much art looks affected and tired after seeing the expressive simple directness of their work. There is a wealth of material to see in the way of art here—It will probably take me several months after I leave to organize and revaluate what I've seen....

Rereading this letter in 1994, Twombly affirmed by way of clarification that he was never seriously attracted to or influenced by Native American art.

35. From the statement Twombly wrote in his application for a travel grant in 1952; see note 48, below.

36. The identification of "Luristan bronzes" as the source of the motifs in these paintings was made by the artist. This term has in the past been rather loosely applied, and often used to include works not actually identified with the Luristan area in Iran. The harness-rings, bits, and bridle ornaments, which seem to have the kind of symmetry and surface Twombly appreciated, date from the tenth through the seventh century B.C. They are figurative works, often involving struggles between men and animals, but Twombly's abstract work does not show directly this representative, religious, or expressive dimension.

37. Olson, "Cy Twombly" (1952), in *Cy Twombly: Poems to the Sea* (1959), p. 4. Note that, in the original text, where Olson is comparing paintings with sculpture and architecture, the word "paintings" in this sentence is italicized. I have removed the emphasis for present usage. Olson's interest in "glyphs" and excavated things was doubtless directly connected to his fascination with the ancient Mayan civilization, which he had been studying in Mexico just prior to his encounter with Twombly at Black Mountain. See Tom Clark, *Charles Olson: The Allegory of a Poet's Life* (New York: W. W. Norton, 1991), especially chapters 14–17.

38. From Twombly's application for a Catherwood Foundation Fellowship in 1956; see note 99, below, for the full text of his statement.

39. Conversation with the artist.

40. References to male and female categories of these early works from a conversation with the artist. Suzanne Delehanty also mentions discussing with the artist male and female categories in his later work, in "The Alchemy of Mind and Hand," in *Cy Twombly: Paintings, Drawings, Constructions, 1951–1974* (Philadelphia: Institute of Contemporary Art, University of Pennsylvania, 1975), p. 20.

Even the physical "skin" of the paintings' surfaces may have been thought of as having an erotic association: when asked to recall Twombly's work of this period, Rauschenberg remembered that "They were massive accumulations of erotic paint in various primordial shapes" (from Barbara Rose's interview with Robert Rauschenberg in *Rauschenberg* [New York: Vintage, 1987], p. 37). See note 43, below.

41. In Bastian, *Cy Twombly: Catalogue Raisonné of the Paintings*, vol. 1: *1948–1960*, the following early works have earth listed as part of their medium: Bastian 1, nos. 24–26, 28, 30–32.

In 1948, shortly after Dubuffet's first exhibition in New York, Twombly clipped a reproduction (which he has kept to this day) of *Smoky Black (Lili)* from the *Life* magazine of December 20, 1948. In an unpublished paper for a seminar at the Institute of Fine Arts, New York University, Aruna d'Souza has pointed out that this may be the same Dubuffet reproduction which attracted Jackson Pollock. Alfonso Ossorio once stated that Pollock "liked Dubuffet. He cut a Dubuffet out of *Life* magazine and pasted it on the wall of his john" (Ossorio, in Francine du Plessix and Cleve Gray, "Who Was Jackson Pollock," *Art in America*, vol. 55, no. 3 [May–June, 1967], p. 58).

42. This somewhat contrary personal project—turning an aesthetics of existential immediacy into a poetics of accreted age—would have had at least an affinity with the photographs of Aaron Siskind (who also was at Black Mountain in the summer of 1951), which transposed Abstract Expressionism into an imagery of weathered and crumbling surfaces.

43. When Barbara Rose asked Rauschenberg what kind of work Twombly was doing around 1952, Rauschenberg said:
I think they were called "Chandeliers" or something. And "Torahs." Sort of primitive abstract ones.

... I was doing the black paintings then. And I would turn them over with all the paint on them and they would pick up gravel. They were pretty tacky. But I painted over most of them so many times that it didn't matter. I used them again because I didn't have any canvas. Anyway, Cy was painting some sort of blackboard series, but he thought that they would understand the "Chandeliers" series better. He had done the "Chandeliers" at the Art Students League.

... They were great. The "Chandeliers" were hot pinks and golds. The "Torahs" were black-and-whites with other primitive black-and-white shapes.

When Rose then asked if these latter pictures were in color, or simply monochrome, Rauschenberg replied, "Monochrome."

A little further on in the interview, Rauschenberg said of Twombly that, despite critics' tendency to see his work as more drawing than painting, "he did some really baroque painting early on." He then added that "I have one. But I think it's in black-and-white, because I was never crazy about color." Presumably this last reference is to MIN-OE (pl. 3), the only Twombly from this period in Rauschenberg's collection. See Rose, *Rauschenberg*, pp. 36–37.

Commenting on Rauschenberg's account, Twombly has recently affirmed that the "chandelier" works were earlier, smaller pieces connected with his Boston studies. He does not understand Rauschenberg's references to "baroque" or highly colorful painting from this period, and says that there is no lost or destroyed group of works that fits this description.

44. According to Twombly, Noah Goldowsky very much liked Twombly's works and those of Rauschenberg. He intended to arrange shows for both of them in Chicago (works were driven there after the summer semester by Aaron Siskind). Rauschenberg's exhibition never took place (see Hopps, *Robert Rauschenberg: The Early 1950s*, p. 64). The complete text of Motherwell's statement for the show, published in a flier by the Seven Stairs Gallery, is as follows:
I believe that Cy Twombly is the most accomplished young painter whose work I happen to have encountered; he is a "natural" in regard to what is going on in painting now. I say "now" because I believe that painting differs greatly from moment to moment in history, and from place to place. It is not only that the aspirations of men, and the conditions under which we work, change from time to time and place to place as humanity constantly struggles against the various obstacles that block the satisfaction of our basic needs and desires; it is that, in any given moment, as William James noted, the "world resists some lines of attack on our part and opens herself to others, so that we must go on with the grain of her willingness." At a remarkably early age, Twombly has come upon the grain of present day painting's willingness. To find himself in this position demands a certain amount of learning, and it is no less remarkable how thorough his knowledge is of those works (if not of their background of thought, which he would no doubt regard with impatience) that would help in his specific expressive aims: the more abstract drawings and paintings of Picasso, the massive, decadent surface (in being only surface) of Dubuffet, the deliberate abandon and sensuality of the present-day New York School of abstract expressionists, and the art of Savages. (He is a Virginian, of

48–50. Cy Twombly. Wall hangings, with fetishes by Robert Rauschenberg. 1952–53. Dimensions unknown. No longer extant. Photographs by Robert Rauschenberg

Yankee descent.) Still, the substance of this learning is accessible to everyone now, through reproductions and museums and quick travel, though surprisingly few acquire it; it requires a certain animation of mind to make one's own imaginary museum, and most young painters begin with the one next door, too rarely outgrowing it. So that perhaps what is most remarkable about Twombly, what leads one quite spontaneously to call him a "natural," is native temperamental affinity with the abandon, the brutality, the irrational in avant-garde painting of the moment. His painting process, of which the pictures are the tracks that are left, as when one walks on a beach, is orgastic: the sexual character of the fetishes half-buried in his violent surface is sufficiently evident (and so is not allowed to emerge any more). Yet the art in his painting is rational, often surprisingly simply symmetrical, and invariably harmonious.
Robert Motherwell, October, 1951

45. Heiner Bastian lists these works as having been shown: Bastian 1, nos. 24–26. The reviews in fuller citation include the following.

Stuart Preston, *New York Times,* December 9, 1951:
There are no questions of symbolism or communication here; plunges are taken into abysses of subjectivity.... Twombly's shadowy patterns, in degraded blacks and ivories, are more gracefully balanced with regard to the over-all surface, more heedful of the demands of flat design.

Prudence B. Read, "Duet," *Art News,* vol. 50, no. 8 (December 1951), p. 48:
[In both artists it is interesting and instructive to look for] the possible influence of Dubuffet. Twombly, using a restrained color scheme of white to black enriched with tan and blue, creates large rhythmic patterns which have insinuating elegance. Some are staccato, others slow and flowing. The blacks carry the framework and yet melt into the lighter areas.

James Fitzsimmons, "New Talent," *Art Digest,* vol. 26, no. 6 (December 15, 1951), p. 20:
Cy Twombly's vision is related to that of Clifford [sic] Still and Weldon Kees. In some of his large dour paintings, irregular circles of grimy white seem to mushroom on a grey or black field. In others, light areas are smoky and

undulant. They gleam like reflections on a wet pavement at night, or make spashes [sic] of stark white. Limiting himself to black, grey, and white, and to configurations that are often too obviously symmetrical, Twombly seems to be handicapping himself. The application of paint shows ingenuity; one would like to see more ingenuity at the conceptual level.

46. See two letters of January 1952 to Leslie Cheek, Jr. The first, undated but responded to on January 24, inquires as to eligibility for a fellowship. The second, dated January 26 and written on the stationery of Black Mountain College, requests the application forms.

47. Rauschenberg remembered (Rose, *Rauschenberg,* p. 36):
At a certain point, he [Twombly] was eligible for a museum scholarship.... So I did his portfolio. He didn't want to go over there by himself. I thought it would be great. We were going to share the scholarship. I did big blowups of his works and dry mounted them beautifully. Albers would have liked that.

Twombly's letter of May 4, 1952, to Leslie Cheek, Jr., states:
For the Out-of-State Fellowship I am sending a portfolio of fine and clear photographs of my paintings taken by a young photographer from New York, along with four of my paintings, so as to give the Committee an idea of my color.

It would be terribly difficult as well as expensive to send ten of my paintings, since many of them are quite large, but I think with the four as color reference the photographs will define the work quite accurately.

48. The complete statement is as follows:
In the complexity of modern art, in the wide and diverse background of causes and origins it is fatal to look merely on the surface for cause, but to go back to the arts of the primitive cultures, classic construction and even national traditions—for it is apparent that Mondrian is an outgrowth of Vermeer and the Flemish tradition, as Matisse is the French tradition, while Picasso draws directly and freely on the Spanish, French, African and Classic cultures.

The twentieth century is the great period of revaluation of all known past cultures—the art of the Africans and Indians and etc., which have been considered barbarian, thus inferior cultures, have taken their due places of impor-

tance in relationship to our own present cultural patterns. The static classic cast and the eighteenth artificiality, which as art concept, has thus been broken to a great degree.

What I am trying to establish is—that Modern Art isn't dislocated, but something with roots, tradition and continuity.

For myself the past is the source (for all art is vitally contemporary). I'm drawn to the primitive, the ritual and fetish elements, to the symmetrical plastic order (peculiarly basic to both primitive and classic concepts, so relating the two).

A Fellowship would be a great benefit. It would enable me to go to Europe to come in direct contact with sculpture, painting and architecture in context. To experience European cultural climates both intellectual and aesthetic.

I will be able to study the prehistoric cave drawings of Lascaux (the first great art of Western civilization). The French, Dutch and Italian Museums, the Gothic, Baroque architecture, and Roman ruins. Such experience will provide energy and material for my work. It will broaden my own knowledge and concepts, not only for the painting I intend to do there, but for a lifetime of work.

49. The letter of recommendation from Ben Shahn, dated April 25, 1952, says:
During the past summer I had, in my class at Black Mountain College, a young artist named Cy Twombley [sic] who was, unquestionably, the best of my students there.... Mr. Twombley's painting is in the abstract direction, but shows a freshness of design that is unusual in this field. He has done extensive exploration in media, and by combining his strong designs with new materials, has created some very impressive and interesting paintings. Personally, he has resourcefulness of mind, a great deal of humor, imagination, and the degree of irreverence for passing art authority that is indispensable for continued good work.

Marion Junkin's letter, dated May 2, states:
I get a more immediate message through paint from Cy's work than anyone else working as he does. His ideas stem from a deep interest in primitive shapes

and he has a broad understanding of art history. Furthermore, I assure you that Cy has had the discipline of realistic growing as a background for his abstract work and can do beautiful sensitives when he so chooses, but for the present, he has gone far in exploiting a future on non-objective expressions.… He works incessantly and probably he forgets his meals for love of painting more often than anyone I know.

Motherwell's letter of April 28 mentions he believes Twombly to be "precisely the proper recipient for a painting fellowship—and … the excellent reception among … painters of his recent exhibition in New York is evidence that I am not alone in this opinion."

50. The letter announcing the award was sent May 26, 1952. The award was $1,800, payable $150 per month for a year.

51. An undated letter to Leslie Cheek, Jr., specifies that Cheek's last letter had not been forwarded to Black Mountain, and that Twombly has just received it on returning to Lexington. Since Cheek replies to that letter on June 10, it must have been written in the first week of June. Another letter to Cheek, announcing, "I was just able to get passage for Aug. 20—so will leave earlier than planned," is dated July 8. This would allow the last three weeks in June for travel.

52. The departure date of August 20 can be established by a letter to Leslie Cheek, Jr., written on July 8, 1952 (see note 51, above). The arrival is announced in a letter to Cheek, September 6, 1952 (see also note 54, below):

I finally arrived in Rome and have a large room in a pensione overlooking the Piazza di Spagna a block from the via Margutta where most of the important contemporary Italian painters and sculptors have studios. I got off the boat in Palermo, Sicily, in hopes of seeing the many Greek ruins throughout Sicily and the Arab-Norman buildings located in Palermo.… In the two days I've been here I've walked miles so excited to see everything at once, but find I will have to plan more. I'm very anxious to start to work myself and just bought materials. I will work each morning in my room then site see in the afternoon, and reading up the night before the history of the Church, ruins, palace & etc. which I will go to the next day. I've met many American painters (so called) while out eating mostly but most of the Sunday type. It is terribly important for me to be here now and I am very excited to work & learn and see as much as it is humanly possible. I will probably stay here at least a mo. if I don't find it too expensive—then to Florence for awhile & Venice.

53. Rauschenberg told Barbara Rose (*Rauschenberg*, p. 38):
We went to Rome. It was good and interesting for about two weeks. Then Cy started collecting antiques. He still collects great antiques. He discovered a flea market, not the flea market outside of town, but one in a little Piazza del something or other. Anyway, the farmers would bring in Etruscan things and occasionally a marble bust. He just went crazy. He kept his half of the money and started spending mine on antiques. I ended up not only being furious and hating him, but also needing to do something to make money to live on.

I didn't have enough money to get back to America. I ran into an American who asked me for directions. We started talking and he bought me a drink and said he worked for the Atlas Construction Company in Casablanca. He told me I should go there because they hired hundreds of people every day.

54. Letter (sent from Rome) to Leslie Cheek, Jr., dated October 15, 1952:
I've been getting along very well. Spent a week in Florence which was almost impossible to take in in such a short time—but I will try and go back later. It was wonderful to return to Rome not as a stranger. I was able to make short stops at Assisi and try to see the beautiful Giottos—but the poor lighting makes it very difficult—also Siena. I plan to go to Africa at the end of this week for 2 or 3 months—going first to Tunis and visiting Carthage, then to Egypt—from there to Crete, Greece and then back to Italy. I'm having a show here in Rome in Jan. at a very nice gallery near Via Veneto. The gallery

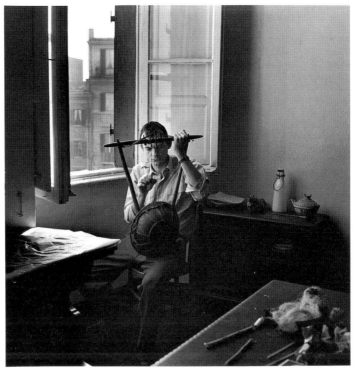

51. Twombly with musical instrument, Rome. 1953.
Photograph by Robert Rauschenberg

where Matta and some young Italian painters exhibit. I've done quite a lot of work lately but mostly small things. I want to do a couple of figures and have them cast in bronze, which you can have done here in Rome very cheaply.

55. Conversation with the artist.

56. In an undated letter to Cheek sent from Tangier, Twombly wrote:
I've just returned from digging at a Roman bath with the Director of the Museum here—Northern Africa is covered with wonderful Roman cities and in this part they are just beginning in the last yr. to excavate. I've learned so much from the Arabs. My painting has changed a great deal. I have hundreds of sketches to use for paintings. Moving so much I haven't been able to actually paint. I've made 6 or 8 large tapestries out of bright material which the natives use for clothing—I plan to use them in my show in Rome next mo.—I can't begin to say how Africa has affected my work (for the better I hope).

I leave in the morning to go to Tetuán in Sp. Maroc for a few weeks, then to Sevilla & Madrid & the prehistoric section in Northern Sp.—before going to Rome. In Feb. I plan to go to Greece, Crete and then down to Egypt.

Cheek, usually quite prompt in his responses, replied to this letter on December 31, which would date Twombly's letter sometime around Christmas. This would seem to coincide with the account in Michelle Green, *The Dream at the End of the World: Paul Bowles and the Literary Renegades in Tangier* (New York: HarperCollins, 1991), p. 102:
In December, the two [Bowles and his friend Ahmed Yacoubi] left Tangier for a month in Tetuán, a handsome town that was the capital of the Spanish

zone. For company, they had the artist Robert Rauschenberg, who happened to be staying down the street from their hotel on the rue General Franco.

57. In his summary letter to the Virginia Museum (see note 61, below), Twombly stated that he had shown the tapestries in Rome and Florence, but no other record of a 1953 Rome showing of the tapestries, or any other work, has appeared.

58. See the letter quoted in note 56, above. Rereading the letter in 1994, Twombly affirms that the drawings now associated with the North African journey were all done after the trip, in Rome.

59. There is a notable resemblance between the tapestry in fig. 50 and Rauschenberg's painting with fabric collage, *Yoicks*, of 1954 (Whitney Museum of American Art, New York).

60. Twombly probably returned to New York in late April or very early May 1953. He remembers traveling on the ocean liner *Andrea Doria*. A letter to him from the Virginia Museum of Fine Arts, sent to Lexington and dated May 7, requested his summary statement regarding the use of the fellowship. The letter he then sent to Leslie Cheek, Jr., cited in note 61, below, mentions nine months of the fellowship, which would date the letter in May 1953.

61. Undated letter to Leslie Cheek, Jr. (probably written in May 1953; see note 60, above). The complete text is as follows:
I was able in nine months to do almost all of the things I intended to do—with possibly the exception of getting to Egypt. I visited most of the important towns, monuments and museums of Sicily, Italy, Spain, and Morocco.

It was important to live in each place long enough to absorb the old as well as the new climate.

Rome and Florence proved inexhaustible, for they are so rich and complex. In Rome on any street one can find a jewel of a Baroque church, or Roman sculpture in a court and etc. hidden away and never found in a tourist guide book.

I was quite taken by the Etruscan's civilization, and made many trips to the tombs of Tarquinia and Vievi.

Each day was filled with so many wonderful experiences that on looking back at the end of the day it was hard to believe that things occurring in the morning, could have happened in the same day.

In Tangier I made large simple abstract tapestries of bright colored satin material, and later exhibited them in Rome and in Florence. My painting matured a great deal.

Mr. Kootz was very happy at the development and has promised me that he will show my work regularly as soon as he has an opening. In the meantime another gallery has asked to show it.

It is difficult to begin to tell of the many, many things I saw and experienced—not only in the art and history but of human poetry and dimensions in the fleeting moment and flux.

I will always be able to find energy and excitement to work with from these times. I see clearer and even more the things I left.

It's been like one enormous awakening of finding many wonderful rooms in a house that you never knew existed.

As for future plans—I would very much like to find a teaching position in Virginia.

62. Rauschenberg told Barbara Rose (*Rauschenberg*, p. 47):
Eleanor Ward wanted to show Twombly, and Cy felt that our works together had such impact that he wanted us to show together. Eleanor said that we could if we could double the space in the gallery. We spent a summer raking out the horseshit and pissed straw from the old Police Department stable. That was the Stable Gallery. We really made it great. And it was the first and the last time I ever saw Cy doing real work. Sledgehammer, putty, pouring cement— we did it all! That was where I had my first all-black and all-white show.... We mixed the work up [i.e., showed Twombly's works and Rauschenberg's intermingled in the installation]. They looked very good together. I also had a bunch of rock sculptures that I had done on Fulton Street. String, rock, plant, nail.

Eleanor Ward gave Calvin Tomkins a slightly different version of this story (see Tomkins, *Off the Wall: Robert Rauschenberg and the Art World of Our Time* [Garden City, N.Y.: Doubleday, 1980], pp. 84–86). By her account, she went to Rauschenberg's loft in the early summer at the insistence of Jack Tworkov, and there saw Twombly's work as well. She offered them a joint show, and they in turn proposed opening the basement to show Rauschenberg's sculptures:
Those boys worked like galley slaves. Dozens and dozens of loads of junk had to be carted away, debris that was two to three feet thick on the floor. They whitewashed the floor and the walls and the ceiling.

According to Walter Hopps, it was the painter Nicolas Carone who "prompted Ward to consider the work of both Rauschenberg and Twombly" (Hopps, *Robert Rauschenberg: The Early 1950s*, p. 159). Twombly confirmed in 1994 that Carone brought Ward to the studio.

Note that Heiner Bastian's *Cy Twombly: Catalogue Raisonné of the Paintings*, vol. 1: *1948–1960*, states that *Solon I* (pl. 5) was shown at the Second Stable Annual in 1953, on the evidence of installation photographs of the show. The announcement for this show, which took place in January, while Rauschenberg and Twombly were still abroad, does not list Twombly's name as a participant. Rauschenberg had a painting in the show, thanks to the insistence of Jack Tworkov, and his

name does appear on the announcement (see Hopps, *Robert Rauschenberg: The Early 1950s*, fig. 60, p. 231).

63. Note that Twombly apparently showed no sculpture at this exhibition. The sculptures shown in 1955 are clearly connected to the fetishes Rauschenberg made in Rome, and may have already been in progress at the time of the September 1953 joint show. In relation to Rauschenberg's rock, string, and wood sculptures, one should also note the reference by Charles Olson to the Twombly sculptures he saw at Black Mountain in January 1952 (Olson, "Cy Twombly" [January 29, 1952], in *Cy Twombly: Poems to the Sea* [1959] [Bridgehampton, N.Y.: Dia Art Foundation, 1988], pp. 3–4):
… his sculptures … are properly made up from what wire, bone, stone, iron, wood, he picks up, and so do respect facts, the accidents of same

(this is the twin methodology, this is documentation, these sculptures of his also show how accurate his penetration of the reality bearing on us is these are the artifacts he finds surrounding himself in the same diggings out of which he is digging himself.

When interviewed by Barbara Rose, Rauschenberg affirmed that his works and Twombly's were mixed together in the exhibition (see note 62, above), and extant photos of the installation confirm this—contrary to the review by Lawrence Campbell, "Rauschenberg and Twombly (Stable; September 15–October 3)," *Art News*, vol. 52, no. 5 (September 1953), p. 50, which said that they "each occupy a separate floor."

64. James Fitzsimmons said, "Twombly's recent paintings are based on drawings made in North Africa, but there is nothing specifically African about them" ("Art," *Arts and Architecture*, vol. 70, no. 10 [October 1953], p. 34). Lawrence Campbell said that the artist "identifies his work by the names of Moroccan cities because he likes the sound of the words and not because they are descriptive" ("Rauschenberg and Twombly [Stable; September 15–October 3]"). Dore Ashton on the other hand felt that the works "convey both the mystery and the austerity of the Moroccan landscape," and went so far as to see the form of a Roman arena in *Volubilus* (pl. 14), and a primitive village in another work ("Cy Twombly," *Art Digest*, vol. 27, no. 20 [September 15, 1953], p. 20).

65. Conversation with the artist.

66. We might compare these materials with those in the fetish pieces Rauschenberg constructed for his shows in Florence and Rome. In his statement for the show in Rome, Rauschenberg wrote: "The Materials used for these Constructions were chosen for either of two reasons: the richness of their past: like bone, hair, faded cloth and photos, broken fixtures, feathers, sticks, rocks, string, and rope; or for their vivid abstract reality: like mirrors, bells, watch-parts, bugs, fringe, pearls, glass, and shells" (Hopps, *Robert Rauschenberg: The Early 1950s*, p. 232).

67. In a letter to Leslie Cheek, Jr., January 21, 1951 (cited in part at note 22, above), Twombly recounts:
Ischacbasor has a class at the League in encaustic and I have been going to watch now and then. He doesn't know how to handle it as Zerbe does [i.e., Karl Zerbe of the Boston Museum School, who was a specialist in encaustic] to take advantage of the underlayers showing through for brilliants and illumining effects. It is a bit tedious a medium for me, but I have been doing crayon drawings, heating and scratching, which is a form of encaustic....

Twombly had impressed Ben Shahn with his knowledge of various mediums (see note 49, above), and this, too, may have come from the courses in Boston. A student who studied under Zerbe at almost exactly the same time as Twombly recalled, "Zerbe's seminar on materials and techniques was special. He gave us a feeling for the quality of paint as an expressive ingredient, which corresponds with

certain criteria of the New York School" (Bernard Chaet, "The Boston Expressionist School: A Painter's Recollections of the Forties," *Smithsonian Institution Journal*, vol. 20, no. 1 [1980], p. 25). Twombly, however, never studied with Zerbe, and does not consider that his education was focused on technique or media in this way (conversation with the artist).

68. See the discussion of the white paintings in Hopps, *Robert Rauschenberg: The Early 1950s*, p. 80; and the reproduction of Rauschenberg's letter of October 18, 1951, to Betty Parsons about these works, p. 230. The letter says the works are "presented with the innocence of a virgin. Dealing with the suspense, excitement and body of an organic silence, the restriction and freedom of absence, the plastic fullness of nothing...." Note that there is a certain confusion, or at least a typographical error, in Hopps's discussion of this letter on p. 71; Hopps incorrectly dates the letter to October 1952, and seems to imply that Parsons's failure to respond positively to the letter was a proximate factor in Rauschenberg's decision to go to Europe with Twombly. If disappointment with Parsons's response did figure in Rauschenberg's decision to go, the thinking would have taken place in late 1951, before he and Twombly laid plans for the trip in early 1952.

69. A story the artist recounted recently may be relevant here. Twombly remembers seeing the Caliph of Spanish Morocco in Tetuán. It was, he said, an incredible spectacle of color: guards in blue robes with orange linings prepared the way, and stood waiting against white painted walls. When the doors finally opened, and the Caliph's convertible Mercedes emerged from within, he was seen seated at the center of all this activity in a garb of pure, gauze white (conversation with the artist).

Based on his own conversations with the artist, Robert Pincus-Witten wrote an account of Twombly's travels that includes a key reference to white, but which may be misleading. Pincus-Witten wrote that "On his discharge [from the Army] Twombly undertook long periods of travel throughout Europe, particularly in Italy and North Africa, where he remembers his most placid and happy moments as those when he painted in brilliantly white rooms overlooking the sea" ("Learning to Write," in *Cy Twombly: Paintings and Drawings* [Milwaukee: Milwaukee Art Center, 1968], n.p.). Though the sentence can be read as saying that the white rooms were in North Africa, it seems more likely they were in Italy. Twombly's letters from 1952–53 as well as his present recollections indicate that he did not paint in North Africa. However, on the island of Procida during the summer of 1957, he did live and paint in two domed rooms that overlooked the sea, and this is the reference intended in the Pincus-Witten text.

70. James Fitzsimmons, in *Arts and Architecture*, vol. 70, no. 10 (October 1953), pp. 33–34:
There is a minimum of art and, consequently, of expression in the paintings which Cy Twombly and Robert Rauschenberg recently exhibited at The Stable Gallery. Patently earnest, intelligent young men, Twombly and Rauschenberg, like a great many other abstract expressionists, seem to feel that today not only painting—its appearance, its shapes and surfaces—but art, and the creative process itself must mean something they never meant before.... Abstract expressionism is an introverted attitude in art, and where it obeys no principle of intellectual order, it is really a kind of inverted naturalism, the naturalism of the solipsist.... Twombly's recent paintings are based on drawings made in North Africa, but there is nothing specifically African about them. Large, streaked expanses of white with struggling black lines scrawled across them, they resemble graffiti, or the drawings of pre-kindergarten children. The contours of the white areas enclosed by line suggest rows of tattering, crudely

fashioned spikes or totems. Presumably the feeling-content of this art is ugliness: shrillness, conflict, cruelty. There is something that resembles a crown of thorns. Fine. The artist is a sensitive man and this is what he finds in the world. Does he have to express it clumsily?... I have devoted space to this exhibition for another reason. The excesses of these two painters, the ineptness and inexpressiveness of their work served to crystallize my impressions of a great deal of our avant garde painting....

In *Art News*, vol. 52, no. 5 (September 1953), p. 50, Lawrence Campbell also saw the relation to graffiti-marked walls, though in less negative terms:

[Twombly] paints fetish forms and black configurations on white surfaces which, in turn, partially hide other figures. These strange struggling lines, like series of carrots, or shapes like fingers or open mouths, are often fringed with smaller radiating lines, sometimes scratched into the white. They suggest anonymous drawings on walls, a resemblance enhanced by his interest in the textures of the paint. In places he has dropped gobs of Dutch Boy lead white which have yellowed, and here and there he has introduced scribbled lines with crayons—very faint touches of color. Both artists show individual and interesting qualities.

71. *New York Herald Tribune*, June 20, 1954. From a clipping in the Eleanor Ward Papers.

72. Tomkins, *Off the Wall*, p. 85. My thanks to Leslie Jones for bringing this reference to my attention. In his unpublished notes for this book, Tomkins recorded a fuller version of Eleanor Ward's reminiscences over the impact of the show: "Everyone was hostile, with the exception of a few artists. One well known critic was so horrified he came out on the street literally clutching his forehead, and then fled down the block...." In another part of these notes, she was recorded as remembering that "Cy's work seemed to affront people as much as Bob's then—the same scribbled image." She also recalled about the joint show that "not a single picture sold." One of Rauschenberg's rock sculptures did sell, directly from his studio. My thanks to Calvin Tomkins for generously allowing me to study these notes, from an interview with Ward.

73. Twombly has related that, when he was faced with the Army, his father convened a colonel and two majors to give him advice. He was told to: (1) never make a mistake, for that would let them "get your name" (he followed this advice and did K.P. only once during his tour); and (2) score high on the I.Q. test (his success in this regard brought him the assignment in cryptography).

He actually remembers basic training with some affection: he was impressed by the military's sense of balance and order, and by the precautions taken in teaching trainees to deal with deadly weapons. The most educational part of the experience was seeing the wide social range among the trainees, rural and urban, white and black, poor and middle-class, educated and uneducated.

74. This phrase is from the chronology prepared in collaboration with Twombly by Heiner Bastian in *Cy Twombly: Catalogue Raisonné of the Paintings*, vol. II: *1961–1965*, p. 276.

75. Robert Pincus-Witten, after conversations with the artist, reported that "While still in the army, Twombly recalls, he often drew at night, with lights out, perfecting a kind of meandering and imprecise graphology for which he would shortly be esteemed" ("Learning to Write," n.p.). In the same text, Pincus-Witten described Twombly's work from 1956–57 onward in these terms, related to the question of the artist's efforts to suppress virtuosity: "The heart of this work was secured in Twombly's sense of an elegance and naturally facile draughtsmanship. Fearing slickness, he drew as if with his left hand. To avoid striking the surface straight-on, he drew in oblique and contorted angles, punitively disciplining his linear seductiveness."

76. Twombly has recently given the following account of his Army

experience after Camp Gordon. He was sent to work at the Pentagon in Washington, but the decoding work he was given was taxing for him: he thinks he is "too vague" for such exacting tasks, and remembers the uncomfortable pressure of feeling that any mistake might be construed as an act of sabotage. Eventually, his superiors gave him a choice of reassignment to London or Paris; but he said he preferred to stay in Washington. Then they proposed to send him to an air base in the Midwest. This prospect "broke my concentration." He stopped decoding near the end of one week and complained to an officer; he was then taken for psychiatric observation to Walter Reed Hospital and kept there for the weekend. By chance that weekend the hospital was host to a conference of psychiatrists, and Twombly and one other patient were chosen to be interviewed by a panel of these doctors. One of the questions asked of him in this interview was, "What do you think of van Gogh's last painting?" Upon the panel's recommendation, he was given a medical discharge for reasons of "anxiety," and he happily went back to his quarters, packed his bags, and left (conversation with the artist).

This departure from the Army can be dated by an article in *The Virginia Reel*, a newsletter of Southern Seminary, vol. 8, no. 2 (April–May 1955), p. 3 (see note 90, below), which specifies in connection with Twombly's appointment that "Mr. Twombly served in the Intelligence Corps of the United States Army, from which he was separated in August."

In the unpublished notes of his interview with Eleanor Ward, Calvin Tomkins records her as saying that Twombly, who was drafted right after the joint show with Rauschenberg, was "away ten months, [and] had a dreadful time." Combining these sources, we can see Twombly's Army period as beginning in November 1953 and ending in August 1954.

77. In her interview with Rauschenberg, Barbara Rose said: "The first pictures I ever saw of Cy's were the 'graffiti' paintings." Rauschenberg corrected her: "The drawings, you mean. Everybody said that it wasn't painting, but drawing. But he did some really baroque painting early on" (Rose, *Rauschenberg*, p. 37) .

78. This exhibition included Bastian I, nos. 43, 45 (pl. 17), 46, 47, 48 (pl. 19), 49. The yearly gallery group show, the Stable Annual, had been held in January 1954, while Twombly was away in the Army, and had included *Solon II* (Bastian I, no. 32). It is interesting to note that this group show came only a few months after the joint show with Rauschenberg, yet Twombly (and/or Ward) chose not to display any of the recent works, which had not sold.

At the time of the January 1955 show, Twombly's work attracted attention from an unlikely quarter: the art department of the Catholic University in Washington, D.C., requested a group of works to show in its gallery the following month. A letter from Clare Fontanini, head of the art department, dated January 24, 1955, confirms that the request had already been made, through Father Alexis Robertson, and that he would select the works on January 31. A checklist of the show (in the Eleanor Ward Papers) documents that it included twelve works by Twombly and eight African masks, and ran February 7–March 4. It lists the following Twombly works: (1) Drawing I, oil and pencil; (2) "Tiznit," oil; (3) "A-oe," oil; (4) Drawing II, oil and pencil; (5) Drawing III, oil and pencil; (6) "Solon II," oil; (7) "Quaday," oil; (8) "Solon II," oil; (9) Drawing IV, oil and pencil; (10) "Laia," oil, owned by Thomas Wilber; (11) "Voluclis," oil; (12) "Marrakect," oil.

Allowing for typing errors, it seems certain that number 11 was *Volubilus* (pl. 14), and very likely that number 10 was *La-La* (Bastian I, no. 38). It also seems possible that those listed as drawings may have

been works on canvas from the just closed 1955 exhibition.

79. Frank O'Hara, "Cy Twombly," *Art News*, vol. 53, no. 8 (December 1954), p. 46: "Cy Twombly previously showed with Gandy [Brodie] and with Rauschenberg and the heavy, brooding forms which dominated his canvases were given an air of force and of experiment alien to them by juxtaposition with quite different works."

Twombly has referred to a now lost 1954 painting with a motif that resembled a "skinned turkey" as being the one that apparently prompted O'Hara's remarks about bird claws dragged through the paint. That "bird" motif is found among the Augusta drawings still owned by the artist. He has also pointed out a passage in the center top of an untitled 1954 painting (pl. 19), which he said related to a doodle made by a sergeant at Camp Gordon (conversation with the artist).

80. Rauschenberg's untitled 1952 sculpture made from a Coca-Cola bottle crate, now in Twombly's collection (reproduced in Hopps, *Robert Rauschenberg: The Early 1950s*, p. 103), includes two circular mirrors closely resembling those which appear in Twombly's piece in The Menil Collection (fig. 18). Rauschenberg also used mirrors in the fetish pieces he made in Rome in early 1953, and in one of the sculptures he showed in the September 1953 joint exhibition at the Stable Gallery.

81. The palm-leaf fans themselves could plausibly have been items associated with the warm climates of either Italy or North Africa (and their metonymic standing in as palm trees makes them even more natural for the latter), but they were also a staple item of the southern United States before the spread of air-conditioning, and would have been for Twombly a reminder of origins as well as travels. Twombly has recently affirmed that the standing fan suggested for him a poised cobra with its hood spread behind its head (my thanks to Heiner Bastian for this information).

82. The painting seen at the left in the background of fig. 16 is a work shown in the 1955 exhibition and now lost (recorded as no. 44 in Bastian I). The other large painting in these photographs, and those attached to sculptures, are not otherwise documented and presumably no longer exist.

The resolutely frontal, planar nature of much of this sculpture is worth noting. Unlike many of Twombly's later assemblages, these works are conceived very pictorially, often to the point of including a frame. Of special interest is the standing "fence" of branch-like rods on the floor behind the totemic bundled column in fig. 16, a sculptural conception without readily identifiable precedent (and without issue in the artist's later work).

83. The reproduction of *Panorama* in Bastian, *Cy Twombly: Catalogue Raisonné of the Paintings*, vol. I: *1948–1960*, pp. 98–99, intensifies the contrasts of light and dark to make the lines clearly visible, but in so doing makes the picture appear more sharply focused and less grey than in fact it now is. A comparison of the painting itself with older photographs of it suggests some differences in surface. In addition to the photograph of the painting in its original state published here, see also the photograph of Twombly seated in front of *Panorama* at or near the time of its execution, in Heiner Bastian, *Cy Twombly: Bilder/Paintings, 1952–1976* (Frankfurt am Main, Berlin, and Vienna: Propyläen Verlag, 1978), p. 54; and the photograph of Twombly standing in front of *Panorama*, published in *Flash Art*, no. 8 (September–October 1968), n.p.

84. The artist remembers that the large scale of *Panorama* was made possible by the acquisition of a 9 x 12' piece of drop-cloth material for the studio (conversation with the artist). The sewn seam of this mate-

rial is clearly visible in the lower part of the picture.

Twombly told Heiner Bastian that, in 1955–56, he painted over all of these works with the exception of *Panorama* (Bastian, *Cy Twombly: Catalogue Raisonné of the Paintings*, vol. I: *1948–1960*, p. 97).

This poses a potential conflict with Ivan Karp's recollection. The grey pictures figure in an interview with Karp carried out by Paul Cummings for the Archives of American Art on March 12, 1969. Of Twombly, Karp said:

To me he's one of the great important forces in American art. I remember as a young man wandering about the New York art scene that Twombly made a very powerful impression on me when I first saw his work at the Stable Gallery in the middle fifties I think it was. The white chalk on the blackboards were shown first at the Stable Gallery; it was actually white chalk at that point. They were made on very bad canvas and a lot of them didn't survive. I think Mrs. Ward, the Director of the Stable Gallery, still has a couple of those paintings. Twombly says he always wants to go see them. I remember there was a disparaging review of him but they had an illustration of his blackboard painting [this may be a reference to Alfred Frankfurter, "The Voyages of Dr. Caligari Through Time and Space," Art News, vol. 55, no. 9 (January 1957), where Panorama is illustrated on p. 31]. I remember cutting it out and I put it on my personal dictionary at home, my little precious dictionary. And that was my prime illustration of what art was supposed to be. I thought that was the most important object of abstract art in the world.

Twombly, on reading this account in 1994, stated that Eleanor Ward never had any of the grey canvases, and that *Panorama* was the only surviving example.

85. Twombly had apparently been working alternately in white on black and black on white for some time: Rauschenberg remembered "some sort of blackboard series" being done in 1952 (see note 43, above), but if grey-ground works were done then, none survive and none were recorded by the artist for his catalogue raisonné.

86. At the upper right of *Panorama* (pl. 23), the form of the sculpture with two fans (pl. 25), drawn in a cartoon-like wavering fashion, can be discerned (identification made by the artist in conversation).

87. This difference in the treatment of the edges of the field may owe something to the different working methods. Pollock circled his larger canvases as they lay on the floor, leaning over them and working back and forth between his own body and the center and far edges of the work. Twombly worked, by contrast, with his canvases tacked to the wall, so that they could bear the pressure of the lines as he drew. The continuity between canvas surface and wall surface, and the nature of Twombly's emphasis on continuously moving line, may have encouraged him to work in and out of the canvas field at its edges. There are countless other instances in later drawings and paintings where forms "enter" the edge of the field from outside, indicating motions of the arm or hand that are not complete within the field of the work but extend beyond it onto the adjacent surfaces.

88. The studio wall and floor shown in the photographs of the grey works are exactly consistent with those shown in other Rauschenberg photographs of the Fulton Street loft. *Panorama* is also too large to have been painted in the residence on William Street that Twombly rented beginning in the autumn of 1954; in fig. 19, it appears that *Panorama* is shown still nailed to the wall on which it was executed. Rauschenberg has confirmed that *Panorama* was executed in the Fulton Street studio (conversation with Rauschenberg, November 1993).

89. My thanks to Walter Hopps for first pointing out this discrepancy to me; according to Hopps's research, Rauschenberg had abandoned the Fulton Street studio by Christmas 1954 at the latest.

90. Southern Seminary, now called Southern Virginia College for Women, is located on the James River in Buena Vista, Va., which is

very close to Lexington. The letterhead of the day advertised the institution as "Southern Seminary and Junior College / A School of Character." Heiner Bastian's chronology in *Cy Twombly: Catalogue Raisonné of the Paintings,* vol. I: *1948–1960,* p. 279), puts this employment in the spring of 1954, but other sources show he taught there in the 1955–56 academic year. His appointment as head of the art department was made in February 1955, according to the school newsletter (*The Virginia Reel*, vol. 8, no. 2 [April–May 1955], p. 3). An undated letter from Twombly to Eleanor Ward says, "I start teaching Mon. Have been offered the job for next yr—which I haven't decided on as yet." In this letter Twombly discusses an upcoming trip to Washington, D.C.; by comparing this reference with one in a subsequent letter on Southern Seminary stationery, in which he mentions having seen the show at Catholic University (see the discussion of this exhibition in note 78, above), the first letter can be dated to late January or early February 1955.

In that same letter, Twombly gives Ward elaborate instructions for paying the rent, light bill, and so on at his apartment. In a subsequent, undated letter to Ward, Twombly describes a visit to the exhibition at Catholic University and says that he wishes to use the apartment for eight or ten days during a spring break that will begin on March 18.

A calendar published in the April–May issue of *The Virginia Reel* shows that commencement ceremonies for 1955 took place May 25–27, from which one might surmise that classes ended shortly before May 25.

For more on Twombly's continued employment at Southern Seminary, in 1955–56, see note 97, below.

91. These three 1954 drawings, in Rauschenberg's collection, are in colored crayon, with some paint, on the same pastel paper as the Augusta drawings, and apparently were made near the same time. Rauschenberg remembers them as having been done in New York, and it is possible they were made during one of the weekend leaves Twombly took from his posting in Washington, or later in 1954 after his discharge from the Army. They also resemble the Twombly drawing that Rauschenberg included in his painting *Rebus* in 1955 (private collection, France).

92. Frank O'Hara, in *Art News*, vol. 54, no. 5 (September 1955), pp. 50–51, reviewed the show at Stable of "Biala, Elaine de Kooning, Twombly, Zogbaum":

Twombly's pencil drawings present lyricism at its most refined and most difficult: the subject seems to be his inspiration and he refuses to exploit it for dramatic qualities which are the more poignant for being understated. These drawings are called Panorama and the individual pieces, "sections," although they are not in a series, but rather details and ramifications of the experience.

93. The canvases in this show included Bastian I, nos. 53–59.

94. Conversation with the artist.

95. The game of trying to "read" these canvases is tedious, reductive, and ultimately inconclusive, albeit also challenging and hard to resist. To guard against too much reading-in, the search is best undertaken in front of the actual works, even if the miniaturizing effect of reproduction can sometimes make the widely dispersed letters more legible. See for example an untitled painting of 1955 (Bastian I, no. 56, reproduced p. 109), where rising and falling cursive strokes to the left and just above center can be read as both "What" and "Why" with a following question mark. Similarly, the word "FUCK" can arguably be discerned at the bottom center of *Academy* (pl. 30). Such "readings" are, however, far from central to the effect of the works, and "legibility" is clearly more denied than encouraged.

96. For a fuller discussion of the attention paid by modern artists

to graffiti, see my chapter "Graffiti," in Kirk Varnedoe and Adam Gopnik, *High and Low: Modern Art and Popular Culture* (New York: The Museum of Modern Art, 1990), pp. 69–98. Twombly is discussed specifically on pp. 94–98. Further on Twombly and graffiti, see also the discussion by Rosalind Krauss in *The Optical Unconscious* (Cambridge, Mass.: MIT Press, 1993), pp. 256–66. See also the remarks of Heiner Bastian, in footnote 10, p. 29, of his Introduction to *Cy Twombly: Catalogue Raisonné of the Paintings*, vol. I: *1948–1960*.

97. While Twombly was teaching, he found it difficult to paint. In an undated letter to Eleanor Ward, apparently written in February 1955, after his return from a weekend in Washington viewing the show at Catholic University (see notes 78, 90, above), Twombly says, "I have tried to paint a little but the teaching takes so much of my energy I have very little to paint with." Most of his production from Buena Vista in 1955 and 1956 came in the form of drawings, usually skeins or clouds of overlaid, looping strokes in soft lead pencil on dusky cream-tan paper. Following on the dark-ground works, these drawings have less and less trace of residual figuration, and embody a process of steady thinning out that would proceed through and beyond the paintings of 1955 and 1956.

98. In an undated letter to Eleanor Ward on the stationery of Southern Seminary, Twombly thanks her for hospitality over the vacation (presumably the spring break that began March 18, 1955; see note 90, above); inquires "When is Burri arriving?" (Alberto Burri's one-person show at the Stable Gallery opened on May 23, 1955); and announces, "I have been asked back here next yr—and have accepted." Ward responded to this letter on April 15, 1955, sending Twombly a copy of a letter of recommendation she had written for him in connection with an application for a fellowship from the Virginia Museum.

The critic Thomas Hess, then working at *Art News*, also wrote on Twombly's behalf in the context of this application; Twombly sent a copy of his letter, dated April 28, 1955, to Ward. Hess wrote:

I have followed his progress as a painter for some years now; have noted with interest and respect his developing maturity in both concepts and methods. My duties as an editor of this magazine have brought me into contact with a great number of younger American artists, and I believe Mr. Twombly to be among the most promising. His recent one man exhibition has shown that he offers a great deal more than promise....

The artist Conrad Marca-Relli also wrote a recommending letter, dated April 30, and a copy of this letter was also sent to Ward. Marca-Relli wrote:

I have known Twombly for over two years—I saw his painting first, and later met him. His work, from the very first, impressed me as having a unique quality. There are many kinds of talents; but in Twombly's case, I feel his talent is of a specific nature. His originality is being himself. He seems to be born out of our time, rather than into it. One seldom sees in a young artist such complete unity between his work and his being. This state is what most artists aim for, and only achieve, when they do at all, in later years.

Twombly subsequently wrote to Ward to say that everything had been sent to the fellowship committee; and noted that he had never seen the recommending letter written by Dorothy C. Miller of The Museum of Modern Art, since this letter was to have been sent directly to the museum. This latter note from Twombly to Ward must date from early May, as Mrs. J. G. Pollard of the Virginia Museum of Fine Arts, writing on May 5 to Ward to thank her for her letter in support of Twombly, specified that the committee would meet on May 20. In the same letter to Ward, Twombly says:

Sch. is out in three wks [a further indication of an early May date, since commencement ceremonies at the school that year took place May 25–27]—and I

had thought about coming to New York for the month of June and staying in the apt. We can make plans about the apt. after I know what I will be doing next yr. & etc. but I would like to stay there in June.

(All the above documents are in the Eleanor Ward Papers. No record of this application exists in the files of the Virginia Museum of Fine Arts.)

As for Twombly's continuation at Southern Seminary the following year, the autumn 1955 issue of *The Virginia Reel* (vol. 9, no. 1, p. 6) relates that he was at the school for the Halloween party: "A hit among hits was the impromptu jitter-bugging of Mr. Twombly, assisted by a series of courageous partners." The return address on Twombly's application for the Catherwood Fellowship (see note 99, below) shows he was still there in the spring of 1956. He taught (according to the Catherwood application) one course in Drawing and Painting, two in Art History, three in Commercial Art, and four in History of Architecture and Interior Decoration (beginning and advanced courses).

99. The application for the Catherwood Foundation Fellowship Grant and associated material are in the files of the Virginia Museum of Fine Arts. Twombly's statement reads:
It is quite obvious that one of the first great assets to a Fellowship is the essential time to direct energy toward one's own work. The second and equally important is the opportunity to go to the cultural & artistic sources of which the roots and expansion are in Europe.

Since having been to parts of Europe, I can renew friendships among the painters, writers and international set that afford invaluable exchange of ideas in creative research and new directions for both sides. I have also been offered shows in galleries in both Paris and Rome, which show only the more important French and Italian contemporary art. Due to the expense of shipping, I could only do this if I were there.

If my work seems difficult to someone not familiar with present trends in painting, it is none the less sincere and dedicated in its intellectual honesty. Since the middle of the 19th Century, the most important and truly creative art has come from the advance groups; therefore the problem then lies in the complete expression of one's own personality through every faculty available. The mass of derivative and mediocre painting soon falls away, leaving only the daring, that work which remains vital because of its unique vision.

I do not dislocate myself from cultural patterns as some advanced painters would have one believe they do. There is a shift in emphasis of course. America in the 20th Century has gone through an era every decade or two, whereas Europe has been through about 6 main ones in 2000 years. The pressures are enormous. The statement is revitalized; the connections become multiple.

Generally speaking my art has evolved out of the interest in symbols abstracted, but never the less humanistic; formal as most arts are in their archaic and classic stages, and a deeply aesthetic sense of eroded or ancient surfaces of time.

I would like to spend some time in Paris, long enough to work and to research in the Louvre on 17th Century French painting and the Egyptian sections; to have contact with people I admire; to go eventually to Egypt (if political events allow), then to Athens and the islands of Crete and Mykonos. I feel it would be better to limit myself to fewer places and be able to really gain from them in every aspect rather than a general sight seeing tour. Such an opportunity would be of immeasurable value to me, and a vital step in the complete realization of my creative aims.

Though not all of the letters of recommendation are preserved (Twombly later asked that those of Dorothy C. Miller and Thomas Hess be returned to him), he apparently had support from Hess, Miller, Eleanor Ward, and Marion Junkin, and included a statement from Motherwell (presumably the earlier statement, done at the time of the 1951 exhibition; see note 44, above). Junkin's letter says,

"Twombly's work is strongly influenced by the primitive sources and has an Oriental sensitivity and depth of conviction, yet is intensely of his own time and country."

A receipt from the Virginia Museum dated April 7, 1956, lists works received in connection with the application: (1) "Columns of Solon," 40 x 52¼"; (2) "Night Images," 40½ x 52"; (3) "Cyclops II," 40 x 48"; (4) "Cyclops I," 36 x 24"; (5) "Ancient Glyph," 36 x 24½"; (6–10) Study for Paintings (Five) black enamel or ink on paper, 15 x 20".

By comparing the measurements here with those of paintings listed in the catalogue raisonné, we can propose that number 1, "Columns of Solon," is *Solon I* (Bastian I, no. 31; pl. 5), which had been shown in 1953. Number 2, "Night Images," roughly the same size as several earlier works, is perhaps the untitled canvas of 1951 (Bastian I, no. 26. Number 3, "Cyclops II," has the same dimensions as Bastian I, no. 21 (untitled, 1951). Number 4, "Cyclops I," and number 5, "Ancient Glyph," differ from each other by only ½" in width; either could be Bastian I, no. 22 (untitled, 1951), a rare vertical, white-on-black. There are no other extant verticals of this period with these dimensions.

It is worth remarking that Twombly submitted only very early paintings for consideration. There is apparently no work in this group from the 1953 show with Rauschenberg nor from either of the one-person exhibitions at the Stable in 1955 and 1956. He seems to have made a strategic decision to present himself to the evaluators in Richmond as a little more conservative than he actually was at the time.

100. An undated letter to Eleanor Ward, sending an announcement of the engagement of Betty Stokes to Alvise di Robilant (see below, in the text), said, "The scholarship was also missed, so I will come to New York this summer & for the winter."

101. On the Catherwood application, see note 99, above.

102. Letter to Leslie Cheek, Jr., September 6, 1952.

103. Burri was apparently ill at the time, and Rauschenberg took him a small "magic" box construction (presumably like those he showed in Rome and Florence) as a superstitious get-well token (conversation with Rauschenberg, November 1993).

104. Rose, *Rauschenberg*, p. 51.

105. See the letter of recommendation written by Marca-Relli in connection with Twombly's 1955 application for a fellowship; note 98, above. Marca-Relli summered on Long Island, and Twombly visited him there. In the summer of 1956, on Long Island, Twombly met Jackson Pollock on three occasions (conversation with the artist).

106. The Museum of Modern Art presented in 1949 a major exhibition, "Twentieth-Century Italian Art." The Catherine Viviano Gallery opened the next year with "Five Italian Painters." Afro spent eight months in the United States around the time of his one-artist show at Viviano in 1950, and at that time developed his knowledge of and admiration for the painting of Gorky (see Germano Celant and Anna Costantini, *Roma–New York, 1948–1964*, trans. Joachim Neugroschel [Milan and Florence: Edizioni Charta, 1993], p. 56). In this period, Sam Kootz and Sidney Janis were mounting exhibitions that presented European and American artists together. The Museum of Modern Art also showed in 1955 (May 10–August 7) "The New Decade: Twenty-two European Painters and Sculptors." Burri came to New York for this exhibition, and for his own one-person show at the Stable Gallery in the same spring. Piero Dorazio was in New York in the same year. Toti Scialoja had a one-person show at Viviano in the autumn of 1956, and he and his American wife, Gabriella Drudi, came over for it (see Celant and Costantini, ibid., pp. 119–23).

107. This account is based largely on conversations with the artist.

The summer on Procida owed in part to Twombly's friendship with Scialoja and Gabriella Drudi, who also vacationed there. Ward's support for his trip is recorded in Calvin Tomkins's unpublished notes from his interview with Ward, in which she said she "made him go to Italy…. Eleanor gave Cy money for passage on the boat, plus a couple of hundred dollars." A photograph of the di Robilants with the newborn child was sent to Twombly, care of the Stable Gallery, postmarked February 20, 1957; apparently never delivered, or else passed on to Ward by Twombly, it remains with Ward's papers.

108. The grandfather of Giorgio and Tatiana Franchetti had purchased the Ca' d'Oro palace in Venice; their father gave the palace and his collection of art, which included important works by Mantegna and others, to the Italian state.

109. The phrase "natural aristocrat" is from a conversation between Giorgio Franchetti and the author, September 1993. A fuller account of the meeting has been published (in Celant and Costantini, *Roma–New York, 1948–1964*, p. 132):
Alvise invited my sister [Tatiana] and me to a luncheon at a country house that he had rented near Grottaferrata. That was how we met this young artist, who was very elegant, very handsome, very aloof, but actually highly emotional. After lunch, he showed me the drawings he was doing, and I was dumbstruck: what an intensity! Like an electric current. They were obviously charged with such powerful mental vibrations that I received the message, even though I was no expert on art but almost as if I were genetically predisposed. Drawn mentally to Twombly, I got together with him more and more, so that through his stories I grew familiar with his world.

110. See the astute analysis of crosscurrents in postwar Italian art, and in particular of attitudes toward American painting, by Marcia Vetrocq, "National Style and the Agenda for Abstract Painting in Post-War Italy," *Art History*, vol. 12, no. 4 (December 1989), pp. 448–67. Thanks to Mimi Braun for recalling this reference to me.

111. As Gabriella Drudi remembered later (in Celant and Costantini, *Roma–New York, 1948–1964*, p. 117), concerning Afro's show and prize at the Biennale:
[It] provided a notion of a possible and different dimension. It created a new climate, prompting us to circulate through Plinio de Martiis' Galleria La Tartaruga, which initially emerged as an institutional enterprise linked to [Mario] Mafai.

They were close to the Communist party; they did not really have Guttuso [Renato Guttuso, the leading artist/ideologue of socialist realism in Italian art of the early 1950s], but they had never shown an abstract picture. Naturally, the young artists did their best to deprovincialize the gallery, to make it show something new. De Martiis was already in touch with Giorgio Franchetti, and when Toti Scialoja and I returned from New York [in the autumn of 1956], Afro informed Toti about what had been going on and said we should think of La Tartaruga as a support for new initiatives. And indeed, two years later, Giorgio Franchetti left for New York.

112. Piero Dorazio, an abstract painter and outspoken enemy of Stalinist policies, had a show there in January 1957. In February, Tartaruga featured Afro, Burri, and Scialoja in a joint show; and in May and October respectively it showed two artists who symbolized the "American connection," Salvatore Scarpitta and Conrad Marca-Relli.

113. See Franchetti's account of his trip to New York in his essay "La Peinture monochrome en Italie: De 1950 à 1970, entre histoire et ideologie," in *La Couleur seule* (Lyon: Octobre des Arts, 1988), pp. 91–94.

114. Cesare Vivaldi, "Cy Twombly tra ironia e lirismo / Cy Twombly entre ironie et lyrisme / Cy Twombly Between Irony and Lyrism [*sic*]," in *Galleria La Tartaruga* (Rome: Galleria La Tartaruga,

1961), n.p. I have used the original English translation here, and not the more fluid recent translation in Celant and Costantini, *Roma–New York, 1948–1964*, pp. 189–90. That latter translation makes one important error, changing the sense of Vivaldi's remark to indicate that Twombly received an influence from the Roman milieu, instead of exerting an influence upon it.

115. See the catalogue *Monochrome Malerei* (Leverkusen, Germany: Städtisches Museum Leverkusen, Schloss Morsbroich, 1960), with texts by Piero Manzoni and other participating artists. Another aspect of this current of reductive abstraction in Italian art of the period would be the "spatial concretions" of the older artist Lucio Fontana. Fontana's works of the late 1950s, with multiple lacerations of monochrome surfaces, have a distinct affinity with Twombly's imagery of scarred walls. More distant in this period, but closer later, would be the evocations of wall surfaces and writing in the work of the Catalan artist Antoni Tàpies.

116. In an undated letter written to Eleanor Ward on his birthday in 1957, Twombly wrote from Rome, "I've been reading seriously Mallarmé & Pound's essays." The same letter, continued on a different day, concludes with the line: "Read Mallarmé or an introduction anyway."

117. "Documenti di una nuova figurazione: Toti Scialoja, Gastone Novelli, Pierre Alechinsky, Achille Perilli, Cy Twombly," *L'Esperienza moderna*, no. 2 (August–September 1957), p. 32.

118. During the summer he worked in the idyllic setting of a small building with two domed rooms overlooking the water, near the Scialojas on the island of Procida—where Ward and others came to visit in the course of July and August. As the autumn approached, however, he went through a phase of intense discontent and destroyed the summer's work. After a respite at the Franchetti family's castle in the Dolomites, he returned to Rome and worked for a while in Salvatore Scarpitta's studio on the via Margutta. Later in the autumn, Franchetti then found an ample apartment for him in the piazza del Colosseo, overlooking the Colosseum, where he could work on a larger scale. The evidence for these conclusions comes in part from a series of unpublished letters to Eleanor Ward. The first of these, apparently written in March or early April 1957, describes a long boat trip (eleven days) recently completed and the beauty of the setting ("The house sits on a hillside & all of the windows open onto the front looking across lovely cultivated vineyards and olive groves to the sea"), and relates that "[I] have done 4 pictures (in color)."

119. This directionality seems a partial residue of the diagonal motifs, often involving three clusters stepping up from lower left, or what seems almost a rightward-leaning "reclining figure," in several of the works done on paper in the summer of 1957 (see Bastian 1, nos. 72–82).

120. In fig. 21, there appears at the center, just above the midline, a wavering rectangle overlaid with a cross, which forms a window. This basic form recurs throughout other parts of Twombly's work (see *Leda and the Swan* of 1962, pl. 64). Of uncertain and varying meaning, it seems to grow out of rectilinear passages in even earlier works and to be introduced to stand loosely for framing rationality, or objective coordinates, in distinction from cursive or biomorphic elements.

121. Again, as in *Academy* and with the same qualifications (see note 95, above), the word "FUCK" might be discerned here, to the left of the word "OLYMPIA."

122. Twombly's use here of his own handwriting as a source of abstract pattern anticipates, in certain senses, his later use of cursive scrolls, in the manner of penmanship exercises, in the grey-ground pictures of 1966–71 (see text below).

123. There are a few works of the Russian avant-garde, by Mikhail Larionov and Aleksandr Rodchenko around 1911–12, that use free-floating words in a fashion that may mimic graffiti, but these are figurative works, in a primitivizing style. See John Bowlt, "A Brazen Can-Can in the Temple of Art: The Russian Avant-Garde and Popular Culture," in Kirk Varnedoe and Adam Gopnik, eds. *Modern Art and Popular Culture: Readings in High and Low* (New York: The Museum of Modern Art and Harry N. Abrams, 1990).

124. See Palma Bucarelli, *Cy Twombly* (Rome: Galleria La Tartaruga, 1958).

125. From Twombly's application for a fellowship in 1956; see note 99, above.

126. "MORTE" appears in *Sunset* (Bastian 1, no. 95) at the upper right; and in *Olympia* (Bastian 1, no. 96; pl. 31), just to the right and above center. "DEATH" is written in an untitled work (Bastian 1, no. 98) at the right just above center; in another work (Bastian 1, no. 99; pl. 35) in the same place; and in a third (fig. 21) in scrawl, at the upper right. There is a likely connection between these inclusions and the contemporary work *Arcadia* (Bastian 1, no. 97). Twombly's notion of Arcadia was strongly marked by Poussin's *Et in Arcadia Ego*, which deals with discovery of a tomb, and hence of death's presence, amidst the idyllic, arcadian realm.

127. Several unpublished letters to Eleanor Ward reveal Twombly's reactions to the Italian scene in his first year there. In what appears to be his first letter after arriving in the spring of 1957, he says, "Had dinner with Gabriela, Toti & the Afros the other nite. Arte Visive has folded. The gallery situation is nil. Even Afro had to show at a Communist gallery on Babuino & there was hardly any response." Presumably, the gallery referred to was in fact the Tartaruga, which was then located at 196 via del Babuino. The reference to the collapse of *Arti visive* was premature: the periodical published its last issue in November 1958. A year later, in a letter apparently from March 1958, Twombly inquires, "Do you know if Bob sold anything from his show?" (presumably referring to Rauschenberg's first one-person exhibition with Leo Castelli, in March 1958), and says, "There is very little chance of my selling here." With regard to employment, in an undated letter apparently from late April 1957, Twombly writes, "I wrote Porter McKray [McCray] about finding me a teaching position for Fall & I hope something comes of it." In the same letter referred to above (apparently from March 1958), he asks, "If anyone is looking for a teacher next winter write to me." Finally, in a letter of October 1958, after a reference to the teaching position Marca-Relli had just taken up in California, Twombly says, "I hope I can get that job next yr. Then I would come back to Europe for a few more yrs."

128. A group of letters from Twombly to Ward indicates that the show at Tartaruga was postponed at least twice because the artist fell ill and had to be hospitalized in the early part of 1958. The show was held August 18–27, 1958, at Galleria del Cavallino in Venice, and then November 1–10, 1958, at Galleria del Naviglio in Milan.

129. Milton Gendel, "Art News from Rome," *Art News*, vol. 57, no. 9 (January 1959), p. 52.

130. In an undated letter to Ward (apparently from February 1958), Twombly says:

My show's in a couple of wks. if I'm well [he was hospitalized; see note 128, above]. I've finished about ten pictures. Eleanor, about sending ones for a show—to roll these with the kind of paint I use or can get in Italy would mean cracking. I've tried rolling even the thinnest painted and they still crack. If you are willing I would much rather wait until next winter for the show. I also think that having this extra time the pictures may be more completely realized. I want this next show to be very good & I'm not that sure about all but 2 or 3 of the things here.

In a subsequent letter, written after leaving the hospital (see note 128, above) and apparently during the run of the Jackson Pollock exhibition at the Galleria Nazionale d'Arte Moderna in Rome (March 1–30, 1958), Twombly made the proposal more specific:

If it's all right with you I would like my show in Dec. or Jan. I will come home in Sept. & go to Va. to work for 3 mos. or so before the show.

131. Twombly sent Ward a postcard on November 10 saying: "Show in Milano 'gran successo.' Sold everything and want more (which don't exist)." A later letter continues, "Art Aujourd'hui is doing a big article with about 6 reproductions to come out in Jan. I think. It all seems so odd. They even want a show in Stockholm."

132. A newspaper clipping in Twombly's file in the alumni office at Washington and Lee, dated January 1, 1959, is headlined "Twombly Returns Here After Successful Stay in Europe." It describes him as "recently returned to Lexington from Europe, where his paintings have been received with wide interest." The article says he "plans to work here for about three months in preparation for shows in New York and in London and Paris." On the basis of this article, it seems safe to assume that Twombly was in Lexington in time for Christmas.

133. Apparently Twombly traveled to Cuba early in 1959, after Castro's forces had entered Havana on January 2. A postcard to Leo Castelli says, "I love Havana as it is quite like Napoli, but not so grand…. Will see you in N.Y. in April." The postmark of the card is illegible except for the year, which is 1959. Both Twombly and his wife, Tatiana, have a clear memory of being in Havana shortly after the Castro triumph, when soldiers had gone there to celebrate and the whole city was alive with festivity. This visit had been thought to be part of their honeymoon in June, but may in fact have been at this earlier date.

An undated letter to Castelli, sent from Lexington, specifies that Twombly has "IV 6 x 8 paintings finished and stretched," and says that he will soon leave for a month's visit elsewhere, then "for my dearest Roma," bringing material to New York "somewhere around the first of April." Castelli apparently is replying to this letter in his of February 28, 1959, when he says, "Yes, do send the four 6 x 8 that you have finished. I would like to have them."

134. Using the letter to Castelli, apparently of mid-February (see note 133, above), we can judge that four of the Lexington canvases, described as 6 x 8', had been finished by that date. Bastian 1, nos. 113–16 are each within an inch or two of being exactly 6 x 8', and are thus presumably the works referred to in the letter. A second group, of somewhat smaller canvases, approximately 5 x 6' in size, includes a work (Bastian 1, no. 109) specifically dated on the recto "Lexington May 23." Presumably the others of the same size (Bastian 1, nos. 110–12) were executed near that same time. Two other works associated with this series (Bastian 1, nos. 117, 118) are a third, larger size, 7' 8" x 9' 10"; their date cannot be fixed precisely.

135. For a listing of the canvases likely to have been executed in May, see note 134, above.

136. Conversation with the artist.

137. The alumni magazine of Washington and Lee University, in its spring 1959 issue, contained the notice:

E. Parker Twombly, Jr. and Baroness Tatiana Franchetti of Rome, Italy, were married April 20, 1959 in New York City. Attending the couple were Countess Camilla Pecci-Blunt and Prince Guido Carpena. The Twomblys will live in Rome.

138. Castelli had told Twombly in a letter of July 22:

I'm planning your show for the end of October. I want your show to be as varied and comprehensive as possible and shall probably use two of your very early paintings. I don't think that I should show more than four of the new ones…. I hope that you will be able to provide the black one….

On August 18 he sent a radiogram urging that Twombly send paintings in a rush, in time for a show in November. It was likely in response to this cable that Twombly replied:

I do have 4 new paintings quite different from those you have, but they are painted with tube paint and so they take a mo. or so to dry. I can't very well send them wet—there are none available of the old ones & I haven't even gotten to the black one as I was waiting to be settled first—You wouldn't consider just using the ones done in Va.?… This fall will be heavy with moving, a child & about 8 shows here in Europe starting in Oct.—will go to Paris the 1st of Nov. as I have a show at the Palace of Arts in Bruxelles … in a way I like the image of seeing just the paintings you have with a few drawings—the obsessive austerity of the idea rather than variation—the book by that time would be ready and can be a reference to before and after works. The new things are naturally more active and physical so a certain poetry would be lost with juxtaposition with these—my ideas at a time are maybe too singular and don't take in a very rounded possibility.

This letter was probably written during the week of August 20, as Castelli responded to it on August 31, chiding Twombly and still urging him to send "the four new paintings and the revised black one" and "if possible to add a few more important ones." Finally, a telegram from Twombly to Castelli on September 17 said, "Everything up in the air and working hopeless will have to postpone show until another year terribly sorry."

139. The circumstances of the making of *The Age of Alexander* were recounted by the artist in a conversation with the author.

140. To some extent these contingencies explain the relative emptiness of the left half, especially in the upper area, and the bareness of the top edge throughout: the dominance of activity, including the heaviest pink-white paint, centers in the right half of the canvas at what would have been eye level, and extends within the compass of an arm's reach above and below.

141. We can read at various points, for example: "7 o'clock," "1959 into 1960," "now 196[0]," "give a Sign?" "Why cry anymore?" "floods," "sad flight," and most prominently, low and left of center "[illegible] / why / my heart / in your / birth / [illegible] Death / for even."

142. He also writes, "There is still work to be done and I have been directing the progress each day in my half-ass Italian without any disastrous results yet … I leave for the Sahara in 10 days or so—for a month and then most likely to Greece in the summer."

143. Conversation with the artist.

144. See for example Bastian I, no. 148 (untitled); and Bastian I, no. 149 (*Narcissus*).

145. See note 43, above, for Rauschenberg on Twombly's "baroque" painting.

146. The connection of "formless" painterly expression with the transgressive nature of the lower body as a theme is a topic closely associated with the writer Georges Bataille, as has often been elucidated in recent writings by Rosalind Krauss. For her latest work, see *The Optical Unconscious*. See also the round-table discussion of "The Politics of the Signifier II: A Conversation on the *Informe* and the Abject," *October,* no. 67 (Winter 1994), pp. 3–21.

147. See Bastian II, no. 82, where Twombly specifically associates colors with landscape and bodily references.

148. Conversation with the artist.

149. The connection of Twombly's art of the 1960s with the Roman Baroque has been a staple of commentary on the artist; its first appearance may be in Robert Pincus-Witten's essay, "Learning to Write," for the catalogue of Twombly's first museum exhibition in America, at the Milwaukee Art Center in 1968: "His pictures, already large, grew

apace with a preoccupation with the Baroque richness of his new environment…. The pictographic unravelling of his pictures was profoundly altered by the sweeping planes and space of the Baroque construct." Pincus-Witten saw the "tenacity" of this "Baroque pageantry" extending to the mid-1960s, and found it "a masterful solution to the dilemma of Abstract Expressionism during the advent of Pop…. Insulated by the Italian environment, Twombly continued to develop his work along lines responsive to great, decorative schema."

150. Conversation with the artist.

151. These are the recollections of Twombly and Nicola del Roscio; in conversation, September 1993.

152. There exists correspondence between Twombly and Leo Castelli on the *Commodus* series. In an undated letter, Twombly says:

Have your series finished. 9 in all and 1 separate piece if u need it…. I am really terribly happy over them & I think you will be pleased by them.

Thank you so much for giving the check on the Commodo: I lost my head for it, but it inspired this series so maybe it is good to lose my head & gain a new.

Note the implication that Twombly's purchase of a head of Commodus in New York was the immediate spur to the paintings. Castelli replies to this letter on January 10, 1964.

153. Conversation with the artist.

154. Donald Judd, "Cy Twombly," *Arts Magazine*, vol. 38, nos. 8–9 (May–June 1964), p. 38:

Twombly has not shown for some time, and this adds to the fiasco. In these paintings there are a couple of swirls of red paint mixed with a little yellow and white and placed high on a medium-grey surface. There are a few drips and spatters and an occasional pencil line. There isn't anything to the paintings.

It should be noted in regard to this devastating review that Judd was not at all a detached or objective observer. His critical writing in this period was governed by an aggressive, partisan commitment to the kind of "specific object" sculpture he himself made, and hence by an across-the-board hostility to painting, which he considered an outdated art form.

In an interview with Paul Cummings, March 12, 1969, Ivan Karp recalled of Twombly:

We had one very bad show of his. It was really a flamboyant French kind of show that Twombly turned out. He's a little ashamed of it himself now, he says. It was all sold intact to somebody. It was called Homage to Commodus, *the Roman emperor. And we had a bust of the emperor on loan during the show. The paintings themselves were related to the School of Paris abstraction. They were really fanciful, unfortunately. And that did not serve Twombly's career. For all the people that I told just before the show that he was the great figure, the great misunderstood figure, they had to confront these foolish pictures. [And they said], "Why did you tell us these lies?"*

155. In his review of Twombly's 1979 retrospective at the Whitney Museum of American Art, John Russell described the *Commodus* group as looking "like one of the decorator's delights that used to abound at the Italian pavilion at the Venice Biennale" ("Art: Twombly Writ on Whitney Walls," *New York Times*, April 13, 1979).

156. Conversation with Giorgio Franchetti, September 1993.

157. Conversation with the artist.

158. In an exchange of letters between Twombly and Leo Castelli in the late summer of 1959, mention is made of a black picture on which the artist was supposed to have been working (see note 138, above). Nothing further is known of this painting.

159. Twombly has been particularly dismayed by attempts to interpret *Night Watch* as a form of paraphrase on, or homage to, the huge Rembrandt canvas in the Rijksmuseum in Amsterdam. He chose the

title after making the picture, he says, solely for its poetic quality in relation to the dark space of the canvas (conversation with the artist).

160. See the article by Piero Dorazio, "The Future That Ended in 1915," *Art News*, vol. 52, no. 9 (January 1954), pp. 54 ff. Also note the painting by Mario Schifano, *When I Remember Giacomo Balla*; reproduced in *Art News*, vol. 63, no. 3 (May 1964), p. 13. Twombly would have found talk of Balla especially unavoidable, as his brother-in-law, Giorgio Franchetti, collects Balla's work and is strongly fascinated by it.

It is curious to compare the Italian revival of interest in Futurism with that of the British in the mid-1950s. The architectural historian Reyner Banham and the painter Richard Hamilton both devoted new attention to Futurism, but very much as a corrective alternative to what they saw as an over-rationalized and too-staid modernism. They stressed the love of speed, and the huge embrace of the romance of technology, in Futurist aesthetics—rather than the abstract, systematic aspect, which seems to have been more important for the Italians.

161. See *Cy Twombly: Peintures et dessins* (Geneva: Galerie D. Benador, 1963), which specifically connects Twombly and Leonardo.

162. See Reiner Speck, "Leonardo zwischen Beuys und Twombly," *Deutsches Ärzteblatt*, vol. 71, no. 45 (November 7, 1974), pp. 3280–82.

163. Conversation with the artist.

164. Conversation with the artist.

165. Pincus-Witten, "Learning to Write," n.p.

166. Max Kozloff, "Cy Twombly, Castelli Gallery," *Artforum*, vol. 6, no. 4 (December 1967), p. 54.

167. Robert Pincus-Witten, "Cy Twombly," *Artforum*, vol. 12, no. 8 (April 1974), pp. 60–64. In relation to the Post-Minimal aesthetics discussed here in the text immediately following, see also Pincus-Witten's book defining that aesthetic, *Postminimalism* (New York: Out of London Press, 1977).

168. The problem of scale presented by this huge canvas and the other one made at the same time was solved in an ingeniously low-tech fashion. Twombly wanted to be able to work continuously across the width of the works, at every level including those well above his reach. A motorized lift or rolling ladder could conceivably have solved the problem, but Twombly worked in a much simpler fashion. The upper areas of both canvases were executed with the artist sitting on the shoulders of a friend, Nicola del Roscio, who shuttled back and forth across the canvas so that Twombly could work on the moving surface as if he were a typewriter striking its moving platen (conversation with Nicola del Roscio, September 1993).

169. Conversation with the artist. To gain some idea of the Bassano environment, see "Portrait of a House—As the Artist," with photographs by Deborah Turbeville, *Vogue*, vol. 172, no. 12 (December 1982), pp. 226–271, 337.

170. Conversation with the artist.

171. Conversation with the artist.

172. John Russell, "Three Striking Current Shows," *New York Times*, January 7, 1979.

173. In discussing this painting, Twombly has mentioned the writer Alain Robbe-Grillet's violations of standard narrative sequences, in connection with his own decision to put all the "action" at the beginning, rather than the end, of his three-part image.

174. Conversation with the artist.

175. Baudelaire's observation is from section 3, "L'Artiste, homme du monde, homme des foules et enfant," in his essay "Le Peintre de la vie moderne," from *Curiosités esthétiques*, originally published 1868; see Charles Baudelaire, *Oeuvres complètes* (Paris: Bibliothèque de la Pléiade, 1968), p. 1159:

L'homme de génie a les nerfs solides; l'enfant les a faibles. Chez l'un, la raison a pris une place considérable; chez l'autre, la sensibilité occupe presque tout l'être. Mais le génie n'est que l'enfance retrouvée à volonté, l'enfance douée maintenant, pour s'exprimer, d'organes virils et d'esprit analytique qui lui permet d'ordonner la somme des matériaux involontairement amassé.

176. In a rough schema of Europe, Twombly thinks, as others have, of Germany in terms of philosophy, France in relation to language, and Italy as a realm of feeling. (One might measure the truth content of such stereotypes by comparing the kinds of critical response Twombly's own work has garnered from each of these cultures.) It is the heavy role of instinct and feeling that he designates as the "infantile" element in Italian, and by extension Mediterranean, culture.

177. On Alexandria and the persistence of the Mediterranean through a personal sensual temperament, see Marguerite Yourcenar's *Présentation critique de Constantin Cavafy, 1863–1933, suivie d'une traduction des poèmes* (Paris: Gallimard, 1978).

178. The text of the poem is as follows (from *The Complete Poems of Cavafy*, trans. Rae Dulven, Introduction by W. H. Auden [expanded ed., New York: Harcourt Brace Jovanovich, 1976], p. 9):

> *Honor to those who in their lives*
> *are committed and guard their Thermopylae.*
> *Never stirring from duty;*
> *just and upright in their deeds, but with pity and compassion too;*
> *generous when they are rich, and when*
> *they are poor, again a little generous,*
> *again helping as much as they are able;*
> *always speaking the truth,*
> *but without rancor for those who lie.*
>
> *And they merit greater honor*
> *when they foresee (and many do foresee)*
> *that Ephialtes will finally appear,*
> *and in the end the Medes will go through.*

179. See *Souvenirs of d'Arros and Gaeta: Drawings by Cy Twombly* (Zurich: Thomas Ammann, 1992).

180. The line is from Baudelaire's *Journaux intimes*, originally published posthumously in 1887; see "Journaux intimes, Fusées [Hygiène]," in Baudelaire, *Oeuvres complètes*, p. 1265:

Au moral comme au physique, j'ai toujours eu la sensation du gouffre, non seulement du gouffre du sommeil, mais du gouffre de l'action, du rêve, du souvenir, du désir, du regret, du remords, du beau, du nombre, etc.

J'ai cultivé mon hystérie avec jouissance et terreur. Maintenant j'ai toujours le vertige, et aujourd'hui 23 janvier 1862, j'ai subi un singulier avertissement, j'ai senti passer sur moi le vent de l'aile de l'imbécilité.

181. My thanks to Udo Brandhorst for identifying the lines of poetry in this painting. See *George Seferis: Collected Poems*, trans. Edmund Keeley and Philip Sherrard (expanded ed., London: Anvil Press Poetry, 1986). Twombly's phrases are fragments of different poems, and several lines are deliberately abbreviated by the artist. The immediate contexts are:

For the top left lines (from p. 411):
> *Yet there, on the other shore,*
> *under the cave's black stare,*
> *suns in your eyes, birds on your shoulders,*
> *you were there; you suffered*
> *the other labor, love,*
> *the other dawn, the reappearance*
> *the other birth, the resurrection.*
> *Yet there, in the vast dilation of time,*
> *you were remade*
> *drop by drop, like resin,*
> *like the stalactite, the stalagmite.*

For the lines at right (from p. 401):
> *Years ago you said*
> *"Essentially I'm a matter of light."*
> *And still today when you lean*
> *on the broad shoulders of sleep*
> *or even when they anchor you*
> *to the seas' drowsy breast*
> *you look for crannies where the blackness*
> *has worn thin and has no resistance*
> *groping you search for the lance—*
> *the lance destined to pierce your heart*
> *and lay it open to the light.*

For the bottom lines (from p. 425):
> *The blood surges now*
> *as heat swells*
> *the veins of the inflamed sky.*
> *It is trying to go beyond death, to discover joy.*
> *The light is a pulse*
> *beating ever more slowly*
> *as though about to stop.*

182. The sentence as Twombly has written it involves an altered version of a line from the chapter "Poetry: A Note in Ontology," from John Crowe Ransom, *The World's Body* (New York: Charles Scribner's Sons, 1938). The original line appears on p. 115, in the context of a discussion of the contrast between a poetry of things and a poetry of ideas. Discussing Imagist poetry, Ransom says:

For the purpose of this note I shall give to such poetry, dwelling as exclusively as it dares upon physical things, the name Physical Poetry. It is to stand opposite to that poetry which dwells as firmly as it dares upon ideas.

But perhaps thing versus idea does not seem to name an opposition precisely. Then we might phrase it a little differently: image versus idea. The idealistic philosophies are not sure that things exist, but they mean the equivalent when they refer to images. (Or they may consent to perceptions; or to impressions, following Hume, and following Croce, who remarks that they are pre-intellectual and independent of concepts. It is all the same, unless we are extremely technical.) It is sufficient if they concede that the image is the raw material of idea. Though it may be an unwieldy and useless affair for the idealist as it stands, much needing to be licked into shape, nevertheless its relation to idea is that of a material cause, and it cannot be dispossessed of its priority.

It cannot be dispossessed of a primordial freshness, which idea can never claim. An idea is derivative and tamed. The image is in the natural or wild state, and it has to be discovered there, not put there, obeying its own law and none of ours. We think we can lay hold of the image and take it captive, but the docile captive is not the real image but only the idea, which is the image with its character beaten out of it.

PLATES

The works illustrated in the plate section are included in the exhibition, with the following exceptions: pls. 8a, 8b, 34, 41, 43, 46, 119, 120.
In the captions, dimensions are given height preceding width, followed in the case of sculpture by depth.

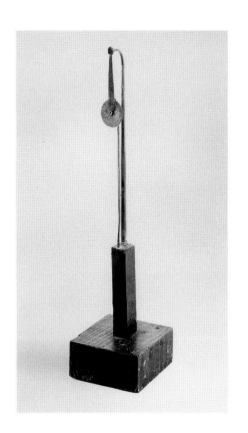 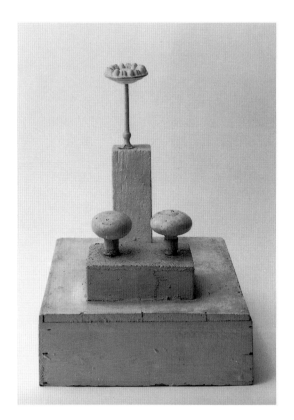

LEFT: 1. Untitled. 1946. Wood and metal, 14½ × 3¾ × 3½" (37 × 9 × 9.5 cm). Private collection

RIGHT: 2. Untitled. c. 1947. Doorknobs, faucet handle, wood, and paint, 14 × 10½ × 12" (35.7 × 26.7 × 30.5 cm). Collection the artist

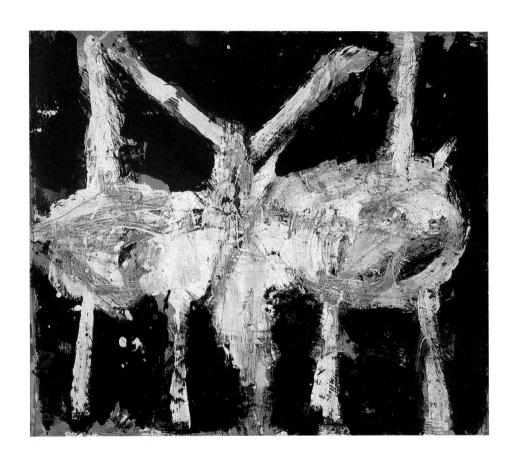

3. **MIN-OE**. 1951. Bitumen and house paint on canvas, 34 × 40" (86.4 × 101.6 cm). Collection Robert Rauschenberg

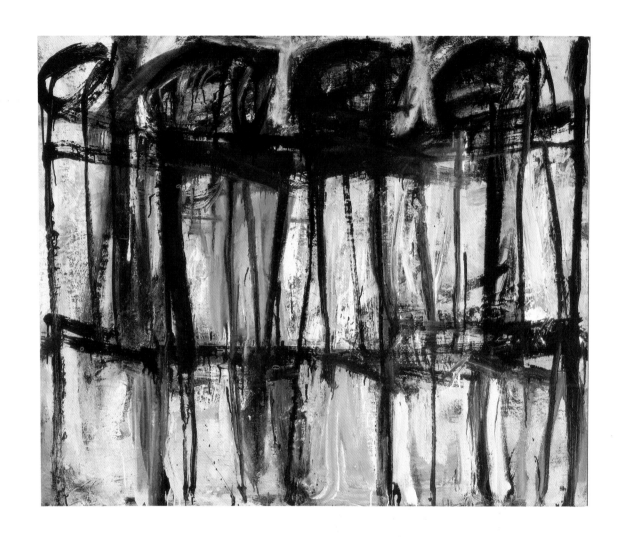

4. Untitled. 1951. House paint on canvas, 40 × 48" (101.6 × 121.9 cm). Private collection

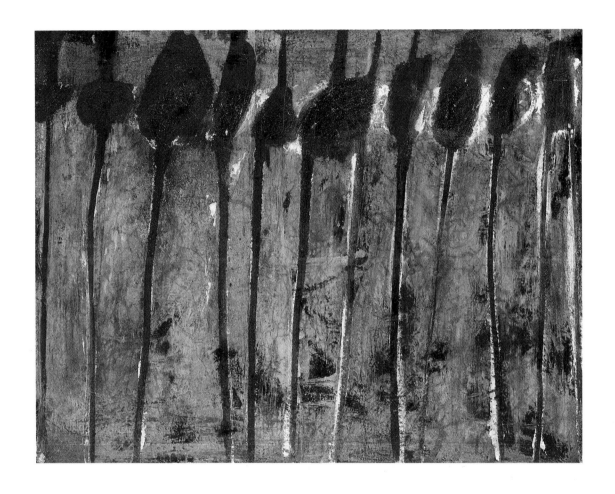

5. **Solon I**. 1952. House paint and earth on canvas, 40 × 52¼" (101.6 × 132.7 cm). Private collection

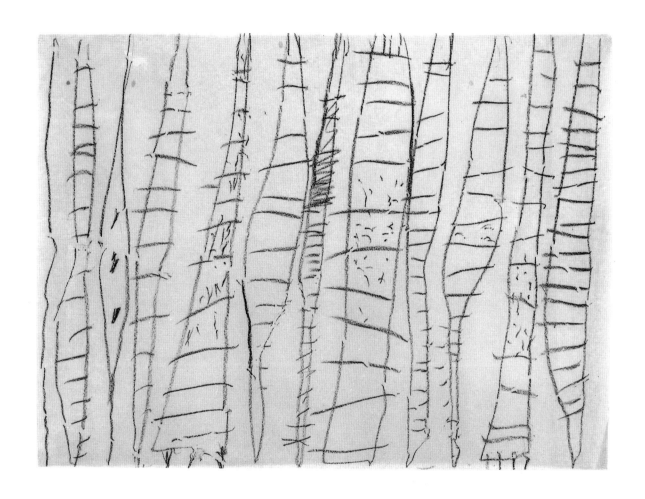

6. Untitled. 1953. Conté crayon on paper, 28¼ × 34½" (71.7 × 87.6 cm). Collection the artist

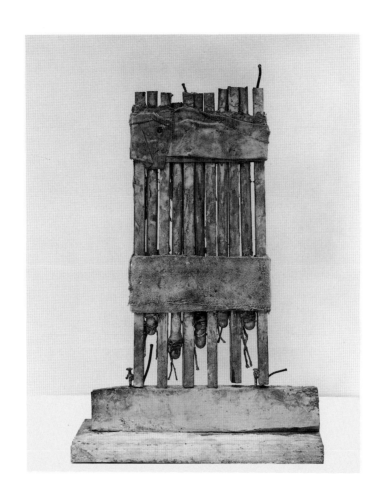

7. Untitled. 1953. House paint and wax on fabric and wood, with twine, wire, and nails, 15⅜ × 10 × 4" (39 × 25.4 × 10.1 cm). Collection Robert Rauschenberg

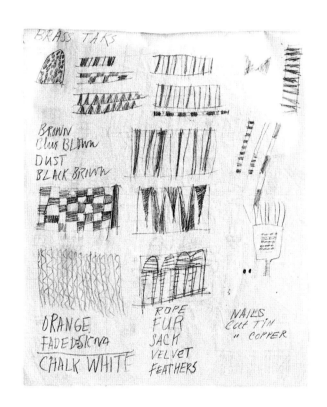

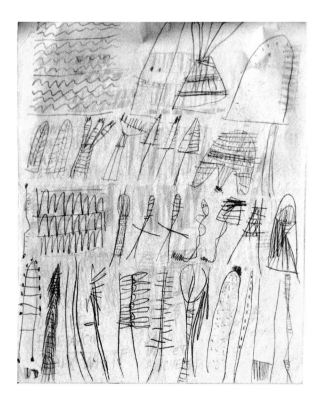

8a and b. Pages from a "North African" sketchbook. 1953. Conté crayon on paper; each sheet, 11 × 8⅝" (28 × 22 cm). Collection the artist

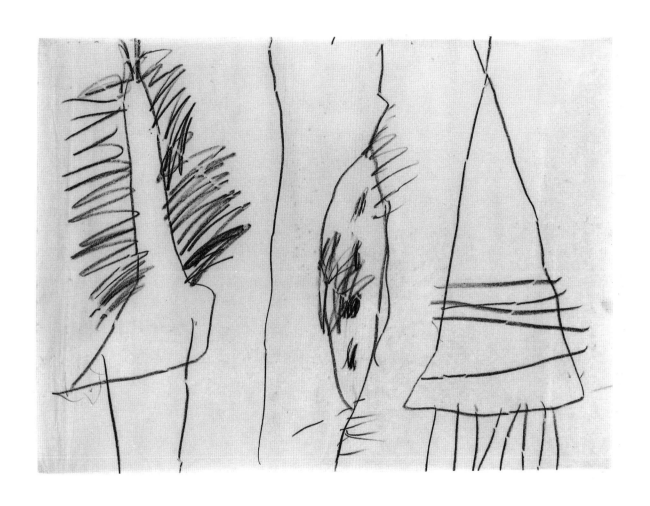

9. Study for **Tiznit**. 1953. Conté crayon on paper, 28¼ × 34½" (71.7 × 87.6 cm). Collection the artist

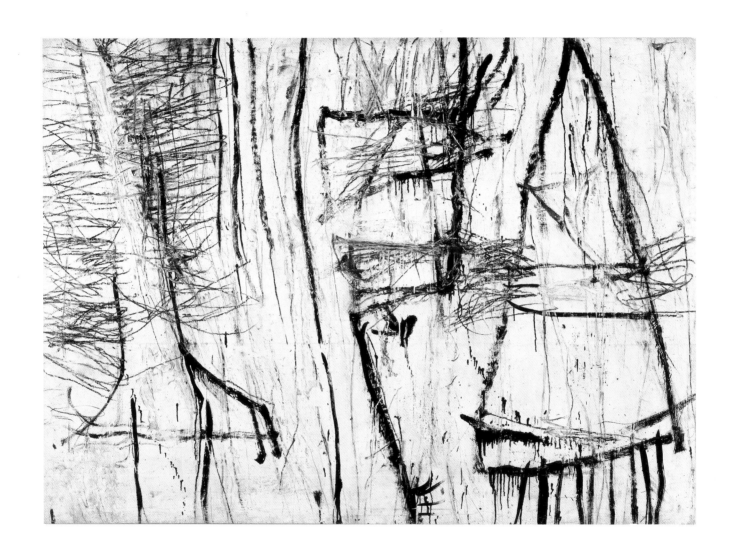

OPPOSITE: 10. Detail of upper center of **Tiznit** (pl. 11), actual size

ABOVE: 11. **Tiznit**. 1953. White lead, house paint, crayon, and pencil on canvas, 53½" × 6' 2½" (135.9 × 189.2 cm). Private collection

LEFT: 12. Untitled. 1953. Monotype in paint, 20⅛ × 26½" (51 × 67.2 cm). Collection the artist

RIGHT: 13. Untitled. 1953. Monotype in paint, 20 × 26½" (50.9 × 67.2 cm). Collection the artist

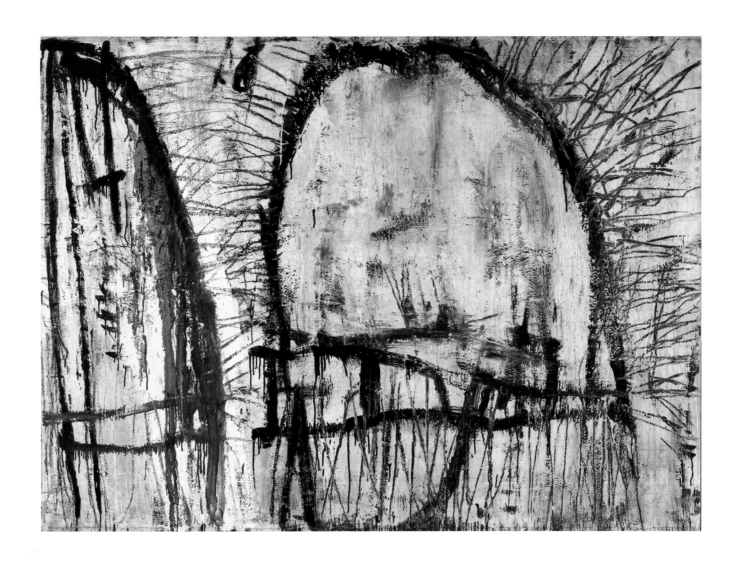

14. **Volubilus**. 1953. White lead, house paint, and crayon on canvas, 55" × 6' 4" (139.7 × 193 cm). Private collection

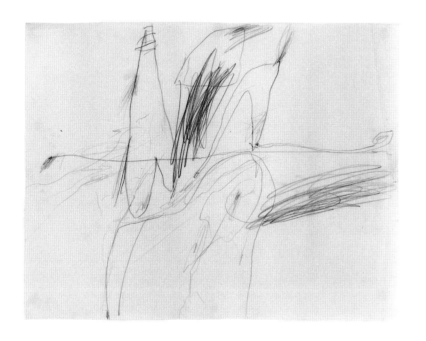 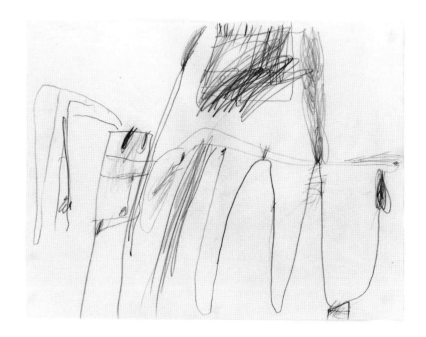

LEFT: 15. Untitled. 1954. Pencil on paper, 19 × 25" (48.2 × 63.5 cm). Collection the artist

RIGHT: 16. Untitled. 1954. Pencil on paper, 19 × 25" (48.2 × 63.5 cm). Collection the artist

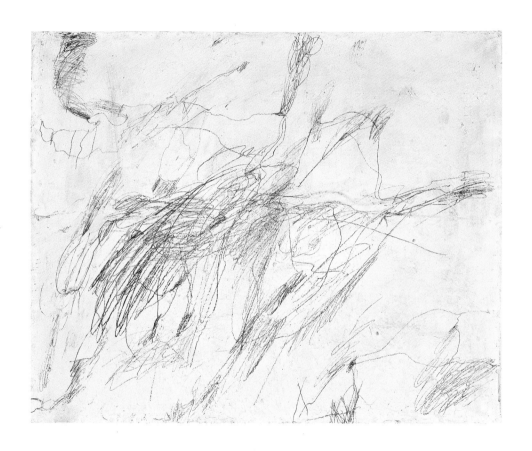

17. Untitled. 1954. House paint and pencil on canvas, 28⅞ × 36" (73.4 × 91.4 cm). The Menil Collection, Houston

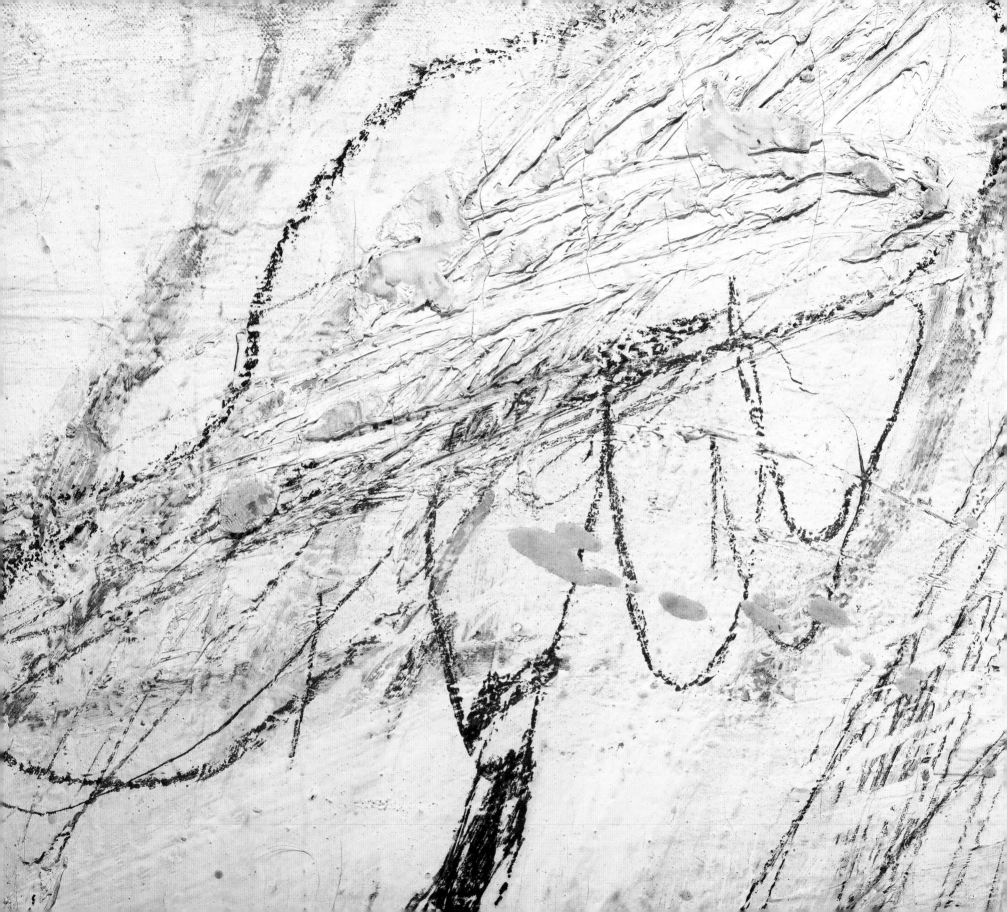

OPPOSITE: 18. Detail of upper edge, center, of untitled painting (pl. 19), actual size

ABOVE: 19. Untitled. 1954. House paint, crayon, and pencil on canvas, 68¾" × 7' 2" (174.5 × 218.5 cm). Private collection

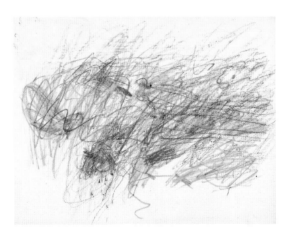

TOP LEFT: 20. Untitled. 1954. Gouache and crayon on paper, 19 × 24⅞" (48.2 × 63.1 cm). Collection Robert Rauschenberg

TOP RIGHT: 21. Untitled. 1954. Gouache and crayon on paper, 19 × 24⅞" (48.2 × 63.1 cm). Collection Robert Rauschenberg

BOTTOM: 22. Untitled. 1954. Gouache and crayon on paper, 19 × 25" (48.2 × 63.5 cm). Collection Robert Rauschenberg

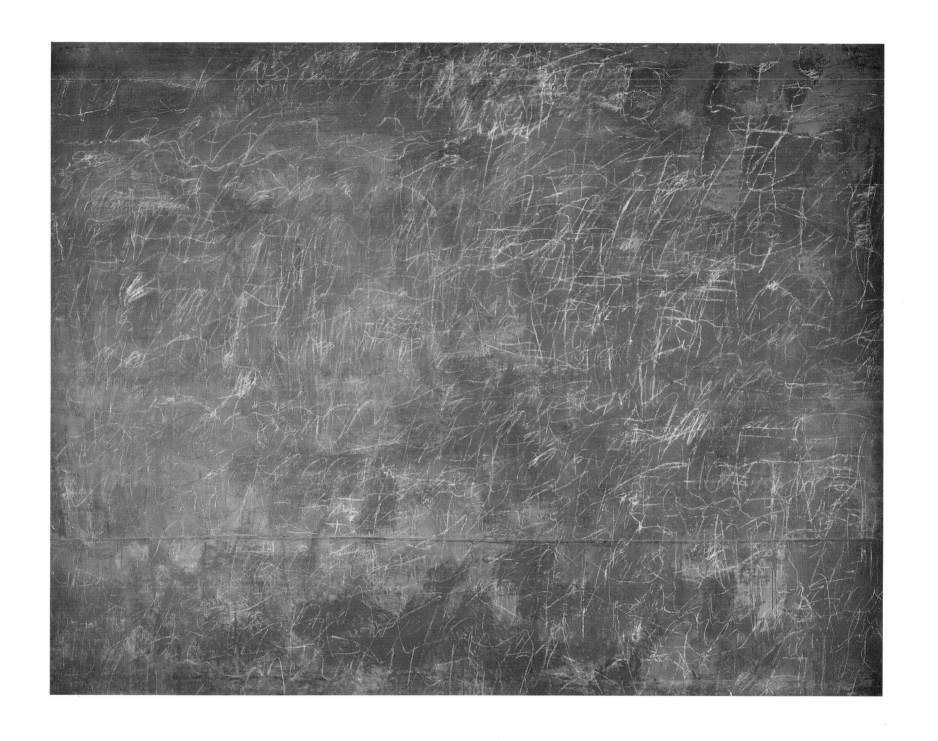

23. **Panorama**. 1954(?). House paint, crayon, and chalk on canvas, 8' 4" × 11' 2" (254 × 340.4 cm). Private collection. Courtesy Thomas Ammann Fine Art, Zurich

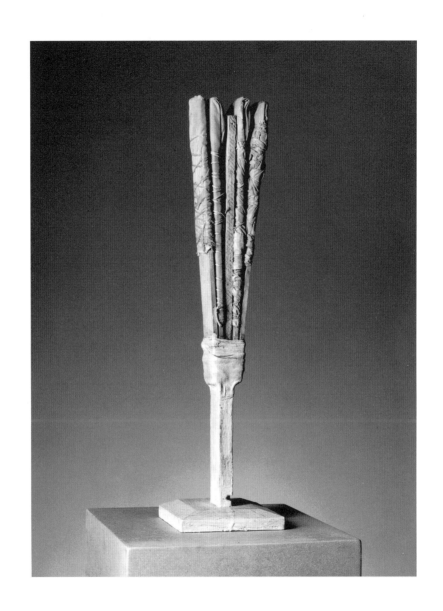

24. Untitled. 1955. Wood, cloth, string, and wall paint, 22¼ × 5⅝ × 5⅛" (56.5 × 14.3 × 13 cm). Collection the artist

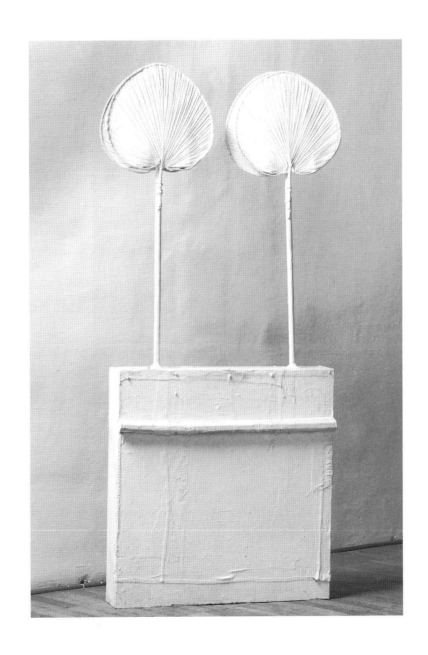

25. Untitled. c. 1955. House paint, two fans, and wooden box, 54½ × 26¼ × 5" (138.5 × 66.8 × 12.8 cm). Collection the artist

26. **The Geeks**. 1955. House paint, pencil, and pastel on canvas, 42½ × 50" (108 × 127 cm). Private collection. Courtesy Thomas Ammann Fine Art, Zurich

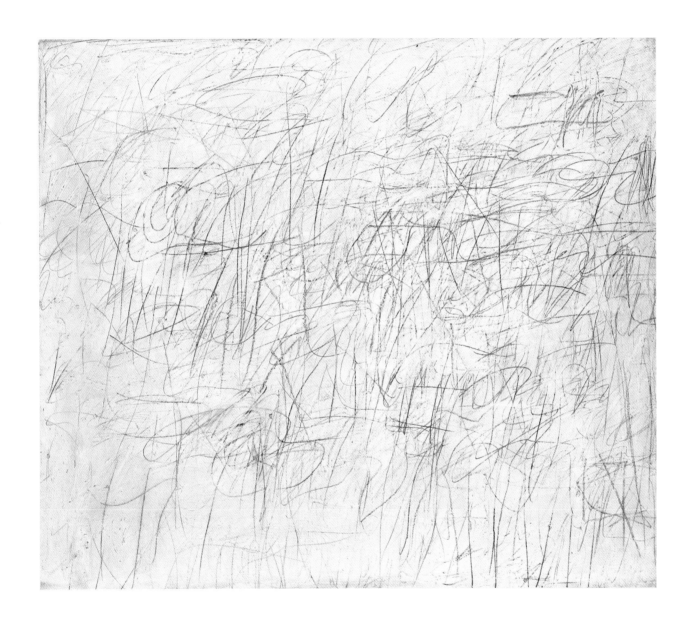

27. **Criticism**. 1955. House paint, crayon, pencil, and pastel on canvas, 50 × 57⅞" (127 × 147 cm). Private collection

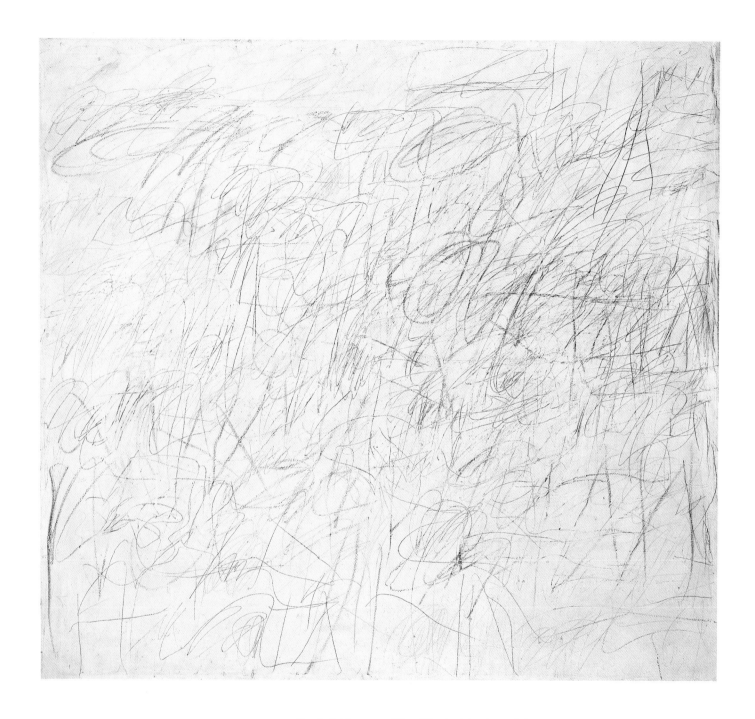

OPPOSITE: 28. Detail of right center of **Free Wheeler** (pl. 29), actual size

ABOVE: 29. **Free Wheeler**. 1955. House paint, crayon, pencil, and pastel on canvas, 68½" × 6' 2¾" (174 × 190 cm). Marx Collection, Berlin

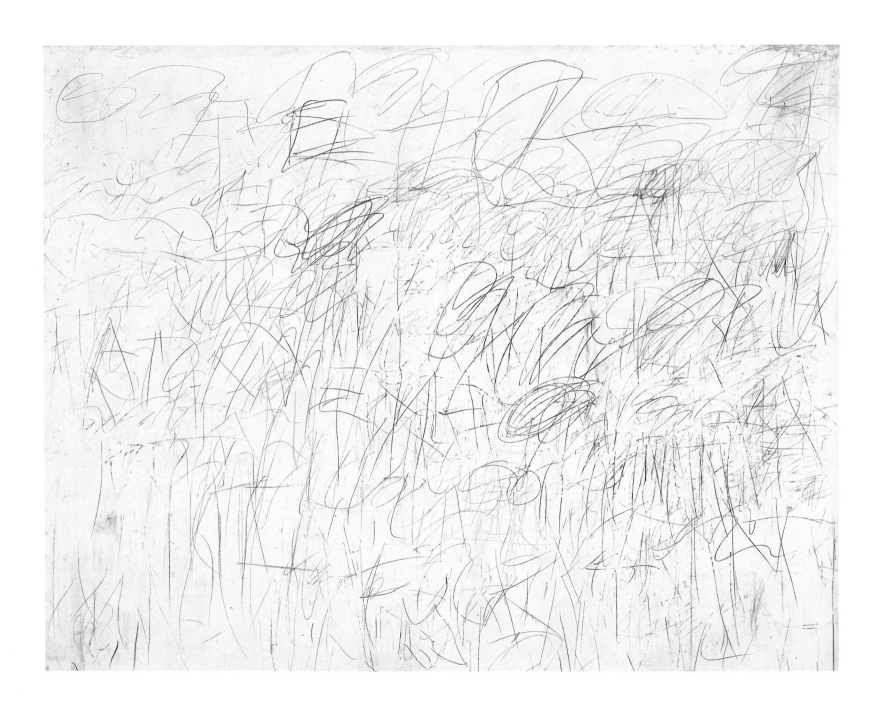

30. **Academy**. 1955. House paint, pencil, and pastel on canvas, 6' 3¼" × 7' 10⅞" (191 × 241 cm). Private collection

31. **Olympia**. 1957. House paint, crayon, and pencil on canvas, 6' 6¾" × 8' 8⅛" (200 × 264.5 cm). Private collection

OPPOSITE: 32. Detail of upper right of **Blue Room** (pl. 33), actual size

ABOVE: 33. **Blue Room**. 1957. House paint, crayon, and pencil on canvas, 56¼ × 71½" (142.9 × 181.6 cm). Sonnabend Collection

34. Untitled. 1958. Pencil and crayon on paper, 27½ × 39⅜" (70 × 100 cm). Courtesy Galerie Karsten Greve, Cologne

35. Untitled. 1958. House paint and pencil on canvas, 52¾ × 62⅝" (134 × 159 cm). Collection David Geffen

36. Untitled. 1959. House paint, pencil, and crayon on canvas, 6' 2" × 8' 2" (188 × 249 cm). Private collection. On loan to The Menil Collection, Houston

37. Untitled. 1959. House paint, pencil, and crayon on canvas, 6' 2" × 8' 2" (188 × 249 cm). Private collection. On loan to The Menil Collection, Houston

38. Untitled. 1959. Pencil on paper, 24 × 36¼" (60.9 × 92 cm). Private collection

39. Untitled. 1959. Pencil on paper, 24 × 36¼" (60.9 × 92 cm). Private collection

40. Untitled (Sperlonga). 1959. Collage with oil paint on paper, 33¾ × 24¼" (85.7 × 61.5 cm). Private collection

41. Untitled. 1959. House paint, pencil, and crayon on canvas, 60" × 6' 2" (152.4 × 188 cm). Private collection

42. Untitled (Sperlonga). 1959. Paint and pencil on paper, 27½ × 39¼" (70 × 99.6 cm). Collection Reiner Speck

43. Untitled (Sperlonga). 1959. Paint and pencil on paper, 27⅜ × 39¼" (69.5 × 99.7 cm). Courtesy Galerie Karsten Greve, Cologne

44. Untitled (Sperlonga). 1959. Paint, pastel, and pencil on paper, 27 × 39½" (68.5 × 100.3 cm). Sonnabend Collection

45. **Study for Presence of a Myth**. 1959. Pencil and oil on canvas, 70⅛" × 6' 6¾" (178 × 200 cm). Öffentliche Kunstsammlung Basel, Kunstmuseum

ABOVE: 46. **View**. 1959. Pencil and oil on canvas, 70" × 6' 6¾" (177.8 × 200 cm). Morton G. Neumann Family Collection

FOLDOUT: 47. **The Age of Alexander**. 1959–60. Oil, crayon, and pencil on canvas, 9' 9¼" × 16' 4⅛" (300 × 500 cm). Private collection. On loan to The Menil Collection, Houston

FOLDOUT: 48. **Triumph of Galatea**. 1961. Oil, crayon, and pencil on canvas, 9' 7⅞" × 15' 10¼" (294.3 × 483.5 cm). Collection the artist. On loan to The Menil Collection, Houston

OPPOSITE: 49. Untitled. 1961. Oil, house paint, crayon, and pencil on canvas, 8' 4¾" × 10' ⅞" (256 × 307 cm). Private collection. Courtesy Thomas Ammann Fine Art, Zurich

50. **The Italians**. 1961. Oil, pencil, and crayon on canvas, 6' 6⅝" × 8' 6¼" (199.5 × 259.6 cm). The Museum of Modern Art, New York. Blanchette Rockefeller Fund

51. **The First Part of the Return from Parnassus**. 1961. Oil, pencil, and crayon on canvas, 7' 10¾" × 9' 10⅜" (240.7 × 300.7 cm). Private collection

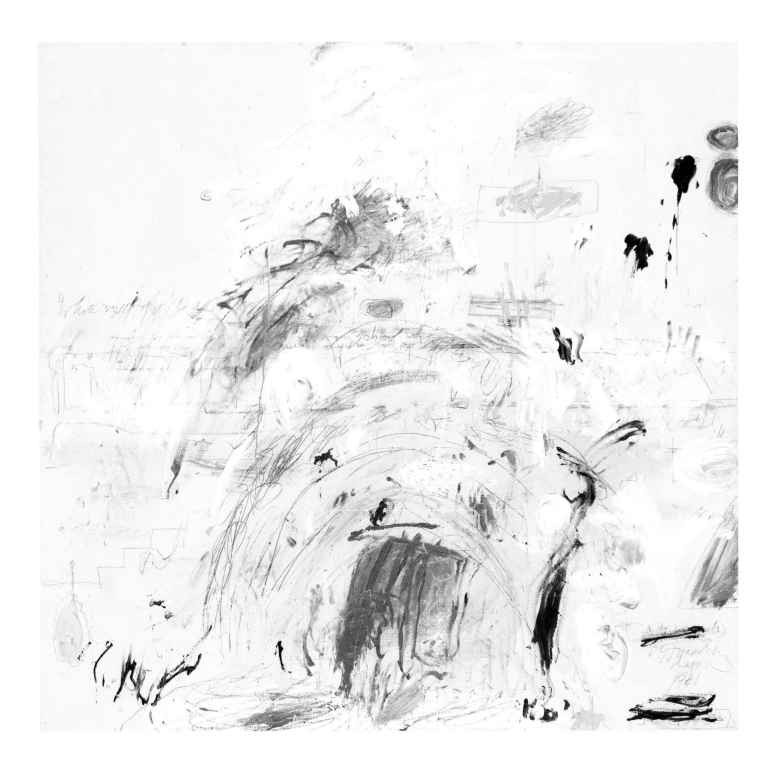

52. **School of Athens**. 1961. Oil, house paint, crayon, and pencil on canvas, 6' 2⅞ × 6' 6⅞" (190.3 × 200.5 cm). Private collection

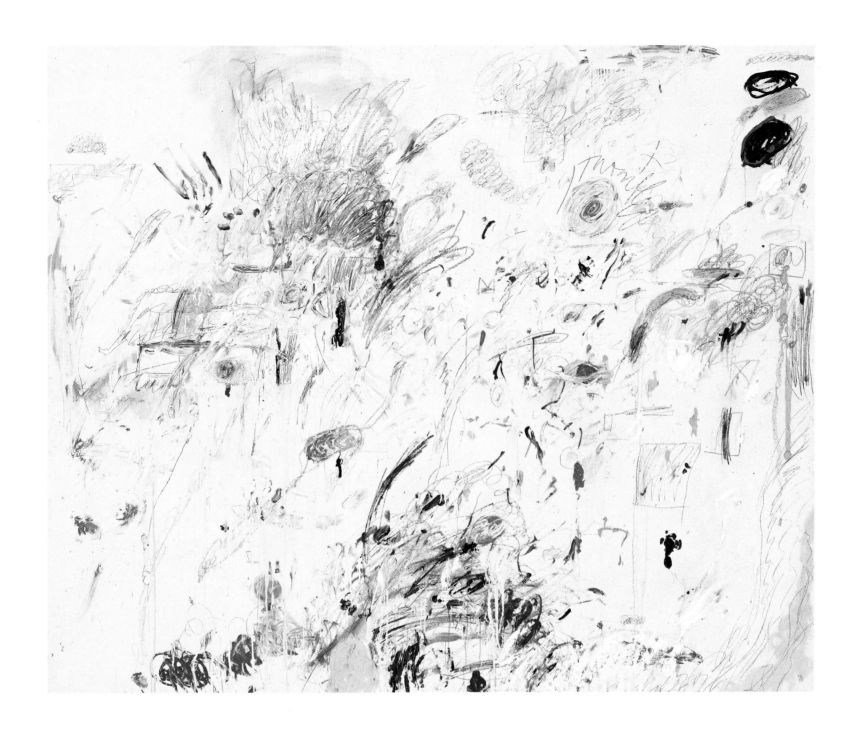

53. **Empire of Flora**. 1961. Oil, crayon, and pencil on canvas, 6' 6¾" × 7' 11¼" (200 × 242 cm). Marx Collection, Berlin

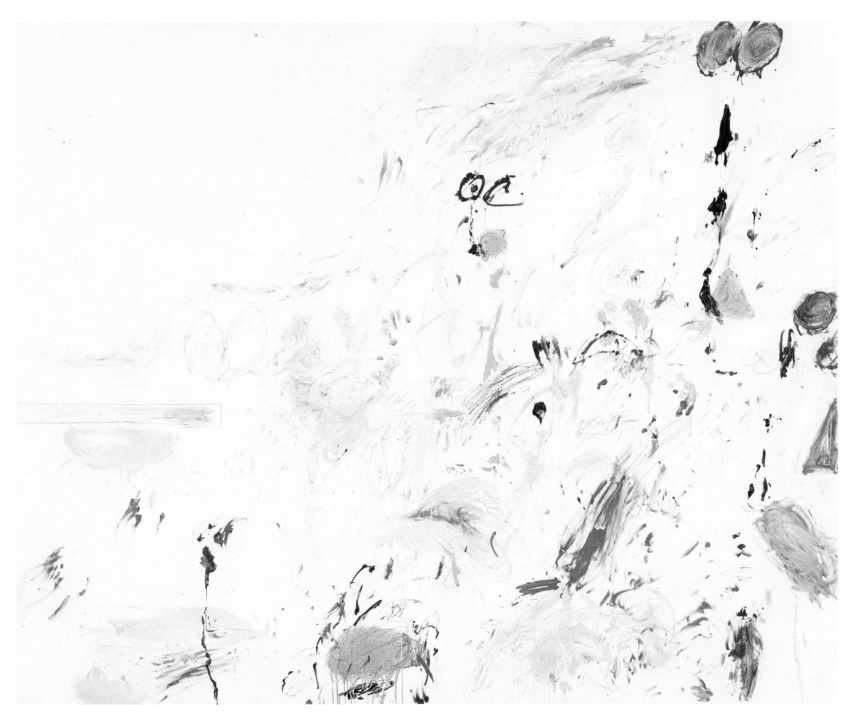

OPPOSITE: 54. Detail of lower right of **Bay of Naples** (pl. 55), actual size

ABOVE: 55. **Bay of Naples**. 1961. Oil, crayon, and pencil on canvas, 7' 11⅜" × 9' 9¾" (240 × 300 cm). Dia Center for the Arts, New York, and The Menil Collection, Houston

TOP LEFT: 56. **Delian Ode**. 1961. Crayon, pencil, ballpoint pen, and felt-tip pen on paper, 15¼ × 14⅛" (38.8 × 35.7 cm). Private collection

TOP RIGHT: 57. **Delian Ode 28**. 1961. Crayon, pencil, ballpoint pen, and felt-tip pen on paper, 13⅛ × 14" (33.4 × 35.6 cm). Private collection

BOTTOM: 58. **Delian Ode 37**. 1961. Crayon, pencil, ballpoint pen, and felt-tip pen on paper, 13 × 13¾" (33.2 × 35.1 cm). Private collection

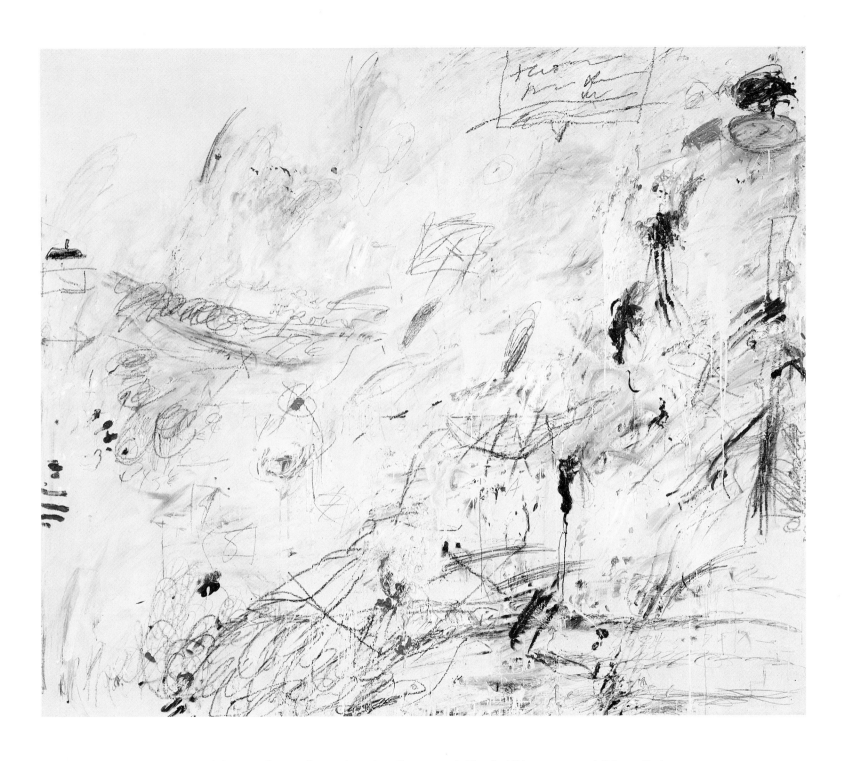

59. Untitled. 1961. Oil, crayon, house paint, and pencil on canvas, 6' 7¾" × 7' 10¾" (202.5 × 240.5 cm). Private collection

60. **Ferragosto IV**. 1961. Oil, crayon, and pencil on canvas, 65¼" × 6' 6⅞" (165.5 × 200.4 cm). Collection David Geffen

61. **Ferragosto V**. 1961. Oil, crayon, and pencil on canvas, 64¾" × 6' 6¾" (164.5 × 200 cm). Private collection. Courtesy Thomas Ammann Fine Art, Zurich

LEFT: 62. Untitled. 1961–63. Ballpoint pen, pencil, and crayon on paper, 13¼ × 14" (33.6 × 35.6 cm). Collection the artist

RIGHT: 63. Untitled. 1961. Ballpoint pen, pencil, and crayon on paper, 13¼ × 14" (33.6 × 35.6 cm). Private collection

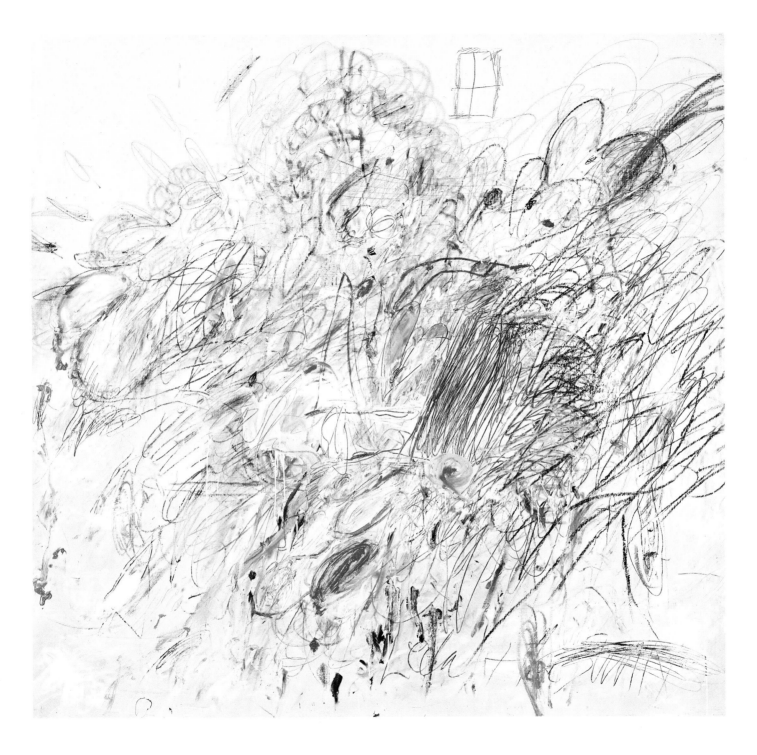

64. **Leda and the Swan**. 1962. Oil, pencil, and crayon on canvas, 6' 3" × 6' 6¾" (190.5 × 200 cm). Private collection.

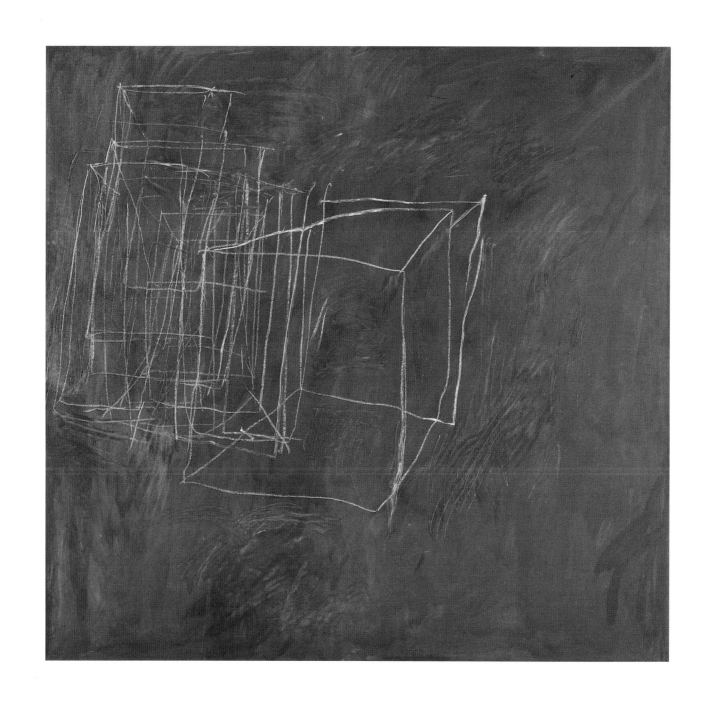

65. **Night Watch**. 1966. House paint and crayon on canvas, 6' 2¾" × 6' 6¾" (190 × 200 cm). Courtesy Galerie Karsten Greve, Cologne, Paris, Milan

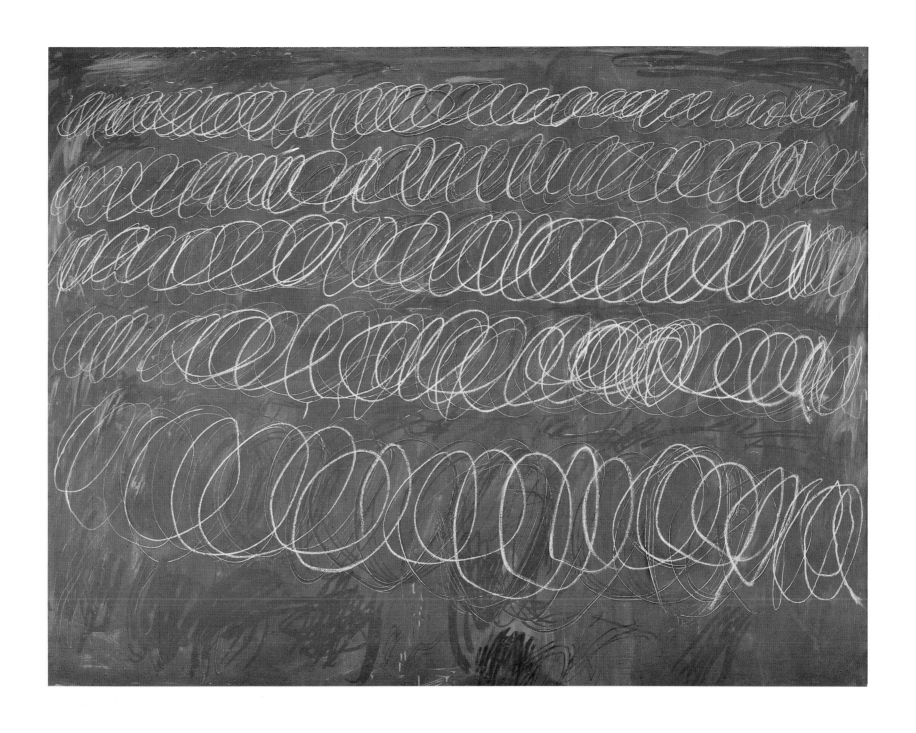

66. Untitled. 1967. House paint and crayon on canvas, 6' 7" × 8' 8" (200.7 × 264.3 cm). Courtesy Galerie Karsten Greve, Cologne, Paris, Milan

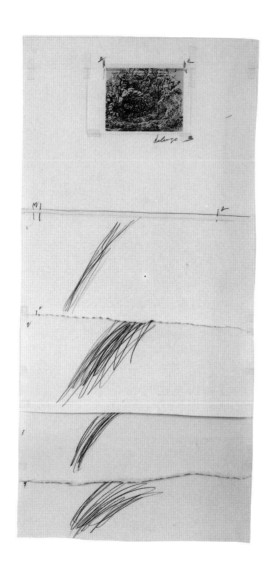

67. Untitled. 1968. Pencil and collage on paper, 37¼ × 17⅞" (94.7 × 45.5 cm). Private collection

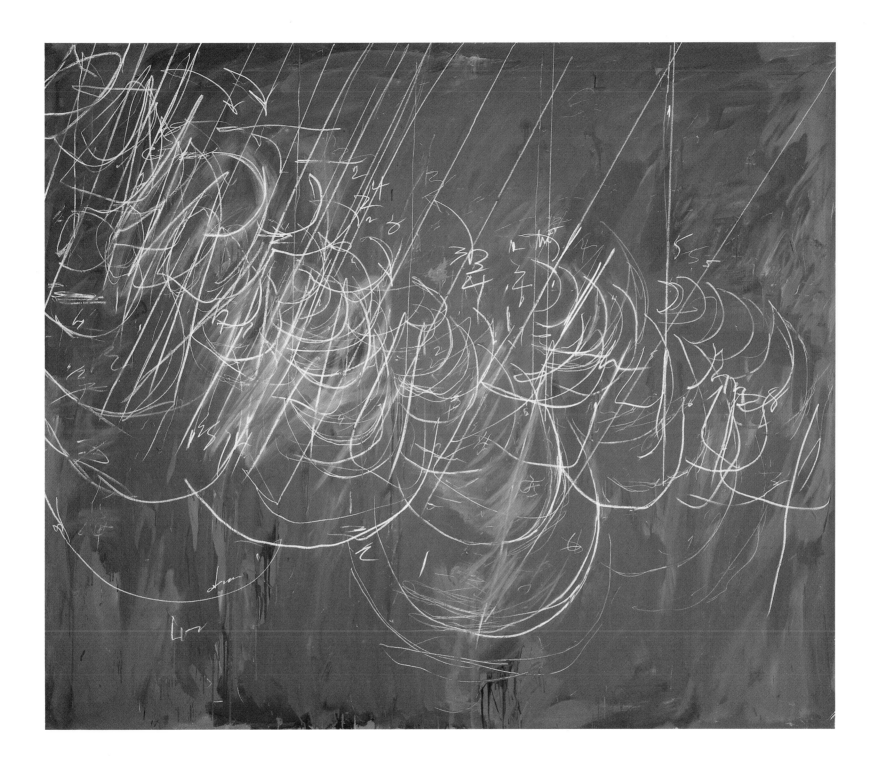

68. Untitled. 1968, 1971. House paint and crayon on canvas, 6' 6¾" × 7' 10⅛" (200 × 239 cm). Private collection, Germany

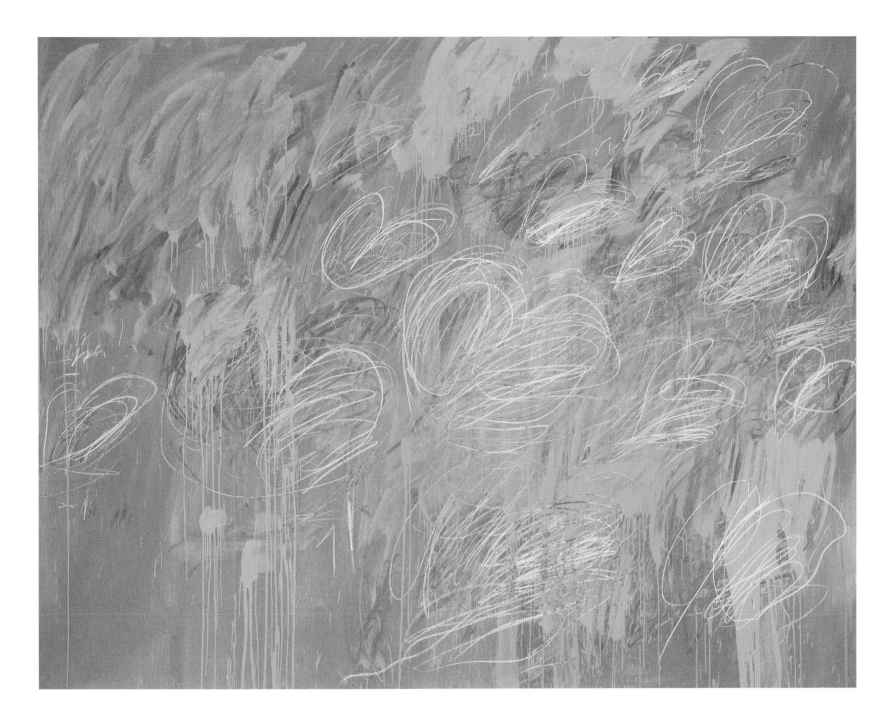

OPPOSITE: 69. Detail of lower left of untitled painting (pl. 70), actual size

ABOVE: 70. Untitled. 1968. Oil and crayon on canvas, 6' 7" × 8' 7" (200.6 × 261.6 cm). Museum of Art, Rhode Island School of Design, Providence.
The Albert Pilavin Collection of Twentieth-Century American Art

71. Untitled. 1969. Pencil and collage on paper, 34⅝ × 18" (87.9 × 45.7 cm). Collection Robert Rauschenberg

72. Untitled. 1968. Pencil and collage on paper, 29 × 17⅞" (73.8 × 45.5 cm). Private collection

73. Untitled. 1969. Pencil and crayon on paper, 22¾ × 30½" (57.8 × 77.5 cm). Private collection

74. Untitled. 1969. Pencil and crayon on paper, 22¾ × 30½" (57.8 × 77.5 cm). Private collection

75. Untitled (Bolsena). 1969. House paint, crayon, and pencil on canvas, 6' 6½" × 7' 10½" (199.5 × 240 cm). Private collection

76. Untitled (Bolsena). 1969. House paint, crayon, and pencil on canvas, 6' 6¾" × 7' 10½" (200 × 240 cm). Collection Nicola del Roscio

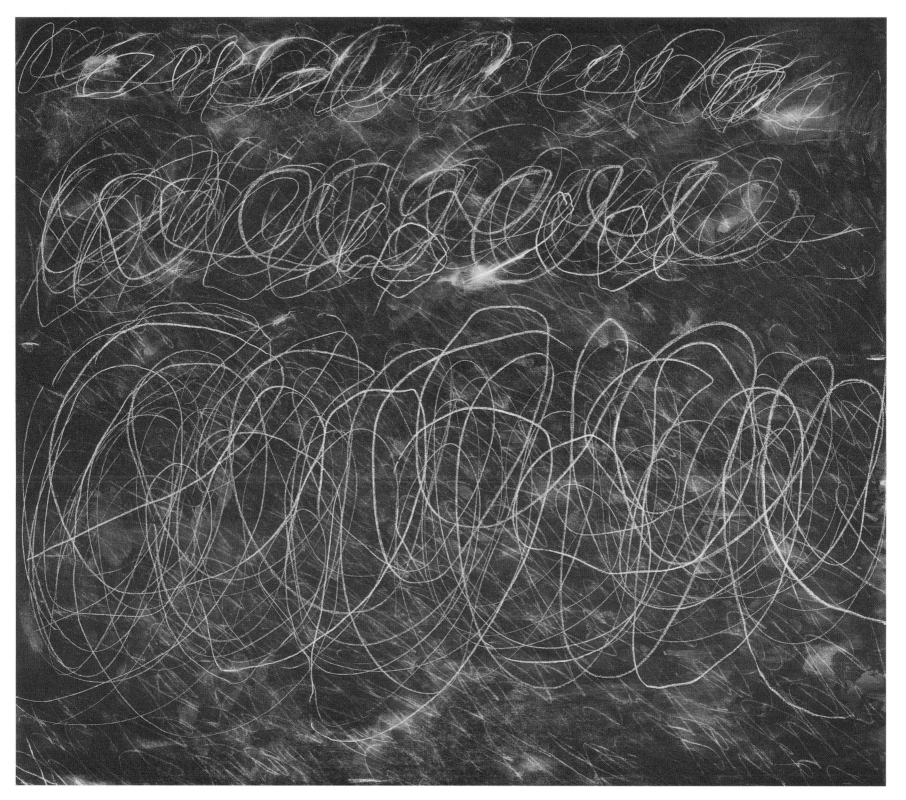

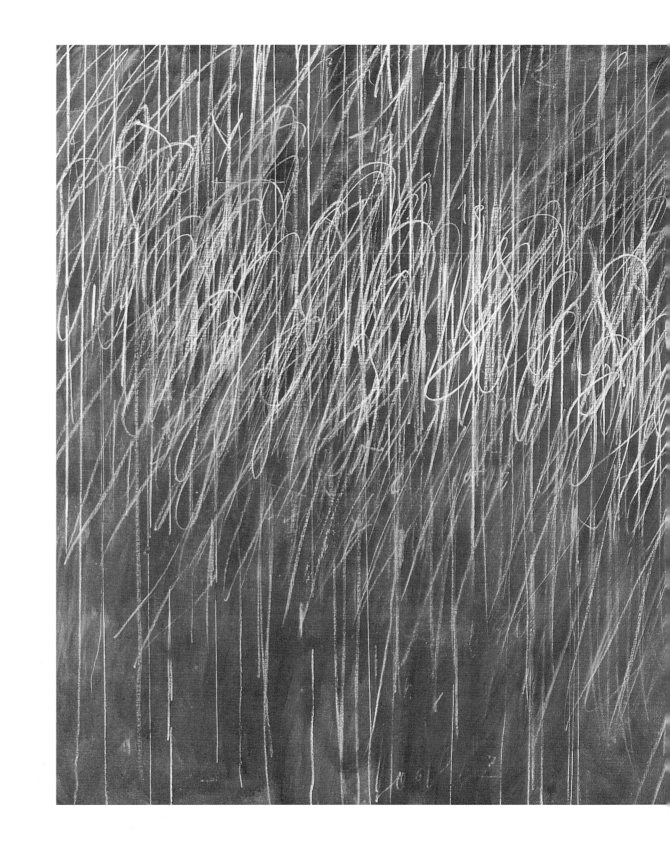

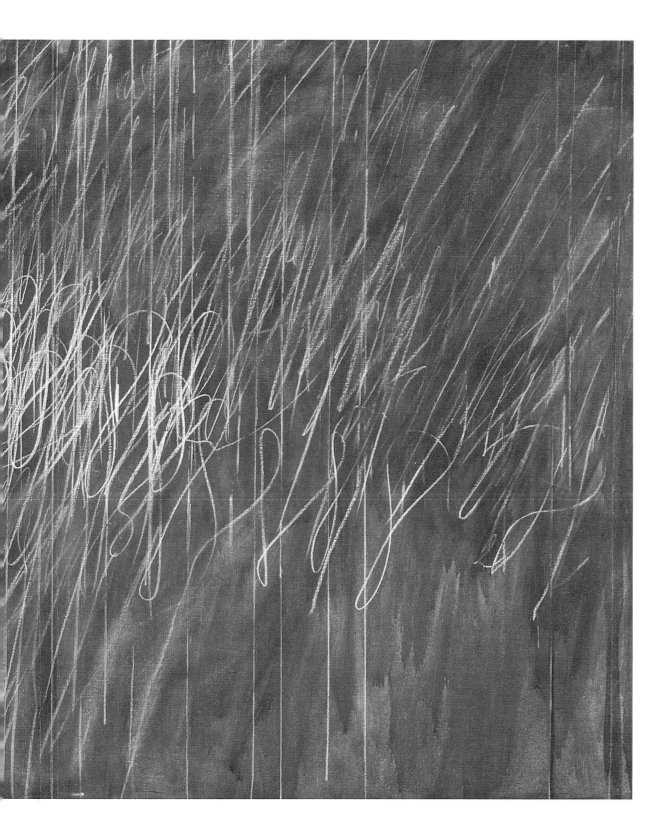

79. Untitled. 1971. Oil, house paint, and crayon on canvas,
6' 7⅛" × 11' 2¼" (198 × 348 cm). Private collection.
On loan to The Menil Collection, Houston

LEFT: 80. Untitled. 1972. Pencil and crayon on paper, 11½ × 10½" (29.2 × 26.7 cm). Collection the artist

RIGHT: 81. Untitled. 1973. Pencil, crayon, and collage on paper, 11½ × 10½" (29.2 × 26.7 cm). Collection the artist

LEFT: 82. **Apollo and the Artist**. 1975. Oil, crayon, pencil, and collage on cardboard, 55⅞ × 50⅛" (142 × 127.4 cm). Collection Alessandro Twombly

RIGHT: 83. **Mars and the Artist**. 1975. Oil, crayon, pencil, charcoal, and collage on cardboard, 55⅞ × 50⅛" (142 × 127.4 cm). Collection Alessandro Twombly

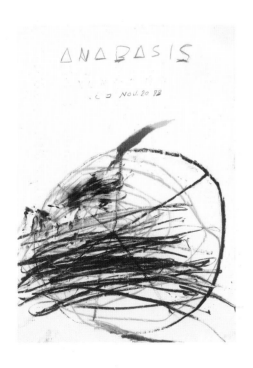

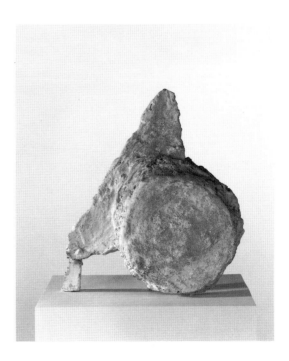

TOP: 84. Untitled. 1978. Wood, fabric, wire, nails, and paint, 17" × 7' 3⅝" × 7¾" (43 × 222.5 × 19.5 cm). Private collection. On loan to The Menil Collection, Houston

BOTTOM LEFT: 85. **Anabasis**. 1983. Pastel, oil, and pencil on paper, 39⅜ × 27½" (100 × 70 cm). Collection the artist

BOTTOM RIGHT: 86. Untitled. 1979. Gesso and paint, 19¼ × 16½ × 8⅝" (49 × 42 × 22 cm). Private collection. On loan to the Kunsthaus, Zurich

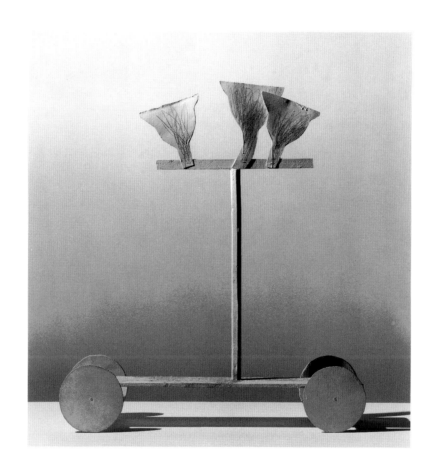

87. Untitled. 1977. Painted synthetic resin with crayon, 34¼ × 31⅛ × 7¼" (87 × 79 × 18.5 cm). Private collection. On loan to The Menil Collection, Houston

88. Untitled. 1980. Oil, watercolor, synthetic polymer paint, chalk, pastel, and photocopy on paper;
three sheets: 25⅝ × 19⅞" (65 × 50.5 cm); 47 × 59⅞" (119.5 × 152 cm); and 13 × 8½" (33 × 21.5 cm). Private collection

89. **Naxos**. 1982. Oil, crayon, pencil, and tempera on paper; three sheets: 32⅜ × 25" (82.3 × 63.5 cm); 68⅜ × 55¾" (173.7 × 141.5 cm); and 32⅜ × 25" (82.3 × 63.5 cm). Collection Froehlich, Stuttgart

90. **Suma**. 1982. Oil, crayon, and pencil on paper, 56½ × 50¼" (143.5 × 127.5 cm). Private collection. Courtesy Thomas Ammann Fine Art, Zurich

THIS PAGE AND OPPOSITE: 91. **Hero and Leander**. 1981 (left panel replaced 1984). Oil and crayon on canvas; three panels: 66⅛" × 6' 8¾" (168 × 205 cm); 68½" × 6' 11⅞" (174 × 213 cm); and 68½" × 6' 11⅞" (174 × 213 cm). Private collection

92. **Wilder Shores of Love**. 1985. Oil, crayon, and pencil on plywood, 55⅛ × 47¼" (140 × 120 cm). Private collection

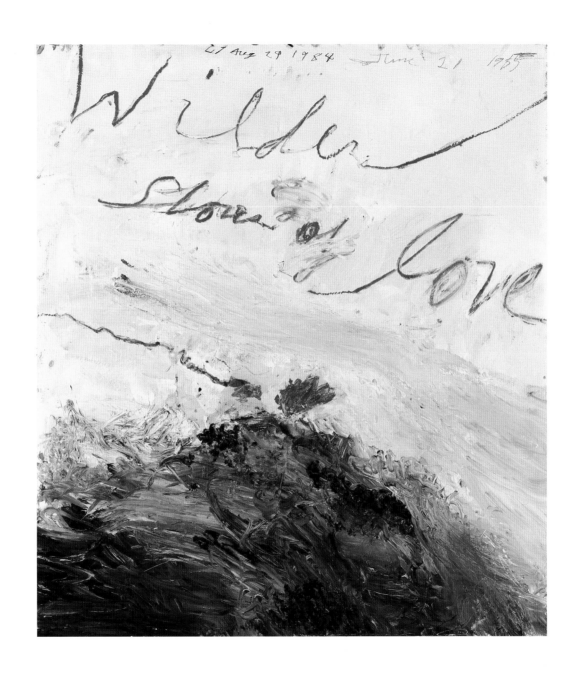

93. **Wilder Shores of Love**. 1985. Oil, crayon, and pencil on plywood, 55⅛ × 47¼" (140 × 120 cm). Private collection

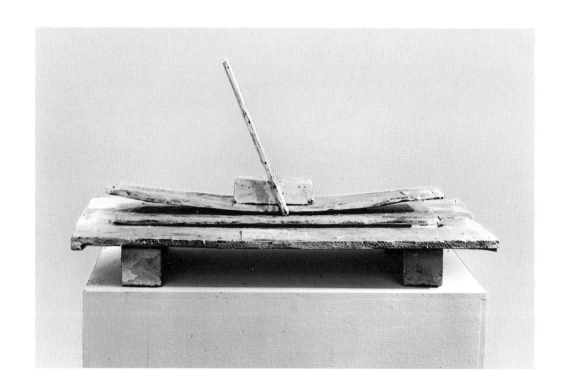

94. **Winter's Passage, LUXOR**. 1985. Wood, nails, and paint, 21¼ × 41⅝ × 20⅜" (54 × 105.7 × 51.6 cm). Private collection. On loan to the Kunsthaus, Zurich

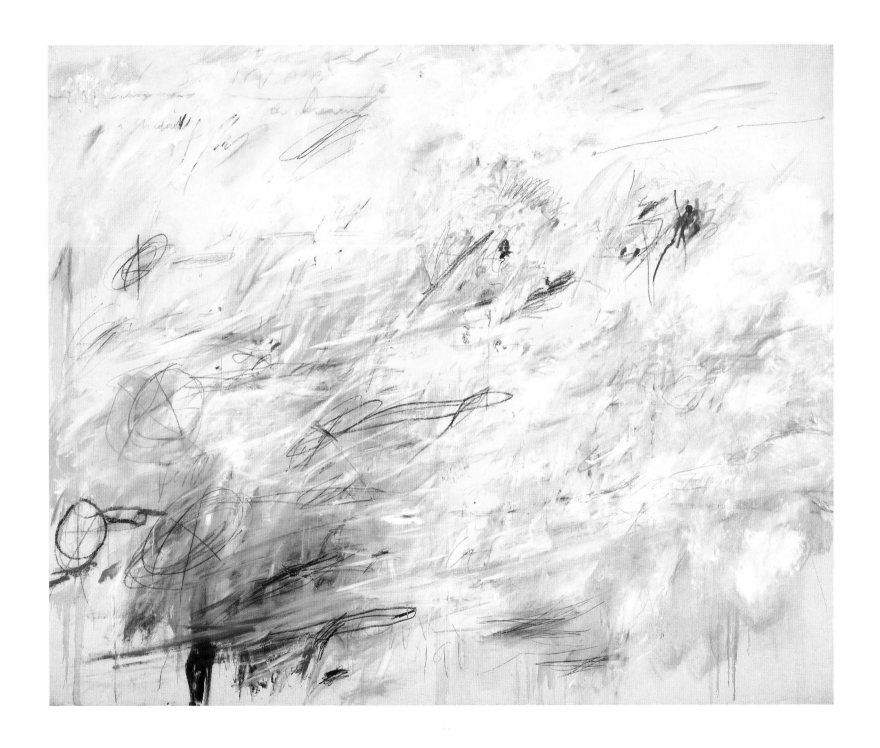

95. Untitled. 1964, 1984. Oil, pencil, and crayon on canvas, 6' 8⅜" × 8' 2¼" (204 × 249.5 cm). Collection Emily Fisher Landau, New York

Gaeta Set I. 1986 (series of six drawings; shown top left to bottom right). Private collection

96. Gaeta Set I, no. 1. House paint, crayon, and oil on paper, 11¼ × 10⅜" (28.5 × 26.5 cm). 97. Gaeta Set I, no. 2. House paint, crayon, and oil on paper, 11¼ × 9⅞" (28.5 × 25 cm)

98. Gaeta Set I, no. 3. House paint, crayon, and oil on paper, 11¼ × 9⅞" (28.5 × 25 cm). 99. Gaeta Set I, no. 4. House paint, pencil, and crayon on paper, 11¼ × 10⅞" (28.5 × 27.5 cm)

100. Gaeta Set I, no. 5. House paint, crayon, and oil on paper, 11¼ × 9⅞" (28.5 × 25 cm). 101. Gaeta Set I, no. 6. House paint, crayon, and oil on paper, 11¼ × 9⅝" (28.5 × 24.5 cm)

Gaeta Set II. 1986 (series of eight drawings; shown top left to bottom right). Private collection

102. Gaeta Set II, no. 1. Pastel on paper, 11½ × 10⅝" (29.2 × 27 cm). 103. Gaeta Set II, no. 2. House paint and tempera on paper, 11½ × 10⅝" (29.2 × 27 cm)

104. Gaeta Set II, no. 3. House paint and tempera on paper, 11½ × 10⅝" (29.2 × 27 cm). 105. Gaeta Set II, no. 4. Tempera, house paint, crayon, and pencil on paper, 11½ × 10⅝" (29.2 × 27 cm)

106. Gaeta Set II, no. 5. Crayon and tempera on paper, 11½ × 10⅝" (29.2 × 27 cm). 107. Gaeta Set II, no. 6. House paint, charcoal, and tempera on paper, 11½ × 10⅝" (29.2 × 27 cm)

108. Gaeta Set II, no. 7. Paint stick and charcoal on paper, 11½ × 10⅝" (29.2 × 27 cm). 109. Gaeta Set II, no. 8. Charcoal on paper, 11½ × 10⅝" (29.2 × 27 cm)

110. **Petals of Fire**. 1988. Collage, gesso, synthetic polymer paint, oil stick, and pencil on paper stapled to painted plywood, 26¾ × 24" (68 × 61 cm). Private collection

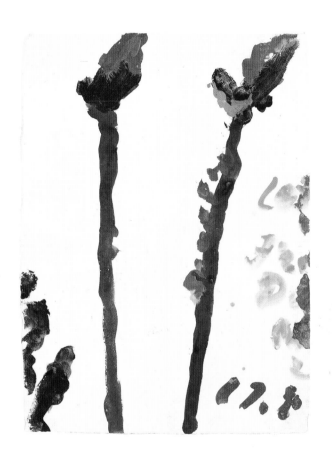

LEFT: 111. Untitled. 1990. Gouache on paper, 29½ × 22½" (75 × 57 cm). Private collection

RIGHT: 112. Untitled. 1990. Gouache on paper, 29½ × 22½" (75 × 57 cm). Private collection

113. Untitled. 1990. Synthetic polymer paint, oil stick, and pencil on paper, 30 × 22¼" (76.2 × 56.5 cm). Private collection

114. Untitled. 1990. Synthetic polymer paint, oil stick, and pencil on paper, 30 × 22¼" (76.2 × 56.5 cm). Private collection

115. **Thermopylae**. 1991. Plaster on wicker and coarsely woven fabric, graphite, wooden sticks, plaster-coated cloth flowers on plastic stems, and wire, 54 × 35 × 26" (137 × 89 × 66 cm). Private collection. On loan to The Menil Collection, Houston

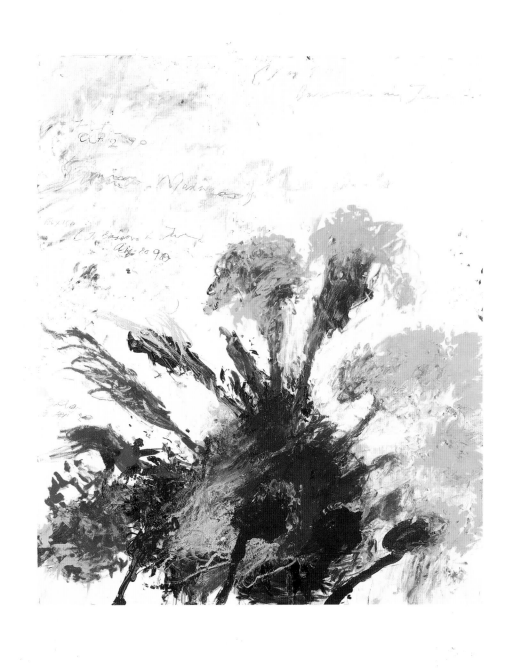

116. **Summer Madness**. 1990. Oil, gouache, pencil, and crayon on paper, 59 × 49⅝" (150 × 126 cm). Collection Udo and Anette Brandhorst, Cologne

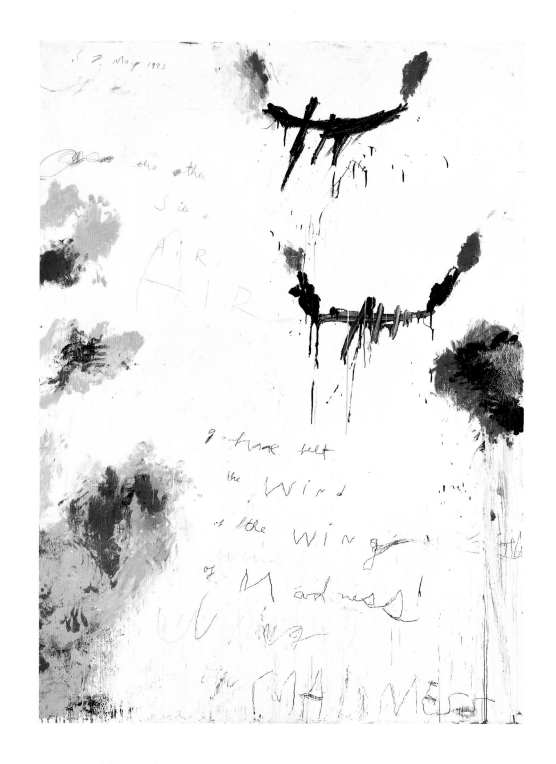

117. Untitled. 1992. Oil, pencil, and crayon on plywood, 7' 8⅛" × 67⅞" (234 × 172.5 cm). Private collection

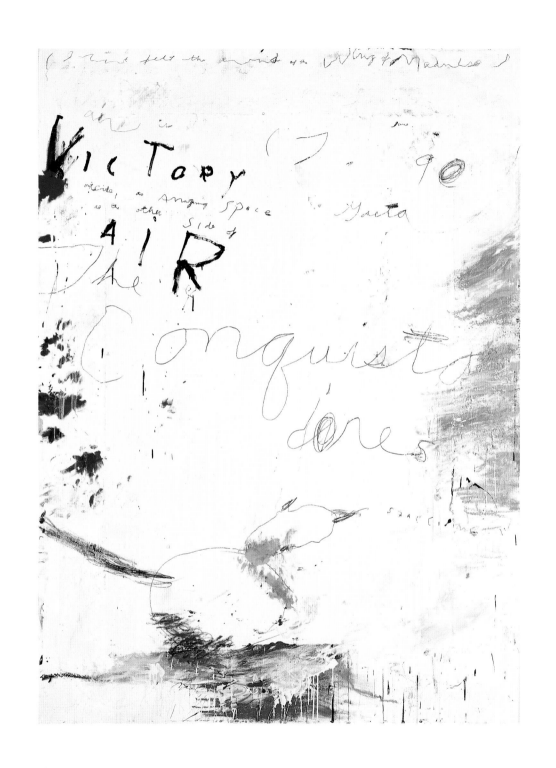

118. Untitled. 1990. Oil, pencil, and crayon on plywood, 7' 8⅛" × 67¾" (234 × 172 cm). Private collection

119. Untitled (Boat). 1991. Baked synthetic clay, 1⅞ × 11¼ × 4½" (4.8 × 28.6 × 11.4 cm). Private collection. On loan to The Menil Collection, Houston

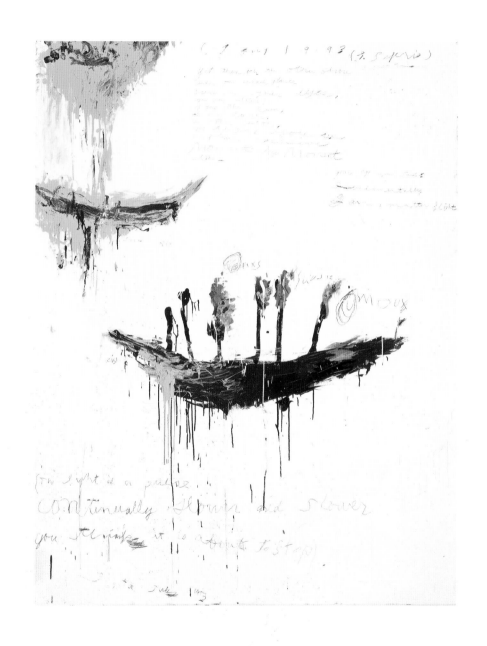

120. Untitled. 1993. Oil, crayon, and pencil on plywood, 6' 5" × 59⅞" (195.5 × 152 cm). Collection Udo and Anette Brandhorst, Cologne

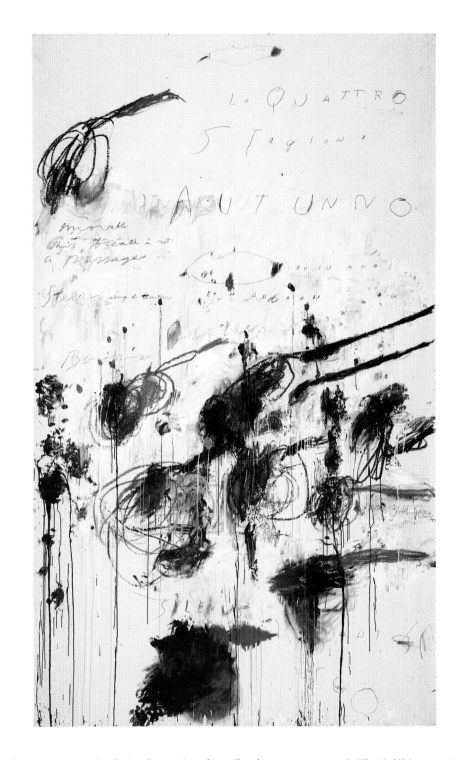

121. **The Four Seasons: Autumn**. 1993–94. Synthetic polymer paint, oil, pencil, and crayon on canvas, 10' 3½" × 6' 2¾" (313.7 × 189.9 cm). Private collection

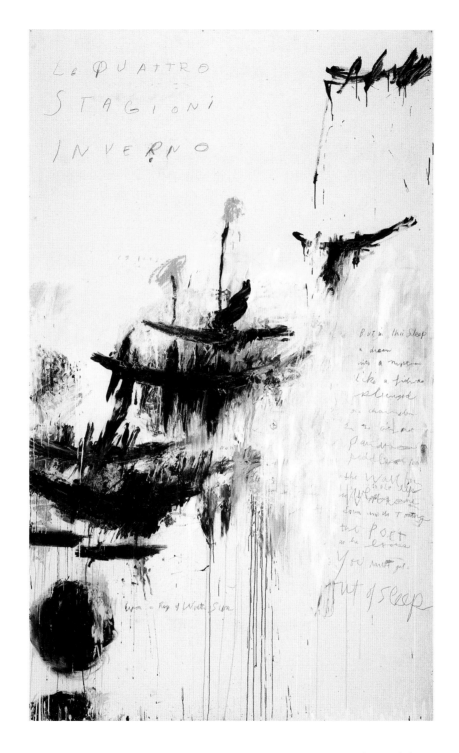

122. **The Four Seasons: Winter**. 1993–94. Synthetic polymer paint, oil, pencil, and crayon on canvas, 10' 3¼" × 6' 2⅞" (313 × 190.1 cm). Private collection

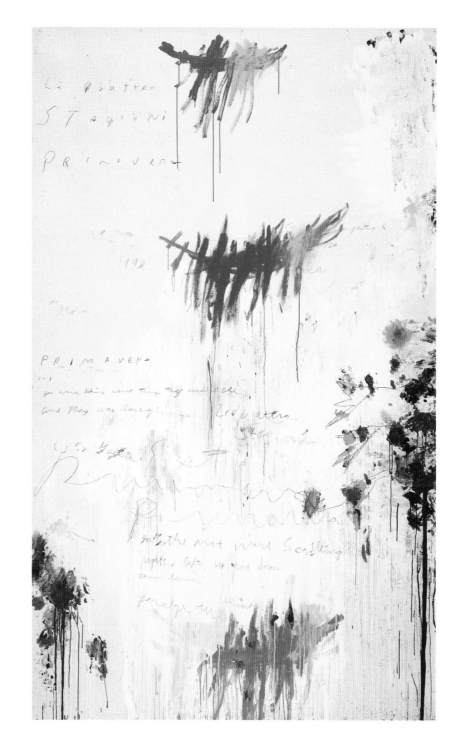

123. **The Four Seasons: Spring**. 1993–94. Synthetic polymer paint, oil, pencil, and crayon on canvas, 10' 3⅛" × 6' 2⅞" (312.5 × 190 cm). Private collection

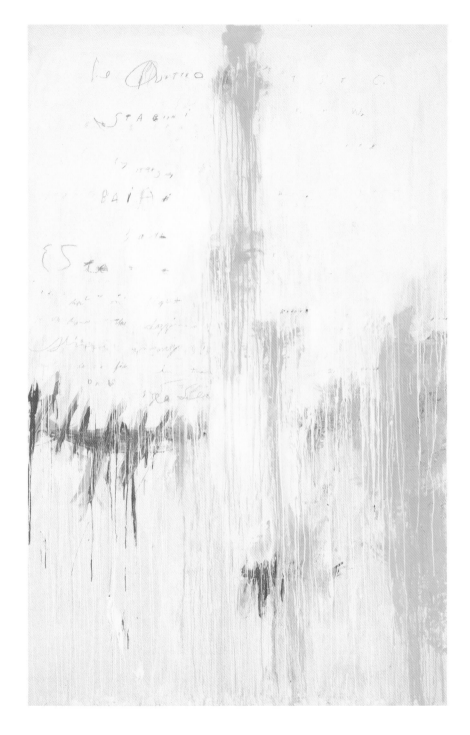

124. **The Four Seasons: Summer**. 1994. Synthetic polymer paint, oil, pencil, and crayon on canvas, 10' 3¾" × 6' 7⅛" (314.5 × 201 cm). Private collection

For a comprehensive bibliography, see the catalogue raisonné of Twombly's paintings, by Heiner Bastian, listed below.

MONOGRAPHS AND CATALOGUES RAISONNÉS

Bastian, Heiner. *Cy Twombly: Zeichnungen, 1953–1973.* Frankfurt am Main, Berlin, and Vienna: Propyläen Verlag, 1973.

———. *Cy Twombly: Bilder/Paintings, 1952–1976.* Frankfurt am Main, Berlin, and Vienna: Propyläen Verlag, 1978.

———. *Cy Twombly: Fifty Days at Ilium—A Painting in Ten Parts.* Frankfurt am Main, Berlin, and Vienna: Propyläen Verlag, 1979. 2nd ed., Stuttgart: Heiner Bastian and Edition Cantz, 1990.

———. *Cy Twombly: Das graphische Werk, 1953–1984 / A Catalogue Raisonné of the Printed Graphic Work.* Munich: Schellmann; New York: New York University Press, 1985.

———. *Cy Twombly: Twenty-four Short Pieces.* Munich: Schirmer/Mosel, 1989.

———. *Cy Twombly: Poems to the Sea.* Munich: Schirmer/Mosel, 1990.

———. *Cy Twombly: Letter of Resignation.* Munich: Schirmer/Mosel, 1991.

———. *Cy Twombly: Catalogue Raisonné of the Paintings,* vol. I: *1948–1960.* Munich: Schirmer/Mosel, 1992.

———. *Cy Twombly: Catalogue Raisonné of the Paintings,* vol. II: *1961–1965.* Munich: Schirmer/Mosel, 1993.

Lambert, Yvon. *Catalogue raisonné des oeuvres sur papier de Cy Twombly: 1973–1976.* Text by Roland Barthes, "Non multa sed multum." Milan: Multhipla, 1979.

———. *Catalogue raisonné des oeuvres sur papier de Cy Twombly: 1977–1982.* Text by Philippe Sollers, "Les Épiphanies de Twombly / Twombly's Epiphanies." Milan: Multhipla Edizioni, 1991.

Villa, Emilio. *Cy Twombly e una parafrasi per Cy Twombly.* Rome: Galleria La Tartaruga, 1961.

EXHIBITION CATALOGUES ON THE ARTIST

1951
Chicago: The Seven Stairs Gallery. *Cy Twombly.* Text by Robert Motherwell, "Notes." Text reprinted, along with text by Charles Olson, in *Cy Twombly: Paintings and Sculptures, 1951 and 1953.* New York: Sperone Westwater, 1989.

1958
Rome: Galleria La Tartaruga. *Cy Twombly.* Text by Palma Bucarelli; text reprinted in *Cy Twombly,* Venice: Galleria del Cavallino, 1958; and in *Cy Twombly,* Milan: Galleria del Naviglio, 1958.

1961
Milan: Galleria del Naviglio. *Cy Twombly.* Text by Cesare Vivaldi.

Paris: Galerie J. *Twombly: La Révolution du signe.* Text by Pierre Restany, "La Révolution du signe."

1963
Rome: Galleria La Tartaruga. *Twombly.* Reprints of excerpts and texts by Frank O'Hara, Palma Bucarelli, Emilio Villa, Franco Marino, Cesare Vivaldi, Manfred de la Motte, Gillo Dorfles, and Pierre Restany.

Cologne: Galerie Änne Abels. *Cy Twombly.* Text by Manfred de la Motte.

1968
Milwaukee: Milwaukee Art Center. *Cy Twombly: Paintings and Drawings.* Text by Robert Pincus-Witten, "Learning to Write."

1973
Bern: Kunsthalle. *Cy Twombly: Bilder, 1953–1972.* Text by Carlo Huber.

Basel: Kunstmuseum. *Cy Twombly: Zeichnungen, 1953–1973.* Texts by Franz Meyer, "Cy Twombly: Zeichnungen, 1953–1973"; and Heiner Bastian, "Ein langer Anfang zu den Arbeiten von Cy Twombly."

1975
Cologne: Galerie Karsten Greve. *Cy Twombly: Bilder und Zeichnungen.* Text by Heiner Bastian.

Munich: Galerie Art in Progress. *Cy Twombly: Grey Paintings + Gouaches.* Text by Heiner Bastian, "Notizen/Notes."

Philadelphia: Institute of Contemporary Art, University of Pennsylvania. *Cy Twombly: Paintings, Drawings, Constructions, 1951–1974.* Texts by Suzanne Delehanty, "The Alchemy of Mind and Hand"; and Heiner Bastian, "The First Part of Notes on Mythology and the Manner in Which It Is Found in the Works of Cy Twombly."

1976
Hannover: Kestner-Gesellschaft. *Cy Twombly.* Text by Heiner Bastian, "Aber auch eine Form von Poesie."

Paris: Musée d'Art Moderne de la Ville de Paris, ARC 2. *Cy Twombly: Dessins, 1954–1976.* Text by Marcelin Pleynet, "Desseins des lettres, des chiffres et des mots, ou la peinture par l'oreille: Cy Twombly."

1977
Cologne: Galerie Karsten Greve. *Cy Twombly: Bilder und Zeichnungen.*

1979
New York: Whitney Museum of American Art. *Cy Twombly: Paintings and Drawings, 1954–1977.* Text by Roland Barthes, "Sagesse de l'art / The Wisdom of Art."

1980
Dallas: The University Gallery, Meadows School of the Arts, Southern Methodist University. *Cy Twombly: Paintings and Drawings.* Text by William B. Jordan, "A Note on Cy Twombly."

Milan: Padiglione d'Arte Contemporanea. *Cy Twombly: 50 disegni, 1953–1980.* Texts by Mercedes Garberi; Zeno Birolli, "Is, the bend, is, in, goes in, the form"; and Gabriella Drudi, "L'epos sfigurato di Cy Twombly."

1981
Krefeld: Museum Haus Lange. *Cy Twombly: Skulpturen—23 Arbeiten aus den Jahren 1955 bis 1981.* Text by M[arianne] Stockebrand.

Newport Beach, Calif.: Newport Harbor Art Museum. *Cy Twombly: Works on Paper, 1954–1976.* Text by Susan C. Larsen.

1982
New York: Sperone Westwater Fischer. *Cy Twombly: XI Recent Works.*

Cologne: Galerie Karsten Greve. *Cy Twombly: Arbeiten auf Papier.* Text by Karsten Greve.

London: The Mayor Gallery. *Cy Twombly: An Exhibition of Paintings.* Text by Richard Francis.

1983
New York: Stephen Mazoh Gallery. *Cy Twombly: Paintings.* Text by Marjorie Welish.

1984
Cologne: Galerie Karsten Greve. *Cy Twombly.*

Bordeaux: CAPC, Musée d'Art Contemporain. *Cy Twombly: Oeuvres de 1973–1983.* Texts by Jean-Louis Froment, "À Cy Twombly"; and Jacques Henric, "Les Stratégies ironiques de Cy Twombly."

Baden-Baden: Staatliche Kunsthalle. *Cy Twombly.* Text by Katharina Schmidt, "Weg nach Arkadien: Gedanken zu Mythos und Bild in der Malerei von Cy Twombly" (revision later published in *Cy Twombly,* Houston: The Menil Collection, 1989).

New York: Hirschl & Adler Modern. *Cy Twombly: Paintings and Drawings, 1952–1984.*

1985
New York: Dia Art Foundation. *Cy Twombly: Paintings and Drawings.* Text by Donna M. De Salvo.

1986
New York: Hirschl & Adler Modern. *Cy Twombly.* Text by Roberta Smith, "Rewriting History."

1987
Zurich: Kunsthaus. *Cy Twombly: Bilder, Arbeiten auf Papier, Skulpturen.* Texts by Harald Szeemann, "Zur Ausstellung"; Roberta Smith, "Der grosse Mittler"; Demosthenes Davvetas, "Ein Abenteuer: Wenn Skriptur Sprache wird"; reprints of texts and excerpts by Cy Twombly, Frank O'Hara, Pierre Restany, and Roland Barthes. Editions produced for travel: *Cy Twombly: Cuadros, trabajos sobre papel, esculturas,* Madrid: Palacio de Velázquez / Palacio de Cristal, 1987; *Cy Twombly: Paintings, Works on Paper, Sculpture,* London: Whitechapel Art Gallery, 1987; *Cy Twombly: Bilder, Arbeiten auf Papier, Skulpturen,* Düsseldorf: Städtische Kunsthalle, 1987; *Cy Twombly: Peintures, oeuvres sur papier, sculptures,* Paris: Musée National d'Art Moderne, Galeries Contemporaines, Centre Georges Pompidou, 1988 (reprints in French all texts from Zurich catalogue except that by O'Hara; includes additional text by Bernard Blistène, "L'Expérience de l'incertitude," and excerpt from Roland Barthes, "Non multa sed multum" [first published 1979]).

Bonn: Städtisches Kunstmuseum. *Cy Twombly: Serien auf Papier, 1957–1987.* Text by Gottfried Boehm, "Erinnern, Vergessen: Cy Twomblys Arbeiten auf Papier." Catalogue produced for travel: *Twombly: Sèries sobre papel, 1959–87,* Barcelona: Centre Cultural de la Fundació Caixa de Pensions, 1987. Text by Katharina Schmidt, "'A System for Passing': Sobre l'obra de Cy Twombly / 'A System for Passing': On the Work of Cy Twombly"; and translation of text by Gottfried Boehm, "Recordar, oblidar: Treballs en paper de Cy Twombly / Remembering, Forgetting: Cy Twombly's Works on Paper."

Siegen: Städtische Galerie Haus Seel. *Cy Twombly.* Text by Katharina Schmidt, "Cy Twombly."

1988
New York: The Pace Gallery. *Cy Twombly: Works on Paper.*

Bridgehampton, N.Y.: Dia Art Foundation. *Cy Twombly: Poems to the Sea (1959).* Text by Charles Olson (written January 29, 1952).

New York: Vrej Baghoomian, Inc. *Cy Twombly.* Text by David Shapiro.

1989

New York: Sperone Westwater. *Cy Twombly: Paintings and Sculptures, 1951 and 1953.* Texts by Charles Olson (written 1951) and Robert Motherwell, "Notes" (first published 1951).

New York: Gagosian Gallery. *Cy Twombly: Bolsena.* Text by Heiner Bastian.

1990

Houston: The Menil Collection. *Cy Twombly.* Text by Katharina Schmidt, "The Way to Arcadia: Thoughts on Myth and Image in Cy Twombly's Painting" (revision of a text previously published in *Cy Twombly,* Baden-Baden: Staatliche Kunsthalle, 1984).

1993

New York: Matthew Marks Gallery. *Cy Twombly Photographs.* Text by William Katz.

ESSAYS, ARTICLES, AND REVIEWS

Adams, Brooks. "Sizing Up Cy Twombly." *Art and Auction,* vol. 14, no. 6 (January 1992), pp. 74–79, 115, 116.

Ashton, Dore. "Cy Twombly." *Art Digest,* vol. 27, no. 20 (September 15, 1953), p. 20.

Bastian, Heiner. "Eine Form aus Zeit und Psyche." In *Joseph Beuys, Robert Rauschenberg, Cy Twombly, Andy Warhol: Sammlung Marx* (exh. cat.). Munich: Prestel Verlag, 1982, pp. 118–57.

Blistène, Bernard. "Cy Twombly: Fifty Days at Ilium / Cy Twombly: Cinquanta giorni a Ilio." *Flash Art,* nos. 88–89 (March–April 1979), pp. 31–32.

Campbell, Lawrence. "Rauschenberg and Twombly." *Art News,* vol. 52, no. 5 (September 1953), p. 50.

——. "Cy Twombly." *Art News,* vol. 63, no. 3 (May 1964), p. 13.

Celant, Germano, "Roma–New York, 1948–1964," and Germano Celant and Anna Costantini, Chronology. In *Roma–New York, 1948–1964: An Art Exploration.* Translated by Joachim Neugroschel. New York: The Murray and Isabella Rayburn Foundation, Inc.; Milan and Florence: Edizioni Charta, 1993.

Crehan, Hubert. "Cy Twombly." *Art Digest,* vol. 29, no. 8 (January 15, 1955), p. 26.

Crimp, Douglas. "New York Letter." *Art International,* vol. 17, no. 4 (April 1973), pp. 57–59, 102–03; Twombly is discussed on p. 57.

"Cy Twombly." *Current Biography,* vol. 49, no. 4 (April 1988), pp. 55–58.

Davvetas, Demosthenes. "The Erography of Cy Twombly." *Artforum,* vol. 27, no. 8 (April 1989), pp. 130–32.

"Documenti di una nuova figurazione: Toti Scialoja, Gastone Novelli, Pierre Alechinsky, Achille Perilli, Cy Twombly." *L'esperienza moderna,* no. 2 (August–September 1957), pp. 24–33; a text by Twombly appears on p. 32.

Dorfles, Gillo. "Le immagini scritte di Cy Twombly / Written Images of Cy Twombly." *Metro,* no. 6 (June 1962), pp. 62–71.

Fahlström, Öyvind. "Målare i Rom." *Konstrevy,* vol. 34, no. 4 (1958), pp. 144–49.

Feinstein, Roni. "Cy Twombly's Eloquent Voice." *Arts Magazine,* vol. 59, no. 5 (January 1985), pp. 90–92.

Ferren, John. "Stable State of Mind." *Art News,* vol. 54, no. 3 (May 1955), pp. 22–23, 63–64.

Fitzsimmons, James. "New Talent." *Art Digest,* vol. 26, no. 6 (December 15, 1951), p. 20.

——. "Art." *Arts and Architecture,* vol. 70, no. 10 (October 1953), pp. 9, 32–36.

G. S. "Mostre d'arte: Alla Galleria del Cavallino." *Il Gazzetto,* August 20, 1958.

Geelhaar, Christian. "Kunsthalle Ausstellung: Cy Twombly—Bilder, 1953–1972." *Pantheon,* vol. 31, no. 3 (July–September 1973), pp. 325–26.

——. "Kunstmuseum Ausstellung: Cy Twombly—Zeichnungen, 1953–1973." *Pantheon,* vol. 31, no. 4 (October–December 1973), pp. 449–50.

Gendel, Milton. "Recent Exhibitions in Milan." *Art News,* vol. 57, no. 9 (January 1959), p. 52.

Gooding, Mel. "Cy Twombly: Whitmanesque Plenitude and Capacity for Self-Contradiction." *Flash Art,* no. 139 (March–April 1988), pp. 102–03.

Hayes, Richard. "Cy Twombly." *Art News,* vol. 59, no. 8 (December 1960), p. 15.

Heartney, Eleanor. "Cy Twombly." *Art News,* vol. 89, no. 5 (May 1990), p. 204.

Judd, Donald. "Cy Twombly." *Arts Magazine,* vol. 38, nos. 8–9 (May–June 1964), p. 38.

Kozloff, Max. "Cy Twombly, Castelli Gallery." *Artforum,* vol. 6, no. 4 (December 1967), p. 54.

Kuspit, Donald. "Cy Twombly." *Artforum,* 25, no. 2 (October 1986), p. 129.

la Motte, Manfred de. "Cy Twombly." *Blätter und Bilder,* no. 12 (January–February 1961), pp. 64–71.

——. "Cy Twombly." *Quadrum,* no. 16 (1964), pp. 35–46.

——. "Cy Twombly." *Art International,* vol. 9, no. 5 (June 1965), pp. 32–35.

——. "Cy Twombly." *Kunstforum International,* vol. 1, nos. 4–5 (1973), pp. 112–23.

Lawford, Valentine. "Roman Classic Surprise." *Vogue,* vol. 148, no. 9 (November 15, 1966), pp. 182–87.

Myers, John Bernard. "Marks: Cy Twombly." *Artforum,* vol. 20, no. 8 (April 1982), pp. 50–57.

Norden, Linda. "Cy Twombly at Sperone Westwater." *Art in America,* vol. 77, no. 10 (October 1989), pp. 208–09.

——. "Not Necessarily Pop: Cy Twombly and America." In Russell Ferguson, ed., *Hand-Painted Pop: American Art in Transition, 1955–62* (exh. cat.). Los Angeles: The Museum of Contemporary Art; New York: Rizzoli, 1992, pp. 146–61.

O'Hara, Frank. "Cy Twombly." *Art News,* vol. 53, no. 9 (January 1955), p. 46.

——. "Biala, Elaine de Kooning, Twombly, Zogbaum." *Art News,* vol. 54, no. 5 (September 1955), pp. 50–51.

Patton, Phil. "Cy Twombly." *Artforum,* vol. 15, no. 4 (December 1976), pp. 70–72.

Pincus-Witten, Robert. "Cy Twombly." *Artforum,* vol. 12, no. 8 (April 1974), pp. 60–64.

——. "Cy Twombly, Institute of Contemporary Art, Philadelphia." *Artforum,* vol. 13, no. 10 (Summer 1975), p. 65.

Pleynet, Marcelin. "Dessein des lettres, des chiffres et des mots, ou la peinture par l'oreille: Cy Twombly" (1976). First published in *Cy Twombly: Dessins, 1954–1976.* Paris: Musée d'Art Moderne de la Ville de Paris, 1976. Reprinted in *Tel Quel,* no. 67 (Autumn 1976), pp. 10–24. Also reprinted in *Art et littérature.* Paris: Seuil, 1977, pp. 304–23.

Read, Prudence B. "Duet." *Art News,* vol. 50, no. 8 (December 1951), p. 48.

Rosenblum, Robert. "Cy Twombly." In *Art of Our Time: The Saatchi Collection,* vol. 2. London and New York: Lund Humphries in association with Rizzoli, 1984, pp. 24–27.

Rudolph, Karen. "Das Prinzip der Delikatesse." *Neue bildende Kunst,* no. 5 (1993), pp. 38–42.

Russell, John. "Three Striking Current Shows." *New York Times,* January 7, 1979.

Sawin, Martica. "Cy Twombly." *Arts Magazine,* vol. 31, no. 5 (February 1957), p. 57.

——. "Cy Twombly." *Arts Magazine,* vol. 35, no. 2 (November 1960), p. 59.

Scarpetta, Guy. "Cy Twombly: Sismographies." *Art Press,* no. 46 (March 1981), pp. 6–8.

Sheffield, Margaret. "Cy Twombly: Major Changes in Space, Idea, Line." *Artforum,* vol. 17, no. 9 (May 1979), pp. 40–45.

Sinisgalli, Leonardo. "Gli scarabocchi di Cy Twombly." In *I martedì colorati.* Genoa: Immordino Editore, 1967, pp. 167–69.

Smith, Roberta. "Backward Versus Forward." *The Village Voice,* May 24, 1983, p. 83.

——. "Cy Twombly's Tuscan Notes to Himself." *New York Times,* January 7, 1990.

Stevens, Mark. "Classical Musings." *Vanity Fair,* vol. 53, no. 3 (March 1990), pp. 122, 125, 130.

Turbeville, Deborah. "Portrait of a House—As the Artist" (photo essay). Texts by Carter Ratcliff and Sandi Britton. *Vogue,* vol. 172, no. 12 (December 1982), pp. 262–71, 337.

"Twombly al Cavallino." *Gazzettino sera,* August 28–29, 1958.

Varnedoe, Kirk. "Graffiti." In Kirk Varnedoe and Adam Gopnik, *High and Low: Modern Art and Popular Culture* (exh. cat.). New York: The Museum of Modern Art, 1990, pp. 69–99.

Vivaldi, Cesare. "Cy Twombly: Tra ironia e lirismo / Cy Twombly entre ironie et lyrisme / Cy Twombly: Between Irony and Lyrism [sic]." In *Galleria La Tartaruga.* Rome: Galleria La Tartaruga, 1961.

Volpi, Marisa. "Cy Twombly dalla Virginia a Roma insegue i suoi ideali neoclassici." *Avanti,* November 23, 1961.

Welish, Marjorie. "A Discourse on Twombly." *Art in America,* vol. 67, no. 5 (September 1979), pp. 80–83.

Wember, Paul. "Ein Twombly: Museumdirektoren plauden über ihren schönsten Ankauf 1964—'So kritzeln kann jedes Kind!'" *Neue Rheinzeitung,* November 13, 1964.

Yau, John. "Cy Twombly." *Contemporanea,* vol. 2, no. 3 (May 1989), p. 93.

SELECTED EXHIBITIONS

This list is devoted to the artist's one-person exhibitions, supplemented by important early group exhibitions. Catalogues of the exhibitions listed here are cited in the Selected Bibliography. For a comprehensive exhibition history, consult the catalogue raisonné of Twombly's paintings, by Heiner Bastian, also cited there.

1951
Chicago, The Seven Stairs Gallery. "Cy Twombly," November 2–30. Leaflet; text by Robert Motherwell.

New York, Kootz Gallery. "New Talent: Gandy and Twombly," December 4–22.

1953
New York, The Stable Gallery. "Second Stable Annual," January.

Florence, Galleria d'Arte Contemporanea. "Mostra di arazzi di Cy Twombly / Scatole contemplative e feticci personali di Robert Rauschenberg," opened March 14.

New York, The Stable Gallery. "Rauschenberg: Paintings and Sculpture / Cy Twombly: Paintings and Drawings," September 15–October 3.

Princeton, N.J., The Little Gallery. "Cy Twombly: Drawings, Paintings, Sculpture," October 25–November 7.

1955
New York, The Stable Gallery. "Cy Twombly," January 10–29.

1956
New York, The Stable Gallery. "Cy Twombly," January 2–19.

1957
New York, The Stable Gallery. "Cy Twombly," January 2–19.

1958
Rome, Galleria La Tartaruga. "Cy Twombly," opened May 17. Leaflet; text by Palma Bucarelli.

1960
Rome, Galleria La Tartaruga. "Cy Twombly," opened April 26.

Stuttgart, Galerie Müller. "Gastone Novelli, Achille Perilli, Cy Twombly," May 28–June 30.

New York, Leo Castelli Gallery. "Summary, 1959–1960: Bluhm, Bontecou, Daphnis, Higgins, Johns, Kohn, Langlais, Rauschenberg, Sander, Scarpitta, Stella, Twombly, Tworkov," May 31–June 25.

1961
Milan, Galleria del Naviglio. "Cy Twombly," March 29–April 7. Leaflet; text by Cesare Vivaldi.

Paris, Galerie J. "Cy Twombly: La Révolution du signe," November. Leaflet; text by Pierre Restany.

1962
Venice, Galleria del Leone. "Cy Twombly," opened June 11.

1963
Rome, Galleria La Tartaruga. "Twombly," opened March 6. Catalogue; reprints of texts and excerpts by Frank O'Hara, Palma Bucarelli, Emilio Villa, Franco Marino, Cesare Vivaldi, Manfred de la Motte, Gillo Dorfles, and Pierre Restany.

Cologne, Galerie Änne Abels. "Cy Twombly," April 20–May 15. Catalogue; text by Manfred de la Motte.

1964
New York, Leo Castelli Gallery. "Nine Discourses on Commodus by Cy Twombly," March 14–April 9.

1965
Turin, Galleria Notizie. "Cy Twombly," opened October 5.

1966
New York, Leo Castelli Gallery. "Cy Twombly," February 12–March 2.

1967
Turin, Galleria Notizie. "Cy Twombly," opened February 15.

1968
Milwaukee, Milwaukee Art Center. "Cy Twombly: Paintings and Drawings," January 19–February 18. Catalogue; text by Robert Pincus-Witten.

New York, Leo Castelli Gallery. "Cy Twombly: Paintings and Drawings," November 30–December 21.

1970
Rome, Galleria La Tartaruga. "Cy Twombly," opened February 28.

1971
Turin, Galleria Sperone. "Cy Twombly," opened February 22.

Paris, Galerie Yvon Lambert. "Cy Twombly," opened June 10.

1972
New York, Leo Castelli Gallery. "Cy Twombly," January 15–February 5.

1973
Turin, Galleria Gian Enzo Sperone. "Cy Twombly," January 8–29.

Bern, Kunsthalle. "Cy Twombly: Bilder, 1953–1972," April 28–June 3. Catalogue; text by Carlo Huber. Traveled to Munich, Städtische Galerie im Lenbachhaus, July 10–August 12.

Basel, Kunstmuseum. "Cy Twombly: Zeichnungen, 1953–1973," May 5–June 24. Catalogue; texts by Franz Meyer and Heiner Bastian.

1974
Munich, Galerie Heiner Friedrich. "Cy Twombly: Roman Notes—Gouachen, 1970," March 7–April 7.

Turin, Galleria Gian Enzo Sperone. "Cy Twombly," opened March 12.

1975
Naples, Lucio Amelio–Modern Art Agency. "Cy Twombly: Allusions (*Bay of Naples*)," February 21–March 21.

Cologne, Galerie Karsten Greve. "Cy Twombly: Bilder und Zeichnungen," March 1–April 15. Catalogue; text by Heiner Bastian.

Munich, Galerie Art in Progress. "Cy Twombly: Grey Paintings + Gouaches," March 6–April 14. Catalogue; text by Heiner Bastian.

Philadelphia, Institute of Contemporary Art, University of Pennsylvania. "Cy Twombly: Paintings, Drawings, Constructions, 1951–1974," March 15–April 27. Catalogue; texts by Suzanne Delehanty and Heiner Bastian. Traveled to San Francisco, San Francisco Museum of Art, May 9–June 22.

1976
Düsseldorf, Galerie Art in Progress. "Cy Twombly: Bilder und Gouachen," January 30–March 4.

Hannover, Kestner-Gesellschaft. "Cy Twombly," May–June 20. Catalogue; text by Heiner Bastian.

Paris, Musée d'Art Moderne de la Ville de Paris, ARC 2. "Cy Twombly: Dessins, 1954–1976," June 24–September 6. Catalogue; text by Marcelin Pleynet.

New York, Leo Castelli Gallery. "Cy Twombly: Watercolors," September 25–October 16.

Rome, Galleria Gian Enzo Sperone. "Cy Twombly," November 23–December 17.

1977
Paris, Galerie Yvon Lambert. "Cy Twombly: Three Dialogues," May 17–June 15.

Cologne, Galerie Karsten Greve. "Cy Twombly: Bilder und Zeichnungen," May 20–July 15. Catalogue.

1978
New York, The Lone Star Foundation at Heiner Friedrich. "Cy Twombly: *Fifty Days at Ilium*," November 18–January 20, 1979.

1979
New York, Whitney Museum of American Art. "Cy Twombly: Paintings and Drawings, 1954–1977," April 10–June 10. Catalogue; text by Roland Barthes.

Cologne, Galerie Karsten Greve. "Cy Twombly: Bilder 1957–1968," November 6–January 20, 1980.

1980

Dallas, The University Gallery, Meadows School of the Arts, Southern Methodist University. "Cy Twombly: Paintings and Drawings," January 15–February 26. Leaflet; text by William B. Jordan.

London, The Mayor Gallery. "Cy Twombly: Paintings and Drawings, 1959–1976," March 18–April 19.

Spoleto, Palazzo Ancaiani, Festival dei Due Mondi. "Cy Twombly: Disegni, 1955–1975," June 26–July 13.

Milan, Padiglione d'Arte Contemporanea. "Cy Twombly: 50 disegni, 1953–1980," October–November. Catalogue; texts by Mercedes Garberi, Zeno Birolli, and Gabriella Drudi.

Paris, Galerie Yvon Lambert. "Cy Twombly at Yvon Lambert," October 18–November 20.

1981

New York, Castelli Graphics. "Cy Twombly: *Natural History*— Part I: *Some Trees of Italy*; Part II: *Mushrooms*," June 6–27.

Krefeld, Museum Haus Lange. "Cy Twombly: Skulpturen—23 Arbeiten aus den Jahren 1955 bis 1981," September 27–November 15. Catalogue; text by M[arianne] Stockebrand.

Newport Beach, Calif., Newport Harbor Art Museum. "Cy Twombly: Works on Paper, 1954–1976," October 2–November 29. Catalogue; text by Susan C. Larsen. Traveled to the Elvehejem Museum of Art, Madison, January 24–March 18, 1982; Virginia Museum of Fine Arts, Richmond, June 15–July 18, 1982; Art Gallery of Ontario, Toronto, September 4–October 17, 1982.

1982

New York, Sperone Westwater Fischer. "Cy Twombly: XI Recent Works," April 1–May 8. Catalogue.

Cologne, Galerie Karsten Greve. "Cy Twombly: Arbeiten auf Papier," June 4–[end of] July. Catalogue; text by Karsten Greve.

London, The Mayor Gallery. "Cy Twombly: An Exhibition of Paintings," September 28–November 6. Catalogue; text by Richard Francis.

1983

New York, Stephen Mazoh Gallery. "Cy Twombly: Paintings," April 19–May 27. Catalogue; text by Marjorie Welish.

1984

Cologne, Galerie Karsten Greve. "Cy Twombly," January 27–March 25. Catalogue. Traveled to The Mayor Gallery, London, April 2–May 4; Galerie Ulysses, Vienna, May 24–June 23.

Bordeaux, CAPC, Musée d'Art Contemporain. "Cy Twombly: Oeuvres de 1973–1983," May 19–September 9. Catalogue; texts by Jean-Louis Froment and Jacques Henric.

Baden-Baden, Staatliche Kunsthalle. "Cy Twombly," September 23–November 11. Catalogue; text by Katharina Schmidt.

New York, Hirschl & Adler Modern. "Cy Twombly: Paintings and Drawings, 1952–1984," October 11–November 3. Catalogue.

Rome, Galleria Gian Enzo Sperone. "Cy Twombly: Sculture," opened October 25.

1985

New York, Dia Art Foundation. "Cy Twombly: Paintings and Drawings," October 31–March 15, 1986. Leaflet; text by Donna M. De Salvo.

Cologne, Galerie Karsten Greve. "Cy Twombly," November 16–January 8, 1986.

1986

New York, Gagosian Gallery. "Cy Twombly: Drawings, Collages and Paintings on Paper, 1955–1985," February 22–April 5.

New York, Hirschl & Adler Modern. "Cy Twombly," April 12–May 7. Catalogue; text by Roberta Smith.

Cologne, Galerie Karsten Greve. "Cy Twombly: Paintings," September 2–November 6.

1987

Zurich, Kunsthaus. "Cy Twombly: Bilder, Arbeiten auf Papier, Skulpturen," February 18–March 29. Catalogue; texts by Harald Szeemann, Roberta Smith, and Demosthenes Davvetas; reprints of texts by Cy Twombly, Frank O'Hara, Pierre Restany, and Roland Barthes. Traveled to Madrid, Palacio de Velázquez and Palacio de Cristal, Parque del Retiro, April 22–July 30; London, Whitechapel Art Gallery, September 25–November 15; Düsseldorf, Städtische Kunsthalle, December 11–January 31, 1988; Paris, Musée National d'Art Moderne, Centre Georges Pompidou, February 16–April 17, 1988.

Bonn, Städtisches Kunstmuseum. "Cy Twombly: Serien auf Papier, 1957–1987," June 2–August 9. Catalogue; text by Gottfried Boehm. Traveled to Barcelona, Centre Cultural de la Fundació Caixa de Pensions, November 30–January 17, 1988. Catalogue with additional text by Katharina Schmidt.

Siegen, Städtische Galerie Haus Seel. "Cy Twombly," June 28–August 2. Catalogue; text by Katharina Schmidt.

London, Anthony d'Offay Gallery. "Cy Twombly: Paintings and Works on Paper and the North African Sketchbook, 1953," September 26–October 31.

1988

New York, The Pace Gallery. "Cy Twombly: Works on Paper," January 8–30. Catalogue.

Bridgehampton, N.Y., Dia Art Foundation. "Cy Twombly: Poems to the Sea," May 28–June 30. Catalogue; text by Charles Olson (written January 29, 1952).

New York, Vrej Baghoomian, Inc. "Cy Twombly," September 24–October 22. Catalogue; text by David Shapiro.

1989

New York, Sperone Westwater. "Cy Twombly: Paintings and Sculptures, 1951 and 1953," February 1–28. Catalogue; reprints of texts by Charles Olson and Robert Motherwell.

Cologne, Galerie Karsten Greve. "Paintings of Cy Twombly," spring.

Houston, The Menil Collection. "Cy Twombly," September 8–March 4, 1990. Catalogue; text by Katharina Schmidt (revision of a text previously published in conjunction with "Cy Twombly," Baden-Baden, Staatliche Kunsthalle, 1984). Traveled to Des Moines, Des Moines Art Center, April 28–June 17.

New York, Gagosian Gallery. "Cy Twombly: Bolsena," December 12–January 20, 1990. Catalogue; text by Heiner Bastian.

1990

Zurich, Thomas Ammann Fine Art. "Cy Twombly: Drawings and Eight Sculptures," June 11–September 1.

Paris, Ameliobrachot/Pièce Unique. "Cy Twombly: *Summer Madness*," October 23–November 24.

1991

Paris, Ameliobrachot. "Cy Twombly: *Thermopylae*." October 2–December 20.

1993

Paris, Galerie Karsten Greve. "Cy Twombly: Peintures, oeuvres sur papier et sculptures," May 29–October 20.

New York, Matthew Marks Gallery. "Cy Twombly Photographs," October 15–December 4. Catalogue; text by William Katz.

1994

Milan, Galleria Karsten Greve. "Cy Twombly," April 9–May 25.

ACKNOWLEDGMENTS

In Paris in 1988, at the comprehensive exhibition of Cy Twombly's work organized by Harald Szeemann, I found myself tremendously moved by the experience, and immediately began to focus on this work as never before. When I then met the artist for the first time, in 1989 in Rome, I became even more deeply engaged: talking with him and seeing the work in the setting from which it had sprung exerted a powerful fascination. Since a retrospective exhibition was already being planned for another museum in America, I did not suspect that I would ever have the good fortune to work on such a project. When that other exhibition was abandoned, I was pleased to be able to enlist the artist's cooperation in preparing a retrospective for The Museum of Modern Art.

At that time, I stood as a rank outsider and non-initiate in regard to the circle of devoted friends and admirers who have followed Twombly and his art for more than three decades. My first two guides in this new terrain were Angela Westwater, who kindly arranged my initial meeting with the artist, and Thomas Ammann, who encouraged my interest, helped me start to discriminate among the many aspects of the oeuvre, and frequently acted as a liaison between Rome and New York. Thomas's enthusiasm for Twombly's work, and his excitement over the prospect of a show at this museum, meant a great deal to me. It is a source of profound regret that—taken from us by an untimely death—he has not been here to give counsel in the final stages of the project, and to enjoy the results. I take consolation in the fact that his sister Doris Ammann has continued to play a vital role, facilitating all our efforts and supporting the exhibition enthusiastically. Angela Westwater has remained a friend of the project from start to finish, and I am very grateful to her and to Gian Enzo Sperone for their help.

When I first began to prepare the checklist of works, I knew that one crucial resource could be the archive assembled by Heiner Bastian in preparation for his multi-volume catalogue raisonné of Twombly's paintings. Mr. Bastian's great generosity in opening these archives to me, even prior to the publication of the first volume, was the key piece of aid that launched the entire endeavor. Since then, he has been generous with his time and patient with my unending inquiries, and has helped me resolve several potentially troublesome problems in the preparation of the exhibition and the text of the catalogue. I have greatly appreciated his hospitality and that of his wife, Céline, during many visits to Berlin. Mr. Bastian has of course written extensively and with special sensitivity on Twombly's work, and I have learned a great deal from our many conversations, as well as from his attentive and helpful suggestions regarding my essay. His advice and aid have been indispensable at every step of the way, and his collabo-

ration with this museum in ensuring the quality of the catalogue's production has been a gesture of truly remarkable devotion to the artist. A debt of appreciation is also owed to Christine Stotz, who assists Mr. Bastian in research, and who has been a constant source of help with our many inquiries.

In Cologne and Paris, Karsten Greve has been very helpful in gaining access for me to many private collections of Twombly's work. Even in the midst of a hectic schedule, he sacrificed large amounts of time, and arranged complex travel schedules that allowed my research to move ahead in the most efficient and unimpeded way. He has also shared with me his broad knowledge of the artist's career, and worked closely with me in my efforts to select the best possible exhibition. For all this, and for his loans to the exhibition, I owe him a great debt of thanks.

I would also like to express special thanks to Nicola del Roscio for all the assistance he has given to me and to Cy Twombly, in countless tasks over the course of the past two years. His good will, and indefatigable ability to "make things happen" in response to countless requests, have been crucial ingredients in the success of the project. I have been grateful for his hospitality in Rome and Gaeta, and for his help in every phase of the exhibition, from its earliest beginnings onward.

Closer to home, Larry Gagosian has also taken a lively interest in the exhibition, and has given a great deal of time in efforts to help realize the project in the best fashion. Leo Castelli opened his archives, and graciously answered many questions. Ileana Sonnabend, and also Antonio Homem of the Sonnabend Gallery, were very helpful in allowing me to study several works and in making available loans for the exhibition. I am also grateful to David Whitney, and to Steven Mazoh, for discussing the show and Twombly's work with me, and for many valuable suggestions. Robert Pincus-Witten, who wrote early, highly valuable essays on Twombly, was kind enough to review my catalogue essay and to provide numerous suggestions which improved it; I very much appreciate his help.

In the course of the research for the exhibition and this publication, my assistants and I were obliged to ask the help of many of the artist's friends, and of several archivists and museum colleagues around the country. Robert Rauschenberg received me with warm hospitality at his home in Florida, and discussed with me the period in the early 1950s when he and Twombly were together in New York, at Black Mountain College, and in Italy and North Africa; he also made available several unpublished photographs of Twombly and his work from that period. The artist's sister, Ann Leland, was kind enough to talk with me about her parents and about the family's life in Lexing-

ton, and to provide information about her father. Betty di Robilant, a close friend of Twombly's since the early 1950s in Lexington, also generously discussed with me her recollections of the artist both in the United States and in Europe. I was fortunate to be able to talk with Camilla McGrath, who, as a longtime friend of Tatiana Franchetti, served as a witness to the marriage of Tatiana and the artist.

When we sought information about Twombly's early years in Lexington, many people stepped forward to aid the research. Martha Daura, the daughter of the artist's first teacher, Pierre Daura, helped us learn more about her father's work. Virginia Irby Davis, Director-Curator of the Daura Gallery at Lynchburg College in Virginia, and Nancy L. Pressley made further material on Daura available to us. At Washington and Lee University, William Cocke, Brian Shaw, and Pamela Simpson all lent their aid to our efforts to gain information about the connections of the artist and his father with that institution. Our research in Lexington was furthered by Barbara Crawford, William Hess and his son, William L. Hess III, Sally Mann, and Henry Simpson, and we thank them all for their aid. Thelma Souder Lomax was especially helpful with information regarding the Southern Virginia College for Women in Buena Vista (formerly Southern Seminary and Junior College).

I am very grateful to Ashley Kistler, Assistant Curator at the Virginia Museum of Fine Arts, for her kindness in helping me study a work there by Twombly, and for her help in giving me access to the material in the museum's files pertaining to the artist's fellowship applications in the 1950s. At the Archives of American Art, I was aided by Judy Throm, Head of Reference, in my pursuit of material among the papers of Eleanor Ward; and Lisa Khoury acted as our temporary researcher in the Washington, D.C., facilities of the Archives. Assistance was also provided at Leo Castelli's archives by Christopher Gallagher and in Rome by Patrizia Cavazzini. In my contact with Robert Rauschenberg and my work with his photography archive, I enjoyed the kind assistance of Bradley Jeffries. Calvin Tomkins, in addition to the resources provided by his published works, generously allowed me to study the notes from his interviews with Ward. In the late stages of research, Michael Sims of Vanderbilt University and Michael Riffaterre and Marina van Zuylen brought to a successful conclusion our search for particular quotations from the works of John Crowe Ransom and of Baudelaire. In these latter searches especially, and in several other tasks, I also appreciate the help of Kadee Robbins, Intern, who worked resourcefully and tirelessly to help solve thorny problems of bibliography and source material.

During the period when I traveled to study Twombly's work in various private and institutional collections, I benefitted from the

assistance of a great many collectors and museum colleagues. I am grateful to Mr. and Mrs. Robert Rademacher and Mr. and Mrs. Fritz Metzeler for their hospitality. I also appreciated the chance to visit and talk with Mr. and Mrs. Udo Brandhorst, Dr. Reiner Speck, Dr. and Mrs. Ernst Jung, Mr. and Mrs. Lutz Schirmer, and other collectors, who wish to remain anonymous; they were each kind enough to permit me to visit their homes, study their collections, and learn from their knowledge of the artist's work.

I also wish to thank Paul Winkler, Director, and Walter Hopps, Curator, of The Menil Collection, Houston, for the help they gave me in studying the holdings of that museum, as well as for their invaluable support of the exhibition, and their great patience and flexibility in working with us on the project. Thanks, too, to Lowery Sims of The Metropolitan Museum of Art, New York, for her assistance, and to Dr. Margret Stuffmann of the Städelsches Kunstinstitut, Frankfurt. In addition to Mr. Winkler and Mr. Hopps, I thank Carol Mancusi-Ungaro, Conservator, and Julie Bakke, Registrar, of The Menil Collection, for the help they gave in arranging for the tour of the exhibition; and Nancy Swallow, Associate Registrar at the same institution, for responding so promptly to our various requests for photographs. It has also been a pleasure to work with Richard Koshalek, Director, Paul Schimmel, Chief Curator, and Alma Ruiz, Exhibition Coordinator, at The Museum of Contemporary Art, Los Angeles, in the planning of the exhibition's tour; and with Dieter Honisch, Director of the Neue Nationalgalerie, Berlin, whose institution will host the exhibition at its final showing. The coordination of that overseas venue has been greatly aided, too, by the work of Elizabeth Streibert, Acting Director of the International Program at this museum.

The administration of the exhibition project, and all arrangements involved with its tour, have been in the very capable hands of Richard Palmer, Coordinator of Exhibitions, and Eleni Cocordas, Associate Coordinator of Exhibitions, at The Museum of Modern Art. They have both been superb at their tasks, and it has been a pleasure to work with them. James Snyder, Deputy Director for Administrative Affairs, has also played a valuable role in these arrangements; and Waldo Rasmussen, formerly Director, International Program, helped establish initial agreements with the Neue Nationalgalerie in Berlin before his retirement. Diane Farynyk, Registrar; Meryl Cohen, Associate Registrar; and James Coddington, Conservator, have worked to ensure that all the objects in the exhibition are transported, handled, and displayed in the safest and most professional fashion possible. Jerome Neuner, Director of Exhibition Production and Design, and Karen Meyerhoff, Assistant Director of Exhibition Production and Design, worked with me on the arrangement of the gallery spaces, and prepared the necessary models and schemas that allowed the show to be envisioned well in advance. For all their efforts, I am deeply appreciative.

The design of the catalogue has drawn on the talents of Emily Waters, Senior Designer, who has worked in cooperation with Michael Hentges, Director of Graphics. I am grateful to them for the sensitive and imaginative work done in the face of considerable challenges. I have also enjoyed working, as often in the past, with James Leggio, Editor, in the revision of texts and the careful scrutiny of all the related components of the publication. His keen attention to detail, and many extremely helpful suggestions, have improved my essay and have contributed enormously to the quality of the catalogue. Amanda Freymann, Production Manager, and Vicki Drake, Associate Production Manager, oversaw this book's production with an admirable combination of exacting control and resilience in the face of problems. Finally, all phases of the publication, from initial inception to completion, were closely and thoughtfully supervised by Osa Brown, Director, Department of Publications. I have been fortunate to work with her, and with her staff.

I would also like to thank my immediate office staff, Victoria Garvin, Administrator/Assistant to the Chief Curator, and Betsy Archey, Executive Secretary, for the countless hours of work they have put into this project, and for the many tasks they have taken on in an effort to free my time to work on it. Their constant support and unstintingly upbeat attitude have been, again and again, essential to the progress of the project. Adrian Sudhalter, Administrative Assistant, gave us invaluable help with the preparation of our applications for United States indemnity.

The person who has been most deeply engaged with the organization of both the exhibition and the publication is Fereshteh Daftari, Curatorial Assistant. On Feri has fallen the full weight of responsibility for all the countless, and endlessly revised, listings of works under consideration, in all mediums; and for the preparation of the bibliography. She also handled alone all the time-consuming chores of obtaining photographs, and in addition spent innumerable hours in archives and libraries, and traveling, in order to secure the basic research materials for my essay. Through everything, she has been impervious to fatigue, and consistently positive and good-natured in the face of every challenge. The seriousness and thoroughness with which she undertakes every task, and the high professional standards to which she holds herself, have been inspirational for me and everyone else involved. I am enormously grateful to her for a job very well done.

Two enlightened patrons have made the exhibition possible through their financial contributions. Emily Fisher Landau was the first person to come forward in support of the project, with a very generous grant for this publication. Her belief in the importance of the catalogue, and her willingness to make an early commitment to it, are greatly appreciated; her generosity allowed us to move ahead, without cutting corners, at a crucial moment. Many thanks, too, to Bill Katz, curator and advisor to Mrs. Landau, for his help in that aspect of the exhibition effort, as in many others. Lily Auchincloss is the principal supporter of the exhibition itself, by virtue of an extremely generous donation that was all the more remarkable for not having been solicited. Before I could ask Mrs. Auchincloss, she came to me on her own initiative, offering a grant to be used for whatever purpose I felt was most urgently important. That extraordinary gesture, for which I am more grateful than I can say, was the critical commitment that guaranteed the project could move forward as it should. To both Mrs. Landau and Mrs. Auchincloss, I offer my most profound and admiring gratitude.

Very special thanks should be extended as well to the many institutions and collectors who so kindly agreed to lend their works for this exhibition. The fact that we were virtually never refused a loan is eloquent testimony to the affection and dedication felt for the artist by all those who live with his works. The lenders' willingness to share those works with a broader public was, of course, the indispensable element in the entire preparation of the show.

My wife, Elyn Zimmerman, has been a valuable counsel in my efforts to understand and express my admiration for the art in this exhibition, and has patiently provided essential support throughout the project, especially during the demanding period of the catalogue's preparation. As in so many other areas, my ability to work at these tasks, and the quality of the results, owe a great deal to her.

Finally, I would like to express my warmest gratitude to Cy Twombly, to his wife, Tatiana Franchetti Twombly, and to their son, Alessandro, for the hospitality they have shown me on my several visits to Rome and Gaeta. I am, above all, grateful to the artist himself for his patience and good will at every step of the way over the past few years. It has been an exceptional privilege to work with him, and it would be my fondest hope that he would feel that this exhibition and catalogue do honor to his work and reward his generous cooperation.

K.V.

LENDERS TO THE EXHIBITION

Dia Center for the Arts, New York
The Menil Collection, Houston
Museum of Art, Rhode Island School of Design, Providence
Öffentliche Kunstsammlung Basel, Kunstmuseum

Thomas Ammann Fine Art, Zurich
Galerie Karsten Greve, Cologne, Paris, Milan

Udo and Anette Brandhorst
Josef W. Froehlich
David Geffen
Emily Fisher Landau
Dr. Erich Marx
Robert Rauschenberg
Nicola del Roscio
Sonnabend Collection
Reiner Speck
Alessandro Twombly
Cy Twombly
Several anonymous lenders

173

PHOTOGRAPH CREDITS

Photographs of works of art reproduced in this volume have been provided in many cases by the owners or custodians of the works, identified in the captions. Copyright © 1994 Cy Twombly for all works by the artist. The following list applies to photographs for which a separate acknowledgment is due.

Claudio Abate: figs. 11, 13, 14; pls. 2, 6, 8b, 9, 10, 12, 13, 15, 16, 25, 38–40, 62, 63, 67, 72–74, 80, 81, 96–109, 111–14

Jon Abbott: pl. 44

Courtesy Thomas Ammann Fine Art, Zurich: pls. 18, 23, 24, 82, 83

Courtesy Heiner Bastian: figs. 6, 7, 21, 26, 30–34, 41, 45 (left panel); pls. 65, 76, 88, 92, 93, 110

Robert Bayer: pl. 65

Lawrence Beck: pls. 32, 33

Will Brown: pls. 17, 50

Cathy Carver: pls. 69, 70

Geoffrey Clements, Inc.: pls. 7, 71

Wolfgang von Contzen: pl. 28

Courtesy Dia Art Foundation Collection: pl. 55

Walter Dräger: pls. 88, 92, 93

Courtesy Galerie Karsten Greve, Cologne and Paris: pl. 68

Reni Hansen: cover

Paul Hester: figs. 24, 25

Hickey-Robertson, Houston: figs. 18, 42–44, 45 (center and right panels); pls. 47, 54, 87, 115, 119

Hans Hinz: pl. 45

Kate Keller: figs. 22, 46; pls. 121–24

Courtesy Kunsthaus, Zurich: pls. 84, 86, 94

Courtesy Yvon Lambert (photograph by Eric Pollitzer, © Jim Strong): fig. 37

Jochen Littkemann, Berlin: figs. 6, 7, 29–33; pls. 19, 26, 27, 29–31, 35–37, 41, 48, 49, 51–53, 59, 61, 64, 75–79, 89, 110, 117, 118

Bill Orcutt: fig. 5

Phillips/Schwab, New York, courtesy Sperone Westwater, New York: fig. 23

Tom Powel, courtesy Gagosian Gallery, New York: pl. 85

F. Rosenstiel, Cologne: figs. 34, 36; pls. 42, 56–58, 116

Courtesy The Saatchi Collection: figs. 26, 45 (left panel); pl. 60

Courtesy Gian Enzo Sperone: pl. 90

Courtesy Sperone Westwater, New York: pls. 3, 4, 11, 14

Jim Strong, Inc.: fig. 2; pl. 95

Soichi Sunami: fig. 35

Michael Tropea: pl. 46

Dorothy Twombly: fig. 1

Kirk Varnedoe: p. 2; figs. 10, 12, 17; pl. 8a

Graydon Wood: figs. 38–40

Dorothy Zeidman: pls. 20–22

INDEX OF ILLUSTRATIONS

The illustrations are cited by figure or plate number.

Academy [painting, 1955]: pl. 30
Achaeans in Battle [from *Fifty Days at Ilium,* painting in ten parts, 1977–78]: fig. 39
Age of Alexander [painting, 1959–60]: pl. 47
Anabasis [drawing, 1983]: pl. 85
Apollo and the Artist [drawing with collage, 1975]: pl. 82

Bay of Naples [painting, 1961]: pls. 54, 55
Blue Room [drawing, 1957]: pls. 32,33

Cold Stream [painting, 1966]: fig. 34
Criticism [painting, 1955]: pl. 27

Delian Ode [drawing, 1961]: pl. 56
Delian Ode 28 [drawing, 1961]: pl. 57
Delian Ode 37 [drawing, 1961]: pl. 58
Didim [painting, 1951]: fig. 6
Discourse on Commodus (Parts IV, VII, VIII) [from the painting in nine parts, 1963]: figs. 30–32

Empire of Flora [painting, 1961]: pl. 53

Ferragosto IV [painting, 1961]: pl. 60
Ferragosto V [painting, 1961]: pl. 61
Fifty Days at Ilium [painting in ten parts, 1977–78]: figs. 38–40
Fire That Consumes All Before It [from *Fifty Days at Ilium,* painting in ten parts, 1977–78]: fig. 40
First Part of the Return from Parnassus [painting, 1961]: pl. 51
Four Seasons: Autumn [painting, 1993–4]: pl. 121
Four Seasons: Spring [painting, 1993–4]: pl. 123
Four Seasons: Winter [painting, 1993–4]: pl. 122
Four Seasons: Summer [painting, 1994]: pl. 124
Free Wheeler [painting, 1955]: pls. 28, 29

Gaeta Set I [series of six drawings, 1986]: pls. 96–101
Gaeta Set II [series of eight drawings, 1986]: pls. 102–09
Geeks [painting, 1955]: pl. 26

Hero and Leander [painting, 1981]: pl. 91
Heroes of the Achaeans [from *Fifty Days at Ilium,* painting in ten parts, 1977–78]: fig. 38

Ides of March [painting, 1962]: fig. 29
Ilium (One Morning Ten Years Later) [painting in three parts, 1964]: fig. 45
Italians, The [painting, 1961]: pl. 50

Landscape [painting, 1951]: fig. 5
Leda and the Swan [painting, 1962]: pl. 64

Mars and the Artist [drawing with collage, 1975]: pl. 83
MIN-OE [painting, 1951]: pl. 3

Naxos [drawing, 1982]: pl. 89
Night Watch [painting, 1966]: pl. 65
"North African" sketchbook [drawings, 1953]: figs. 10–12; pl. 8

Olympia [painting, 1957]: pl. 31

Panorama [painting, 1954(?)]: fig. 19; pl. 23
Petals of Fire [painting, 1988]: pl. 110
Poems to the Sea [nos. 10 and 20 in a suite of twenty-four drawings, 1959]: figs. 24, 25
Problem I, II, III [painting in three parts, 1966]: fig. 33

Sahara [painting, 1960]: fig. 26
School of Athens [painting, 1961]: pl. 52
Solon I [painting, 1952]: pl. 5
Study for Presence of a Myth [painting, 1959]: pl. 45
Suma [drawing, 1982]: pl. 90
Summer Madness [drawing, 1990]: pl. 116

Thermopylae [sculpture, 1991]: pl. 115
Tiznit [drawing for, 1953]: pl. 9; [painting, 1953]: pls. 10, 11
Triumph of Galatea [painting, 1961]: pl. 48

UNTITLED DRAWINGS: c. 1951, fig. 17; 1953, pl. 6; 1954, pl. 15; 1954, pl. 16; 1954, pl. 20; 1954, pl. 21; 1954, pl. 22; 1954, fig. 14; 1958, pl. 34; 1959, fig. 23; 1959, pl. 38; 1959, pl. 39; 1961, pl. 63; 1961–63, pl. 62; 1968, pl. 67; 1968, pl. 72; 1969, fig. 37; 1969, pl. 71; 1969, pl. 73; 1969, pl. 74; 1971, fig. 36; 1972, pl. 80; 1973, pl. 81; 1980, pl. 88; 1990, pl. 111; 1990, pl. 112; 1990, pl. 113; 1990, pl. 114

UNTITLED MONOTYPES IN PAINT [1953]: fig. 13; pls. 12, 13

UNTITLED PAINTINGS: 1951, fig. 7, pl. 4; 1953, 1954, pls. 17, 18, 19; 1955, no longer extant, fig. 19; 1955, fig. 20; 1958, pl. 35; 1958, fig. 21; 1959, pl. 36; 1959, pl. 37; 1959, pl. 41; 1961, pl. 49; 1961, pl. 59; 1967, pl. 66; 1968, pls. 69, 70; 1968, 1971, pl. 68; 1970, pl. 77; 1970, pl. 78; 1971, pl. 79; 1964, 1984, pl. 95; 1985, figs. 42–44; 1990, pl. 118; 1992, pl. 117; 1993, pl. 120

UNTITLED SCULPTURES: 1946, pl. 1; c. 1947, pl. 2; 1953, pl. 7; c. 1954, fig. 18; 1955, pl. 24; c. 1955, pl. 25; 1977, pl. 87; 1978, pl. 84; 1979, pl. 86

Untitled (Boat) [sculpture, 1991]: pl. 119
Untitled (Bolsena) [paintings, 1969]: pls. 75, 76
Untitled (Sperlonga) [drawings, 1959]: pls. 40, 42, 43, 44
Untitled (Studio Note) [drawing, c. 1990]: fig. 46

Vengeance of Achilles [painting, 1962]: fig. 41
View [painting, 1959]: pl. 46
Volubilus [painting, 1953]: pl. 14

Wall hangings [1952–53; no longer extant]: figs. 48–50
Wilder Shores of Love [painting, 1985]: pl. 92
Wilder Shores of Love [painting, 1985]: pl. 93
Winter's Passage, LUXOR [sculpture, 1985]: pl. 94

WORKS BY OTHER ARTISTS

Boccioni, Umberto: study for *States of Mind: Those Who Stay* [drawing, 1911], fig. 35

Kandinsky, Vasily: study for *Painting with White Border* [drawing, c. 1913], fig. 27; study for *Small Pleasures* [drawing, 1913], fig. 28

Pollock, Jackson: *Stenographic Figure* [painting, 1942], fig. 22

Rauschenberg, Robert: *22 The Lily White* [painting, c. 1950], fig. 2. Photographs by: Twombly at Black Mountain College [1951], p. 8; Cy, Black Mountain II [1951], fig. 3; Twombly at Black Mountain College [1951(?)], fig. 4; *Cy + Relics*, Rome [1952], fig. 8; tomb-stone, Tangier [1952], fig. 9; wall hangings by Twombly [1952–53; no longer extant] with fetishes by Rauschenberg, figs. 48–50; Twombly with musical instrument, Rome [1953], fig. 51; Twombly with sculptures and paintings [1954; no longer extant], figs. 15, 16